THE COMPLETE BOOK
OF
TRADITIONAL
S

DATE			

THE COMPLETE BOOK OF TRADITIONAL SCANDINAVIAN KNITTING

Sheila McGregor

with a foreword by
the Bishop of Leicester

St. Martin's Press, New York

Acknowledgement

I owe a deep debt of gratitude to the many people who have all helped in their various ways during the months spent researching and writing this book. I must make special mention here of the Bishop of Leicester, Dr Richard Rutt, and Dr Helen Bennett of Edinburgh for their guidance in an area where their expertise far outweighs my own; my knitters, Mrs Johnson, Mrs Williamson, Mrs MacKenzie, Mrs Simpson and Mrs Craig, who all worked enthusiastically and often from very sketchy instructions; Pieter Hintjens who has again produced many of the photographs used here; Mr Buckie, Mrs Griffiths and Mr Mulholland for their essential help with translation; and, lastly, the various members of the staff of the Scandinavian institutions where I worked, and who supplied me most generously not only with material but with all the essential background information: in Denmark, Hanne Frøsig and Lisa Warburg; in Faeroe, Nicolina Jensen; in Norway, Aagot Noss, Brigitte Naessa, Jahn Storum, Marit Wang, Anne Thommesen and Inger Gogstad; in Sweden, Inga Wintzell, Ulla Tegman, and Christina Lindvall Nordin; and in and for Iceland, Magnus Magnusson and Elsa Gudjonsson.

I hope I have done justice to their efforts.

The author and publishers would also like to thank the following organisations for permission to reproduce their photographs: Norsk Folkemuseum, Oslo, Norway, for Figs 44, 50–53, 60 and 61 (from the Wilse Collection), 67 and 167, and colour plate 3; Nordiska Museet, Stockholm, Sweden, for Figs 16, 73 and 77, and for colour plate 1; Lund Museum, Lund, Sweden, for Figs 5 and 74; National Museum, Copenhagen, Denmark, for Figs 87, 88 and 91.

Library of Congress Cataloging in Publication Number: 84–50459
ISBN 0-312-15638-3

First published in Great Britain by B. T. Batsford Ltd.

First U.S. Edition
10 9 8 7 6 5 4 3 2

Contents

Foreword

By the eighteenth century, hand knitting in Europe, which had once been the work of tradesmen's guilds, had become largely a cottage industry. During that century the export of merino sheep from Spain to Germany led to developments in the spinning and supply of wool which contributed towards the growth of hand knitting during the Napoleonic era. When international trading recovered from the Napoleonic wars, the availability of the improved yarns led to the adoption of hand knitting as a popular craft in all sections of society in several European countries. Among the upper and middle classes, hand knitting was taken up by women and, as a result, men of the working classes came to reject it as a feminine pursuit. The chief products of hand knitting had previously been caps, stockings, gloves and purses, and it was to such small garments that leisured knitters gave their attention.

Larger garments were less common. Aristocratic, knitted, silk shirts and coats had been made in the seventeenth century and are now to be found in collections in several countries. Jerseys for manual work were made in parts of Scandinavia before 1700, but they were not widely adopted until the middle of the nineteenth century, when the knit-frock became the typical dress of the North Atlantic seaman. (Machine-knitted jerseys for football seem to have preceded the popularity of the working gansey in Britain.)

The comfort and ergonomic advantages of knitted outerwear did not influence the world of fashion until the twentieth century, when Binge was established in Sweden shortly before the first World War. After the war, Chanel, with her *trompe l'oeil* jumpers and her bathing costumes for the influential ballet, *Le Train Bleu*, gave knitting the accolade of Parisian haute couture. It has never been out of fashion since; yet hand knitting has retained an image of domestication and triviality which has discouraged careful and scholarly approaches to its history.

Most knitting literature is ephemeral, commercial, and popular in its appeal. Victorian books often contained brief historical notes by way of introduction, and a few writers were cultivated as well as well-read ladies, who brought a certain critical aplomb to their essays in history, but they all included legends and romantic details which appealed to the commercial instinct for advertising. Thus, some pleasant fictions about knitting history have gained wide currency and led to widespread belief in the high antiquity of knitted textiles, whose patterns are thought to have emerged in a mysterious religious past. Stories about Fair Isle patterns being

derived from sailors shipwrecked during the sixteenth-century Armada expedition, and of pre-Celtic origins for 'Aran' designs typify the stories and help to sell wool. Miss McGregor, in an earlier book (*The Complete Book of Traditional Fair Isle Knitting*, Batsford, 1981), has shown that the true story of Fair Isle knitting is not so romantic. It is more complex and more fascinating. The making of textiles is an art of life spurred by necessity, and improved by manual skills, just like any other craft. In any culture religious and aesthetic considerations naturally merge in the mind of the craftsman, and simple primitive designs acquire religious names: religion springs from life, not life from religion.

During the past decade, serious research has been begun to test the traditional views. Our British approach to the subject has been bedevilled by insularity. We know too little about the story of hand knitting on the Continent, and even less about what was done in the Middle East. Crafts travel by mysterious means and it will be years before the whole story of knitting is clearly unfolded. Rigorous academic studies are beginning to show how essential it is that we should understand the whole European tradition. In particular, the inter-relations between British and Scandinavian knitting are proving to have crucial importance.

Miss McGregor's work in this field has double excellence: not only as a rigorous and honest search for truth, but as an encouragement to today's knitter to return to earlier sources. She both unravels the past and stimulates further development and pleasure in the practice of the craft.

<div align="right">The Bishop of Leicester</div>

Symbols and abbreviations

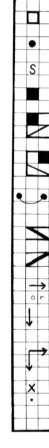

Background colour *or* knit (plain) stitch (K)

Pattern colour *or* purl stitch (P)

Twisted plain stitch (knitted through back of loop)

No stitch (as after reduction or before increase)

Decrease one by knitting two together (K2 tog)

Decrease one by slipping one, knitting one and passing the slipped stitch over (S1, K1, psso)

Chain stitch

Travelling stitch crossed right over left

Travelling stitch crossed left over right

Pattern (or stitch) continues in one direction as indicated

All-over pattern (AO) which continues in both directions

Additional colours, etc. (see explanation in caption of chart)

A Centre underarm line
B Centre back
C Centre front *or* centre of symmetrical pattern

Introduction

In 1955, as a near-penniless student, I spent two sunny weeks exploring Copenhagen. My wanderings brought me again and again to a shop window which contained The Jersey. This dream was dark grey with a circular yoke pattern in white, so delicate and decorative that it seemed almost to float on top of the jersey. Needless to say I couldn't afford it. However I yearned after it so much that I bought a knitting pattern for a similar jersey and, through the following winter, laboriously translated the knitting instructions into English and eventually knitted the jersey. To complete the story I should add that it was too small for me but fitted my sister to perfection; I believe she wears it to this day.

During the intervening years I have knitted many more, which fit their intended wearers rather better than my first attempt, and my interest in the traditional knitting of Scandinavia has finally taken me back to Denmark and Norway to study the craft in depth. While not quite so penniless as I was in 1955, neither time nor finances permitted a visit to the other parts of Scandinavia – Sweden and (usually added as a courtesy, as they belong nowhere else) the islands of Faeroe and Iceland. However, the generous-hearted museum staff of these countries helped to bridge the gap and I have also been able to piece together a part of the whole from several excellent and recently published small books on traditional knitting in Scandinavia.

I went back to Denmark with rather vague ideas of white yokes and snowflakes only to find a whole world of knitting history and design, as well as technique, which was completely new to me. What I found in Norway and what I learned about Sweden completed the picture. The story is told in the following pages. Some parts relate to one country only, while some techniques are found all over Scandinavia and further afield, and some are related to the main garments which have been knitted through the centuries in these countries. You can work through this book from front to back but it can be taken in any order as each chapter complements the others.

1 Origins of knitting in Scandinavia

There is some argument as to whether knitting first developed in Denmark or southern Sweden. It is unlikely that this will ever be resolved as we just will never know enough about the earliest days. However, the general picture for every country is very similar. First came exotic imported silk knitwear, hose, gloves and the marvellous silk jackets. If the technique was practised locally much before the seventeenth century (which is certainly possible), we know nothing about it. We do find local copies of these very elegant and well-made jackets knitted in wool in Denmark in the seventeenth century. Indeed, it was one of the greatest surprises of my recent researches to find that virtually identical jackets were knitted and worn by country women right into the early days of the twentieth century.

The well-documented history of folk costume in the rest of Scandinavia fills in the picture and also gives us a framework and dating reference lacking in Britain where folk costume seems to have disappeared earlier and have been less studied while it was still possible to get authentic information. Thus we can find similar jackets to the Danish jackets in both Norway and Sweden, but only in museum collections. A changeover to a Fair Isle type of pattern took place in a great number of places around 1840, perhaps as early as 1820, but often within the memory of old people still living when folk costume was researched earlier this century. In other cases, the very individual who started a new fashion in stranded knitting could be identified – the first knitter of the now world-famous, black-and-white patterns from Selbu in Norway lived on until 1929. Before her there may have been much local knitting in Selbu, but it can only have been of plain stockings and plain mittens. Such stories are repeated in several places and confirm that Fair Isle-type patterns are not very ancient; it was a new folk fashion in mid-nineteenth century, perhaps from further east in the Baltic, perhaps a local inspiration spreading more by word of mouth than by the actual movement of designs. Indeed, the knitted jackets of the nineteenth century vary so greatly that some local development seems likely. It ties in very neatly with the story of Fair Isle knitting which I tried to unravel in my previous book (*The Complete Book of Traditional Fair Isle Knitting*, Batsford 1981), picking a cautious way between the assorted myths of Viking and Spanish origins and claims of great antiquity.

Another intriguing link-up is between British fishermen's 'gansies' and the early textured Danish jackets. Although the

gansies are now worn only by men, and the Danish jackets only by women, this was probably not the case when they were a new fashion, and there are so many similarities of style that a common origin seems possible. Were gansies copied from Danish jackets, or do they go right back, as the jackets do, to the finely crafted knitted shirts of the seventeenth and eighteenth centuries? The wider horizons opened up by looking at the knitting of these countries linked to us by the North Sea have been very illuminating and thought provoking.

Not only is the history of this relatively young craft illuminated by a look at Scandinavian knitting – the basic techniques which each country takes for granted also benefit very much from comparison. Here, my visit was certainly too short. It is one thing to recognise a technique but quite another to imitate it and come up with the same effect. My versions of the double purl stitch, for example, are not quite right, even though one has been copied from a Finnish publication. What did the Danish knitters do to avoid a rather unseemly bump? Was it only that their yarn was heavier and firmer and their knitting tighter? Or is there some further refinement still to be learned? Anyone who has tried to analyse the course of a knitted thread through its convolutions in old, possibly felted, and even fragile knitting will know how difficult this can be. But, in knitting, there is often more than one way of achieving an effect and a good knitter in this century will not necessarily work in the same way as a good knitter several hundred years ago.

I have tried to include only what I know to be authentic and representative examples of Scandinavian knitting. To make complete technical analyses of old stockings and caps would be tedious and not very instructive, and so many of the more unusual items, while still very interesting, have been mentioned only in passing. We in the twentieth century also have our contribution to make to the development of the craft. It would be nice to see a return to a finer and more craftsmanlike approach; very thick wool and needles like fence-posts are certainly quick and can be most effective, but delicate, textured work done on fine needles with silk yarn, or one of the silk-and-wool mixtures available, has a lasting charm and gives great scope for expert knitting. If this book can inspire a few good knitters to rediscover fine knitting it will have served a useful purpose. But I believe it has a very general appeal and wish my readers as much pleasure in reading it as I have had in researching and writing it.

2 Types of knitting traditionally used in Scandinavia

The earliest knitting in Scandinavia was probably knitted entirely in stocking stitch from white wool, and coloured, if at all, by boiling up in a dye vat once it was completed. The earliest piece to survive, in Denmark, has the addition of a simple pattern in purl stitch. This style seems to have survived right into the twentieth century and, indeed, was the only style known until early in the nineteenth century. It was around 1840 or 1850 that a great knitting revolution took place in country places. Folk costumes, by definition, identify the wearer as coming from a particular region – a parish, a village, a valley, a fishing town. Many costumes began to contain patterned jackets, patterned stockings, caps with stars and other borders knitted in, and so on to differentiate them from those of a neighbouring area. Local knitting traditions grew up, each one being completely, and often remarkably, different from every other. This is the main reason why this part of the world is so rich in inspiration, both for the student of knitting history and for the practical knitter who carries on this sympathetic craft today.

Did all the different traditional techniques serve a useful purpose? Or were decorations just added for the sake of it, or for good luck, or because things had always been done that way? Fashion certainly has played its part in folk knitting, as elsewhere; nevertheless, peasants are essentially practical people and it is often possible to work out why things were done one way and not another. In some cases we know why from stories that have been passed down and from our own commonsense. We know, for example, that a purl pattern in a large expanse of plain stocking stitch will make it slightly thicker, and hence more resistant and warmer, and that a stranded pattern will virtually double the thickness of the fabric, as will the earlier, two-stranded technique. The complex small cables and twisted stitches found in many Norwegian stockings, both men's and women's, added greatly to their weight and warmth.

Some of the less common variations were used for a purely decorative effect; 'poor man's braid', found in Norway on coastal jerseys and Setesdal socks for example, is a slow, tedious and technically clumsy process, but imitates very effectively woven braid – why this had to be imitated in this laborious way we cannot say. Perhaps they normally bought supplies from a pedlar who failed to arrive one year; perhaps their loom broke down and some replacement was needed – who knows? But behind every stitch and every variation on every stitch lies some such small story

1 *Knitted wool jersey from Sunnhordland, Norway. A very finely knitted, textured jacket, showing many seventeenth-century features details of which are given in Fig. 2. One point of refinement is the rows of double knitting, done with two threads, on either side of the welt pattern and bodice pattern. For the bodice pattern, an extra strand of the same wool is used and carried along on the outside of the work to knit every second stitch purlwise. The original yarn is used to knit every alternate stitch knitwise, and is stranded along on the inside of the work. For the welt pattern, a double twisted purl is worked using two strands alternating as above, but both being kept on the right side of the work and twisted round each other at every stitch (see page 22).*

of local ingenuity meeting local need. It is this contact with the original knitter that makes study of old knitting so exciting and satisfying; the person who held the needles often seems very close, not kept apart by a large and complicated piece of machinery, like a loom, but revealed in every single stitch.

TEXTURED KNITTING

This type of single-colour knitting, sometimes known as 'damask' knitting, was originally particularly popular in Denmark and jerseys with textured patterns were worn by most of the population for hundreds of years. A few jackets in the same technique are also known to have come from Norway, Sweden, Finland and Estonia and then, in the nineteenth century, this type of knitting reached its height when the Norwegians in Setesdal began to make cabled stockings. The original jersey pattern was usually only purl-on-plain, though travelling stitches and small cables were also used here and there. All the variations – moss stitch, larger purl-on-plain patterns, twisted stitches, small cables, travelling stitches and the double purl stitch – have the desirable effect (when your jersey is your main protection against the elements) of making plain stocking stitch thicker, stronger and firmer. This fact was known as

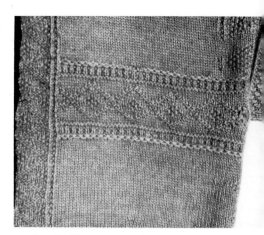

2 *Detail of knitted jersey from Sunnhordland, Norway, to show the front band, bodice pattern with row of two-strand knitting above and below, armhole and seam decoration, and pattern at top of sleeve.*

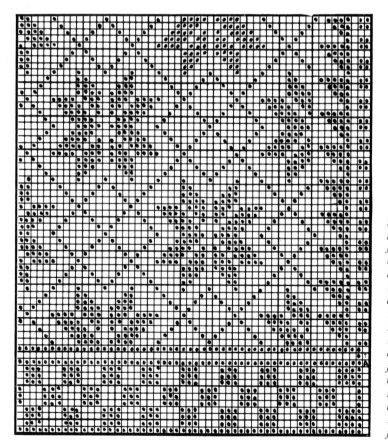

3 *Textured knitting patterns (plain and purl). A scaled-down version of a pattern from a lady's jacket from Skåne, Sweden, knitted in red wool. It is remarkably like the pattern of the Danish silk jacket in Fig. 87. The patterns shown are for bodice and sleeves, side 'seam' decoration and welt. The original star was on a much larger scale, ten stitches to the four given here. The net would normally be double with finer knitting. This very successful pattern is also found in the Bergen silk jackets (under a mass of later floral embroidery), in a seventeenth century Danish fragment and in a red and blue version in Faeroe. The diced welt has also been a persistent and popular feature in folk knitting.*

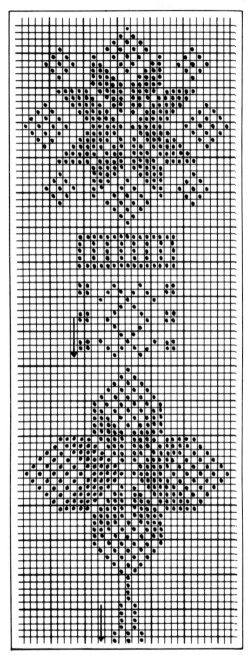

far back as the seventeenth century when textured silk jackets using the same purl-and-plain, all-over patterns were imported to Scandinavia, perhaps from England, perhaps from Italy. In the Norwegian cabled stockings, known as *krotasokkar*, every stitch is either twisted or purled or cabled (or both twisted and cabled). A popular pattern has vertical lines of twisted plain stitches alternating with purl stitches. This gives a very strong, tight rib. To prevent it pulling too tightly together, purl and plain stitches are alternated every few rows to give a form of moss stitch and, indeed, several variations. Setesdal cables are very small, involving only two stitches. Larger cables, requiring cable needles, were used in Telemark in Norway and travelling stitches are quite common.

TRAVELLING STITCHES

These make surface patterns on plain or purl knitting by moving diagonally from row to row. They are always in plain knitting and lie entirely on top of the normal fabric which is therefore double at

4 *Two stocking clock patterns in purl and plain from Denmark.*

5 *Detail of typical clock pattern from nineteenth-century woollen stocking; star in single purl and diamonds in what might be double purl.*

14

6 *Stocking patterns in purl and plain.* TOP
RIGHT, CENTRE AND LEFT CENTRE: *clock
patterns (twisted purl stitches marked S).
Top centre stocking is patterned all over in
panels as marked; pattern under star divides
at heel, half continuing along side of foot
and half on heel flap. (From Norway.)* TOP
RIGHT: *two small stocking patterns which
can be used AO or in panels; purl stitches
only are marked and the plain stitches can
be twisted or not.* BELOW: *motifs in panels
from Swedish stocking.* BELOW RIGHT:
*decorated arrangement from Norwegian
stocking.*

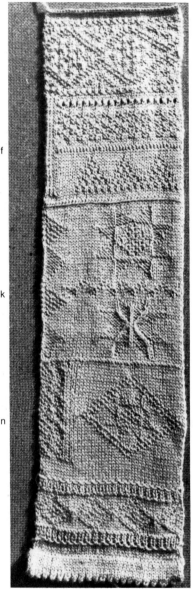

f
k
n

a
b
c
d
e
g
h
i
j
l
m
o
p

7 *Textured knitting sampler.*

that point. They should not count in calculation of tension, etc., in making up the width of the fabric. To keep the tension correct it is necessary to create a new stitch for every travelling stitch used and to reduce the same number at the end of the section. This surface decoration is used all over Scandinavia and in Finland and the Baltic States (*see page 141*).

Method

To cross two right: knit into the second stitch on the left-hand needle through the front of the loop, and then immediately into the first stitch on the left-hand needle through the front of the loop. Drop off both stitches from left-hand needle.

To cross two left: go behind the first stitch on the left-hand needle and knit into the front or the back of the second stitch on that needle and then into the first stitch. Let both drop off the left-hand needle.

DOUBLE PURL STITCH

Double purl is something of a mystery stitch. It is described in a Finnish knitting book as being used for a double effect in 'quick' knitting; this almost certainly compares single-strand knitting (the normal method for us today) with two-strand knitting which is rather slower. In Danish women's jackets and elsewhere a double stitch can be recognised – it is a purl stitch, but has an extra bar below it which also appears on the back. This can be achieved by moving the stitch to be purled from left-hand to right-hand needle without working it, passing the yarn between the needles and moving the stitch back before working it. The yarn is wound once right round the base of the stitch. However, in practice, this does not seem to add much to the effect of a purl stitch, which may explain its lack of popularity.

Other ways of emphasising a purl stitch have been used, for example by alternating purl stitches and twisted plain stitches from row to row. Also, when knitting a purl stitch, it is the top of the loop of the preceding stitch which actually shows (i.e., the corresponding stitch in the previous round). A double purl can then be achieved by knitting a double plain stitch in the row or round below (*see also page 23*).

TEXTURED KNITTING SAMPLER *(Figs 7 and 8)*

These patterns are from Danish, Swedish and Norwegian textured jerseys and the sampler was knitted in Jaeger Wool/Silk on $2\frac{1}{2}$ mm (U.K. 13; U.S. 1) needles to give a fairly close texture.

Symbols used:

☐ Plain stitch

• Purl stitch

s Twisted plain stitch

∪ Chain stitch

a Large border pattern (*see chart*).

b Row of holes (*First row:* knit 2 together, make 1 by passing wool over needle; repeat. *Second row:* stocking stitch).

c Small two-and-two check (*see chart*).

d Row of small 'double plain' knots – the only stitch not traditional to Scandinavia, as far as I know, but certainly inspired by the old 'double purl' stitch and so effective I decided to include it. The knots are made as follows: the yarn is passed to the right side as though to purl; the next stitch on the left-hand needle is transferred unknitted to the right-hand needle; the yarn is passed between the needles; the stitch is moved back to the left-hand needle and knitted; repeat.

e Pyramid pattern (*see chart*).

f Border pattern of vertical rows of twisted plain and purl stitches (*see chart*). This pulls together very closely and gives a neat edge.

g A row of double purl stitches, recorded in Finland but formerly known more widely and certainly worth knowing for its neat relief effect. In Finland they call it the 'quick' (or lazy) method of working a double purl. It makes a good alternative when worked in a row to the double purled winding stripe used in the Norwegian jacket (*see Fig. 2*). It is similar in working to the double plain knots described above under (d). With the yarn on the right side of the work, as though to purl, the next stitch to be worked is transferred from the left-hand to the right-hand needle (without being knitted); the yarn is passed between the points of the two needles, the stitch is moved back and purled. This gives an extra strand of wool on the right side of the work and a good imitation of a double purl twist.

h Typical Danish star (*see Fig. 102*).

i Double zig-zag (*see Fig. 101*)

j Star from Danish nattrøje with travelling stitch (*see Fig. 102*).

k Armhole (or other) border (*see chart*).

l Single purl row.

m Small star in double diamond (*see chart*).

n A front edge pattern from a Norwegian jacket (*see chart*). It combines purl-and-plain with vertical rows of purl and twisted plain stitches.

o Complete border pattern from Norwegian jacket (*see Fig. 2*). The centre pattern is shown in the chart. The two outer rows are worked as follows: an extra strand of the same yarn is joined in at the beginning of the row. It is looped along on the *right* side of the work and the stitches are alternately knitted with the original yarn and purled with the second strand.

p A picot hem worked as an alternative to a single-textured welt (*see page 35*).

Two more tips: an alternation of single purl and plain stitches often stands out better than a solid purl pattern; and, for a more prominent purl effect, knit the stitch immediately below it (in the previous row) as a twisted plain stitch.

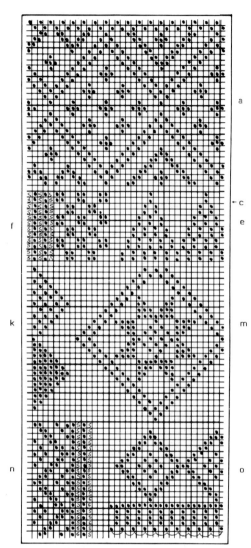

8 *Textured knitting patterns.*

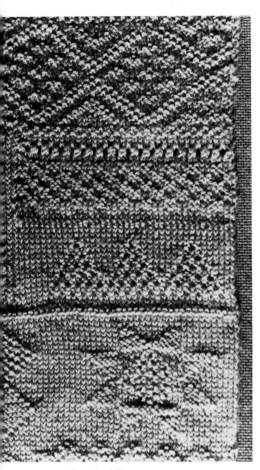

9 *Detail of Fig. 7.*

STRANDED KNITTING

The simplest type of stranded knitting (knitting with more than one yarn in each row, and with the yarn not in use stranded from one stitch to the next) is still practised in Sweden and consists simply of one dark stitch and one light stitch repeated, so that the final effect is of vertical dark and light stripes. This seems to be a version of two-strand knitting (*see page 22*) which is more usually done with both ends of one ball of yarn, hence its other name of two-end knitting. However, it is possible to see a connection between the light-and-dark, striped pattern and more elaborate knitted patterns, particularly the optical-effect type of pattern found in Finland, Estonia and also in the north of Sweden. The chart on page 19 shows this possible development and if this connection does exist, these are the only knitting patterns in the stranded tradition derived directly from a knitting technique and not copied from some other source.

Most stranded patterns in use today seem to copy embroidered or woven originals. The link with embroidery is clear in Estonia, a country whose knitting greatly influenced Baltic knitting and even Fair Isle knitting. Gloves are found in Estonia with the same patterns embroidered on some and knitted into others. From Estonia, the stranded technique and many patterns were copied by the Swedish women living on the islands in the Gulf of Riga and from there, or perhaps directly from Estonia, the patterns went to Gotland, on to Sweden and eventually were taken up by most countries around the North Sea. A cap with an Estonian pattern can be found in the Shetland Museum in Lerwick, and Estonian gloves in a Copenhagen collection. Other patterns were copied locally from weaving charts, printed materials, cross-stitch patterns, woven rugs and wall hangings. Behind all these patterns (quite literally) lies extra warmth; stranded mittens are twice as warm as plain ones.

Many modern printed patterns for so-called 'Fair Isle' patterns have more than two colours in one row and often have enormous stretches in one colour (which means the yarn must be stranded very long distances on the back of the work; always a tricky thing to do without pulling it too tight). Such patterns are found in one or two places in Scandinavia – on the west coast of Norway, for example, and in Delsbo in Sweden – and required great skill on the part of the traditional knitters in these places. Most Scandinavian knitters would agree with modern Shetland knitters: use only two colours in each row and keep the stretches in any one colour as short as possible. As in Shetland, they juggle around on graph paper, adding little stars, filling in the background with the small repetitive 'seeding' patterns, knitting smaller stars (five stitches rather than ten) when the yarn is thicker.

Method

Plain row: technique is not standard but best results follow from knitting always with the background yarn (the main colour) on the first finger of the right hand and the pattern colour on the second finger. Both yarns are wound once round the little finger. This means that the main colour is stranded above and the pattern

colour is stranded below. This works particularly well when there are roughly equal numbers of stitches to work in each colour.

Purl row: if for any reason it is necessary to work a row in purl, work the main colour with the second finger (stranded above) and the other colour with the first (stranded below). In this way, the same yarn is always on top and an even effect is obtained. This is particularly important in two-stranded knitting in two colours. For an even effect here the same one must always lie on top.

Left-handed knitters will normally hold both yarns over the first finger of the left hand. The main colour will then be the one on the left and the same principle of keeping the relative positions of the two yarns applies.

WEAVING IN

Sometimes long stretches do occur – some of the Norwegian coastal jerseys seem to have been designed and knitted with supreme confidence, and have endless lengths of yarn stranded inside with never a weaving-in to be seen. Traditional jerseys would often be felted and the loops were then not hanging free, but they can, however, be a real hazard in a modern jersey. I like to weave in when a loop would otherwise be longer than 2.5 cm (1 in.) or so. This should always be done in such a way that the colour woven in does not show at all on the front. If it does, it will spoil the clean lines of the pattern.

Method

If both yarns are being worked with the right hand, weaving in can be done without too much effort, if certain rules are followed (*Fig. 11*). This will also tend to improve the final appearance. Always keep the yarn to be woven in below the other, i.e. work it with the second finger. As the yarn to be woven in is generally the pattern colour this will achieve a more prominent effect. Just as the needles are engaged to knit the next stitch, but before the main yarn has been moved, bring the yarn to be stranded up from under the other and lay it over the right-hand needle and down between the points of the right-hand and left-hand needles. Then knit normally with the working yarn, meanwhile holding the woven yarn with the left hand until it is completely woven in one stitch later.

Weaving in is one manoeuvre I find easier to work with the left hand, in spite of being a dedicated right-hander. So, if I am faced with a pattern row which involves regular weaving-in, I will, for this one row, work the main yarn with my right hand and the other with my left. On other occasions (though I have seen it recommended) I find the combination of left-handed and right-handed techniques for stranded knitting slow and awkward.

MULTI-COLOUR KNITTING

Several patterns, probably copied from cross stitch, are traditionally knitted with three or even more colours per round. Norrbotten mittens are particularly notable for this (*Fig. 12*), but multi-coloured knitting was also worked in parts of Norway (*see page 27*) to knit imitations of woven edgings or bindings. The

10 *Development of stranded patterns.*

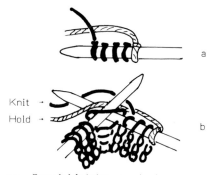

Knit →
Hold →

a

b

11 *Stranded knitting; weaving in.*

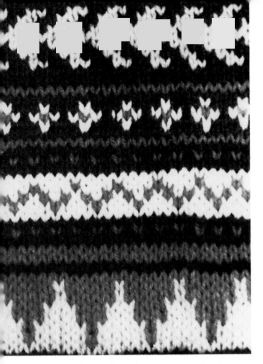

technical problems of knitting these little bands have obviously been less important than the splendour of the final effect. The knitting becomes very thick and quite inelastic. Remember that a simpler way of introducing a dot of colour (a white centre for a red and blue star, for example) is by Swiss darning (*see page 39*).

Method

If working with three or more yarns at once, follow the Norwegian way of rolling them all round each other on the back (*Fig. 13*). Always bring each new colour into play by bringing it up from under all the others. This is neither quick nor convenient, as the balls of yarns tend to get very tangled unless you can devise some system of bobbins, but it allows a yarn which is not used very often to run along inside the bundle, and the bundle itself is held every time the colours change.

When moving from round to round, keep all the yarns attached to the work as a general rule; keep them moving up the line of the join by twisting in every second row or so. Pull out the colours needed for the new row and pull quite tightly to avoid a gap in the knitting. The yarns not in use will be held by the same process and a very neat join can be obtained.

12 Norrbotten mitten patterns showing use of colour (often three colours per row) and join in circular pattern (normally on inside of mitten).
13 Multi-coloured knitting. Reverse side of Fig. 12 to show yarns coiled from pattern to pattern.

DIAGONAL PATCHWORK KNITTING

This intriguing variation for once does not seem to have any functional reason behind it: it is purely decorative, and is certainly eye-catching when knitted in the traditional red and black squares which are found from Finland to the far west of Norway. The finished knitting has the appearance of basketwork but is simply small squares knitted in stocking stitch and joined to each other on all sides in very much the same way as the heel of a sock is turned. Any size of square can be worked, usually with even stitches to give an easier turn. I have used eight as the basis for the instructions but this could be any number. There will always be twice as many rows per square as there are stitches in each row: for example, a square with eight stitches will take sixteen rows to work. This is necessary both to work in all the side stitches (from the previous round) and to give eight points at the side of the square from which the next round of stitches may be picked up. The natural elasticity of knitting allows each piece to be pulled into the right shape (*Fig. 14*).

Knit or purl every stitch in every row, including the first. Do not slip the first stitch as is often suggested for flat knitting.

This technique is one of the few that is as easy to work in flat pieces as in a round. Base triangles are knitted working in one direction, then a row of entire squares is worked one at a time working in the opposite direction. As each section is worked in plain and purl, sometimes one side is facing and sometimes the other. If knitted in flat pieces (e.g. for a waistcoat) half triangles have to be knitted at the sides as well as at top and bottom.

Method

Base triangles: cast on a multiple of eight stitches (or any even number) or work from a row of stocking stitch. Knit 2, turn; purl 2, turn; repeat; then knit 3, turn; purl 3, turn; knit 4, turn; purl 4,

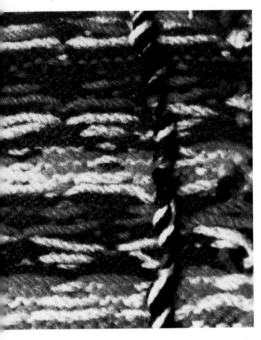

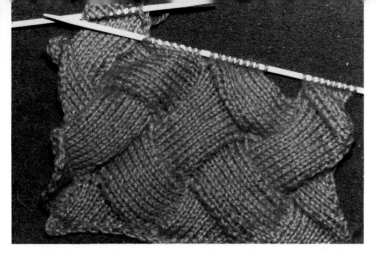

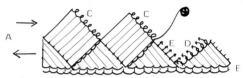

15 *Diagonal patchwork knitting* **A** *direction of work;* **B** *foundation row (cast-on edge or stocking stitch);* **C** *stitches held on right-hand needle;* **D** *stitches held on left-hand needle;* **E** *stitches to be picked up from edge of foundation triangle.*

turn. Continue working one more stitch in every knit row until you have knitted eight. That completes the first triangle. Repeat this until all triangles have been made.

First squares: working now in the opposite direction, pick up eight stitches along the adjoining side of the first triangle to be knitted, and purl to the end. These form the base stitches of the new square. Turn; knit 8, turn; purl 7, purl 2 together (last stitch of those picked up with first stitch of base triangle). Turn and repeat, until all stitches on the base triangle have been knitted up. This forms the first complete square. Leave its stitches on a needle and work the rest of the squares in the row in the same way (*Fig. 15*).

Second squares: done as above, except that purl rows will be plain and vice versa, and that the reduction will be made by slipping the last stitch of the new square, knitting the next one from the previous square, and passing the slipped stitch over.

Final triangles: to shape the last triangle, or to cast off, reduce in the appropriate way at the top end of every second row. If the knitting is to continue in stocking stitch, leave one stitch unworked at the top end of every second row. The top end is the end away from the join between two squares. To check this, every time you have decreased and turned the work, count the number of stitches from the previous square still to be knitted in, and work only the same number back before turning again. Slip the first stitch at the outside for a neater edge.

Side triangles for flat knitting: work as for a square but reduce one at each turn at the outside edge. For example, you might pick up and knit down 8 stitches, turn; purl back to last stitch, purl 2 together, turn; knit 6, knit 2 together, turn; slip 1, purl to last two stitches, purl 2 together, turn; knit 5, and so on. A good edge is given by knitting 2 together at the end of the row and slipping the first stitch of the next purlwise. The slip 1, knit 1 method gives too loose an edge.

The triangle at the opposite side is formed by a different method: knit 2, turn, purl 2, turn; increase in first stitch (by knitting into it twice), slip 1, knit 1, pass slip stitch over, turn; purl 4. Continue in same way by working one extra stitch between the increase and decrease each time until there are eight stitches on the needle; continue to knit the next full square.

Both these side triangles may have to be reversed, substituting plain for purl and adapting the reductions or increases to give a firm edge.

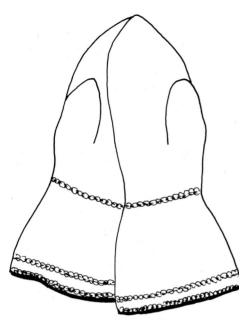

This type of work can be used on gloves or caps or jersey yokes or in flat pieces for a jacket or waistcoat; it is fun to knit and the visual impact is striking. Note that the yarn never has to be cut; it should be one continuous knit, however done. Picking up stitches must be done neatly and regularly from the knots along the edge, or just under the edge, to give the patchwork effect. It can be done in one colour, two colours or more.

TWO-STRAND KNITTING

Two-strand knitting is an old tradition, certainly pre-dating left-handed knitting as it can only be done with the yarns in the right hand. It survived in Norway and Sweden in general use until the mid-nineteenth century, but does not seem to have been known by then in Finland or Denmark. It was rediscovered in the mid-twentieth century in Dalarna in Sweden.

Many old stockings, which appear on the outside to be ordinary stocking stitch, are, in fact, double. Only a look at the inside can tell you. In the old days, the two yarns in use were continually twisted round each other to make it as firm and, as they thought, warm as possible. I find it easier (and warmer) to strand them, one above and one below, as in other forms of stranded knitting.

The simplest type of two-strand knitting is knitted with both ends of the same ball of yarn. Hold one yarn with the first finger (of the right hand) and the other over the second, and knit one stitch with one finger and one with the other. You might feel that this is not very complicated and hardly worth mentioning. It is indeed very easy, but the firmness and warmth of the texture are extraordinary.

More complex effects are best explained in conjunction with the illustrations (*Figs 18 and 20*), and with a set of needles and two strands of yarn at hand.

DOUBLE PURL TWIST

The main sophistication is to knit in purl stitch with the stranded yarn or yarns on the *right* side of the work. If both yarns are purled they are normally twisted to make a corded effect known as double purl twist. They can be twisted S-wise or Z-wise, and it is best to twist them according to their original ply (which is usually S in 2-ply commercial wool). Some people prefer to reverse the work and knit it plain on the inside, but I don't feel it makes much difference, except that, in my case, it generally leads to a hole where I have turned!

CHAIN STITCH

If only every second stitch is purled (i.e. one yarn is worked on the inside for the plain stitches and the other stranded on the outside for the purl stitches) we get chain stitch, a very useful and decorative stitch which is also very easy to work once your fingers organise themselves. It is completely reversible.

16 *Dala mittens, probably a mediaeval design, still made and sold today; fine two-strand knitting with a red twisted cast-on and three rows of chain stitch as their only decoration. Felted and brushed.*

17 *Gloves from Dalarna in two-strand knitting. Details include cuff decorated with combination of chain stitch and double purl twist; thumb increase along one line, also decorated with chain stitch; and chain stitch decoration at wrist and back of thumb.*

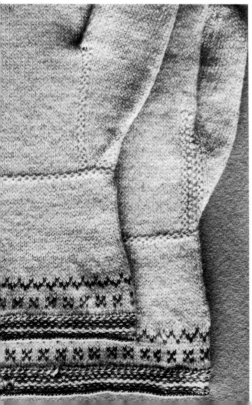

PURL KNOTS

Other decoration is possible with individual purl stitches with no stranding on the right side. Various methods exist to emphasise the little knot thus made, such as purling with both yarns at once, twisting the corresponding plain stitch in the preceding row, or knitting it with both strands.

INCREASING

It is easy to increase in ordinary plain two-strand knitting – one simply knits with both yarns into one stitch and next time round treats each thread as a separate stitch. This is used, along one line only, for the thumb gussets in Dalarna gloves (*Fig. 17*). In spite of the rather odd topology they seem to fit as well as gloves with a symmetrical gusset.

Also of note are the Dalarna stocking-tops which were decorated with differing small zig-zag patterns (all in one colour two-strand knitting) so that they could be identified by the owner after wash-day.

TWO-STRAND KNITTING SAMPLER (*Fig. 18*)

Knitted with Shetland 3-ply (S-plied and equivalent of double knitting) on size 3 mm (U.K. 11, U.S. $2\frac{1}{2}$) needles.

a One row double purl twist (Z-wise); three rows synchronised chain stitch (which gives a double fabric so is only suitable for short distances); one row double purl twist (S-wise).

b One row double purl twist both S-wise and Z-wise to show differing effects on S-plied yarn; S-twist is better, giving a firm, tidy outline.

c One row chain stitch.

d Two rows off-set chain stitch making a 'hole' pattern.

e One row chain stitch (as [c]).

f One row double purl stranded, not twisted (as [f]). appearance on the inside).

g A row of 'holes' made over three stitches and two rows. *Row 1:* move strand A to the right side, purl 1 with it and leave on the right side, knit 1 with strand B, purl 1 with A and return to wrong side. *Row 2:* pass yarn B to the right side, knit 1 with yarn A, purl 1 with yarn B stranding this on the right side, knit 1 with strand A and return strand B to wrong side. Used in Dalarna gloves illustrated (*Fig. 16*) to form vertical 'holes' in imitation of horizontal border of chain stitch. Repeat in a vertical direction, alternating rows 1 and 2.

h One row double purl stranded, not knitted (as [f]).

i Little pattern of chain-stitch zig-zags crowned by a 'hole'. Each pattern point covers three stitches and must be offset to make a 'hole' (see chart).

j A 'flet' or plait made of one row double purl twisted Z-wise and the next twisted S-wise. A common and effective decoration for cuffs.

k Zig-zags in single purl knots; these would be more effective over a wider and more definite area, such as a diamond shape.

l A row of single purl knots.

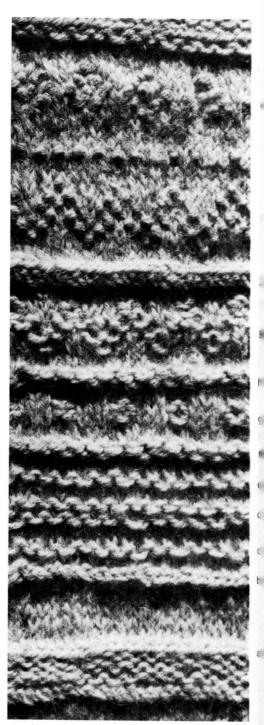

18 *Two-strand knitting sampler.*

19 *Knitting two-strand stocking stitch in one colour. Mitt with a simple traditional border (see Fig. 24) being knitted; wool held in traditional fashion on fingers of right hand.*

m Small diamond pattern of double purl knots (knitted with both yarns). I do not, personally, find these better in any way than the single purl knots; they add too much to the thickness for the result to be satisfactory.

CHARTING FOR TWO-STRAND KNITTING *(Fig. 20)*

The large dots are purl stitches, blank squares are plain stitches and where yarn is stranded on the right side this is shown by a loop covering the plain stitch. Remember that the 'hole' pattern takes up three stitches and that, if worked vertically the two rows are different. But, if diagonal patterns are used (the most common traditional type), every pattern unit will be the same: purl 1 (keep yarn on right side and strand it), knit 1, purl 1 (return yarn to wrong side).

a A typical small border pattern adapted for two-strand knitting.

b Two 'holes': a length of 'hole' pattern as used on Dalarna mittens and gloves, and a small area of what I call 'basket weave'.

c The pattern from the sampler – line (i).

d A row of single chain stitch.

e An example of a typical Dalarna pattern which could be done

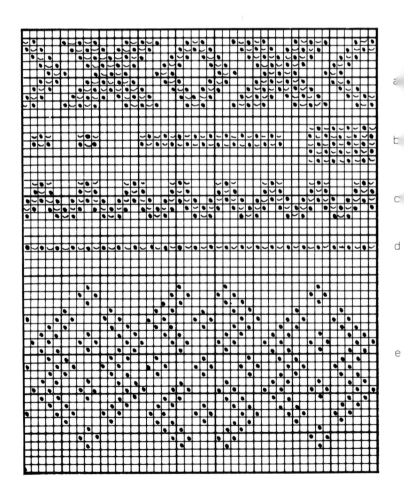

20 *Charting for two-strand knitting.*

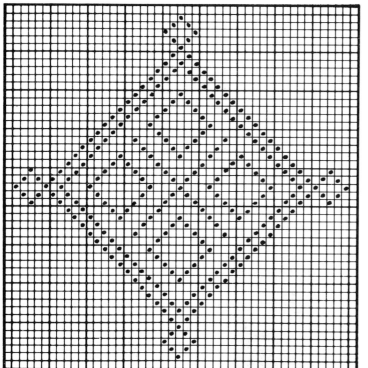

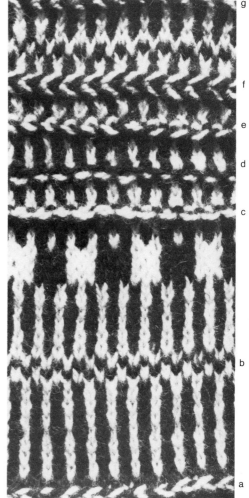

in single purl knots or one of the stranded methods – it was probably intended for the stranded method shown at (a). Many similar designs exist in the eastern Baltic and of course any free-standing and fairly simple motif can be knitted in.

TWO-COLOUR TWO-STRAND KNITTING

Two-colour, two-strand knitting seems a logical development and is probably the oldest two-coloured knitting. At its simplest you will get regular lines of light and dark on the flat side of the knitting. These can be changed around to give various optical effects. Stranding on the right side with one colour will now give a more striking effect, as will the double purl twist using two colours. If there are two rows together, one twisted S-wise and the other Z-wise, quite a variety of effects can be produced.

Two-colour sampler *(Fig. 22)*

Quite dramatic effects can be achieved with simple means as this sampler shows. Knitted in natural brown and white wool from Hebridean sheep on size $4\frac{1}{2}$ mm (U.K. 7; U.S. 6) needles. Tension over two-strand stocking stitch around $22\frac{1}{2}$ stitches and $20\frac{1}{2}$ rows to 10 cm (4 in.).

a Twisted cast-on in black and white, each alternating as foundation loop and cast-off stitch and twisted on the front of the work.

b Stripes which come from regular alternation of black and white wool in ordinary two-strand knitting. Variations lead to a three-and-three pattern (used in north Sweden); this is more

22 *Two-colour, two-strand knitting sampler.*

25

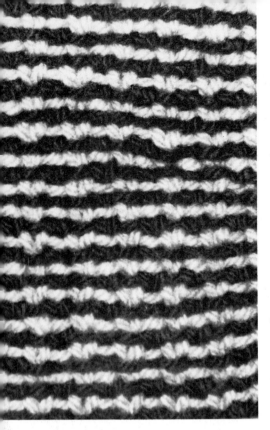

23a and **b** *Jacket stitch* **a** *right side;* **b** *purl side. It is completely reversible and has the interesting effect of having horizontal stripes on the right side and vertical stripes on the purl side.*

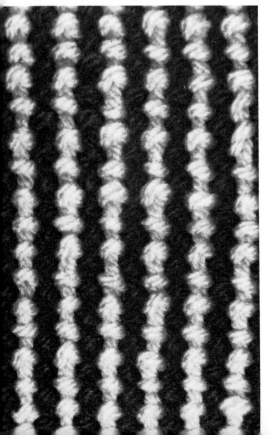

difficult to work as the tension on each thread begins to vary but has extra design appeal.

c Relief row: double purl untwisted, with white on top and brown below, and the following stocking stitch row alternating colours.

d As (c) but the colours in the following stocking-stitch row are the same as those in the purl row.

e A row of double purl twist, half S-wise and half Z-wise. As the yarn is plied S-wise, different effects are obtained.

f A plait made up of two rows of double purl twist, one S-wise, one Z-wise. The yarns will twist up during the knitting of the first row but will untwist again during the working of the second row.

g Cast off with two strands in plain from the plain side (or purl from the purl side – the stitches will face in opposite directions). The cast-off edge can also be decorated in the last row or two by a row of chain stitch.

Jacket stitch *(Fig. 23a and b)*

This pattern was recorded from the heel of a Dalarna two-strand sock; a remarkably firm but flexible texture suitable for unshaped garments such as jackets, tunics, skirts.

Method: one side is plain and one purl; i.e. each row is entirely knitted in plain (every row if knitted in the round), or in purl (if knitted in a flat piece). The working wool is always on the purl side of the work and the other wool on the plain side. *Between each stitch* the yarns cross. This leads to the yarn not knitted being stranded on the plain side of the work.

Note: for an even effect keep one yarn always above the other when they cross.

For those who like their instructions in technical terms: if the two yarns are P and Q, with yarn P on the right side knit 1 Q; cross yarns so that yarn Q is on the right side and knit 1 P; repeat.

Quick mitt in two-strand knitting *(Fig. 24)*

Knitted in Pingouin Pingoland on size 7 mm (U.K. 2; U.S. 10½) needles. This pattern is easily adaptable to any oddments of yarn. Cast on 28 to 30 stitches with a simple over-needle loop (*see page 32*) in yellow. When this is complete, join in one strand of brown and knit 1 row double purl twist Z-wise and then one row S-wise to give a good edge. Knit on up in two-strand stocking stitch, keeping the positions of the different colours always the same (see my deliberate mistake around round 12 – I changed yarns and the yellow is dominant for a few rows). As the wool was so thick I don't feel they needed more pattern but thinner wool would allow detail as in Fig. 22.

Two- and three-stitch repeats *(Fig. 25)*

To go one stage further with two-strand knitting, you can knit not one stitch with each yarn but two, or even three, without upsetting very much the rhythm or texture of the work. I think we can deduce that this has been done in the past. There is a series of small patterns with, at most, a three-stitch repeat and interspersed rows of single-stitch, two-strand knitting. These are found quite widely and probably are invented spontaneously whenever people experiment with small patterns in two colours. They are worth mentioning because it is rare to discover a knitting

pattern derived from a knitting technique and not copied from weaving, embroidery, lacework, woodwork, braiding, darning or printed patterns.

24 *Quick mitt in two-strand knitting.*
25 *Four small all-over patterns, probably derived from two-strand knitting. Used widely from Estonia to Norway.*

MULTI-COLOURED TWO-STRAND KNITTING
Setesdal sock top *(Fig. 26 and colour plate 7)*
Cast on in white to give a single Z-twist *(see page 32)*.

Round 1: always knit in circular fashion, in alternating yellow and black, stranding on the back (the inside).
Round 2: use two strands of red in a double purl twist.
 Repeat rounds 1 and 2 twice more.
Round 7: double purl twist in black.
Round 8: double purl twist in white.

(If working a flat piece the easiest method is to purl with yellow and black in row 1 and work a double red purl twist in row 2; repeat twice more.)
 The important point is that the purl stitches of round 1 show, in the finished edge, *above* the red twist made in round 2, although they are knitted first. For a tidy effect the needles should be on the small side for the thickness of the wool.

Dalarna glove *(Fig. 28)*
Fig. 28 shows a typical multi-coloured two-strand cuff, small stranded wrist pattern with double purl twist rows for emphasis, and method of enlarging for thumb along one line only. The small decoration is knitted in with a third ball of contrasting yarn and lies on the back of the hand.

Row 1: cast on with two strands of white (twisted cast-on).
Row 2: plain row with two strands of pale blue (or could be done with two colours).
Row 3: double purl twist in red.

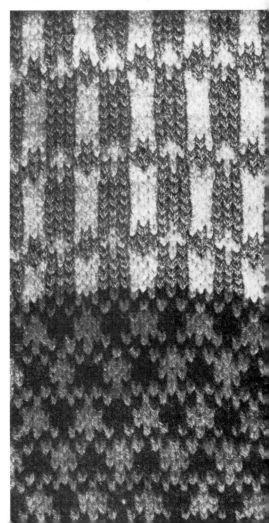

26 *Multi-colour stranded pattern from Setesdal. Used around the cuff of a sock and knitted so tight it looks like embroidery or weaving. Above and below is a small, four-row border: one row green, one row alternating red and white; one alternating white and red; one row green. Large dot: yellow; small dot: dark brown; small circle: green; small cross: white. Background (no symbol): red. Not easy to knit!*

Row 4: plain row in white and dark blue (twisted at back).
Row 5: double purl twist in dark blue and light blue.
Row 6: double purl twist in red.
Row 7: plain row in dark blue and white (twisted at back).
Row 8: double purl twist in white and light blue.
Row 9: double purl twist in red.
Row 10: plain row in white (twist at back).
Row 11: double purl twist in white.

Note that row 2 shows above row 3 when seen from front and that rows 10 and 11 give a method of working a single-colour twisted rib.

27 *Setesdal* snesokkar, *'cut stockings' or short socks, worn with the* krotasokkar *for splendid occasions. Single knitting except round the top where there is a three-strand twisted cast-on, followed by complex, coloured, two-strand knitting. The way of turning the heel is unusual, either an ancient survival or a local Norwegian invention. The yarn end at the toe was left so that they could be hung to dry.*

28 *Dalarna glove: thumb increase*

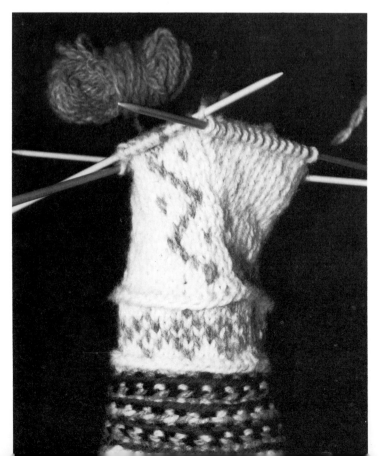

3 Knitting techniques from Scandinavia

STARTING OFF

TENSION

Tension means the number of stitches and rows which occupy a
given area of knitted fabric. All the tensions quoted in this book
are for a square of 10 cm (4 in.). This is the normal European (and
Scandinavian) tension. To measure tension, a sample is knitted in
the pattern to be used for the main part of the garment (e.g. the
body of a jersey), aiming at a size of around 12 cm (5 in.) square so
that an accurate 10 cm (4 in.) measurement can be made. The
sample should be pressed lightly and the rows and stitches read off
against a ruler laid over the top.

Knitting tension varies enormously with the knitter, the yarn,
the size of needles, the knitting method and the pattern. Some of
these can be changed but the size of needles is the easiest to alter.
Tensions given in this book (or anywhere else) can only be a guide
to the size of needles to use. Makers of knitting yarns now often
give a suggestion on the wrapper of the range of needle sizes to
consider. We generally like our knitwear loose and light, so we use
much thicker needles than our grandmothers and great-
grandmothers.

It is interesting to notice how tension has varied. It is always
lower (fewer stitches to the centimetre or inch) in 'export' jerseys.
Those exported from Iceland around 1850 reached a low of around
13 or 14 stitches to 10 cm (4 in.), equalled only by modern Faeroese
export jerseys. A Faeroese jersey knitted for home use around 80
years ago was knitted at 20 stitches and 24 rows to 10 cm (4 in.);
one bought in Faeroe in 1960 has 18 stitches to 10 cm (4 in.); one
observed on a Faeroese fisherman in Lerwick in 1975 had 16 and
those advertised today for the tourist market have only 13 or so
(though I have no doubt finer ones are still knitted). Only the very
smallest patterns can be effective on such coarse knitting.

If you want to reduce the number of stitches per centimetre, use
a larger needle; if you want to increase it use a smaller needle. If
you want to knit a much closer garment, order more yarn.

Changing needle size can also be used while you are knitting to
alter shape without increasing or decreasing stitches. Long
gauntlets of mittens can be shaped in this way, and often were in
Norway and Finland. It is one way of fitting a pattern into a small
area, for example, a Selbu thumb pattern. Smaller needles can also

be used to shape tops of fingers of gloves without having to alter the pattern.

It is useful to collect knitting needles, particularly sets of stocking needles and circular needles in different sizes and lengths. The longer the stocking needles and the shorter the circular needles, the more generally useful they are. In Scandinavia, stocking needles are a convenient length and come in sets of five which seems a very sensible idea.

CHARTING

Almost all knitting patterns can be put on to charts. Many traditional patterns have been worked for centuries (or, at least one hundred years) from charts. Most popular knitting patterns have a rhythm, which connects each row to the preceding one, and are symmetrical so that, after a few rows, the chart is only required for occasional reference.

Each square represents one stitch. Each row of stitches represents one row. I have tried to use fairly obvious symbols and to be fairly consistent, but odd things crop up and these should be explained in the captions to the charts. The same symbols can mean different things on different charts; on the other hand many 'textured' patterns can be knitted in two or more colours as 'stranded' patterns, and many were, as stranded knitting replaced the earlier, single-coloured knitting.

I have counted out the repeats for some of the charts, i.e. the number of stitches into which one repeat fits exactly. This will help with designing (a four-repeat border will look good with a twelve-repeat border; so will a six-repeat one). However, I have not tried to give complete repeats. I think this can be very confusing and is often the fault with many so-called 'traditional' patterns repeated without much thought from charts. So most of my charts show several repeats, enough to show the general idea, and they stop usually where the graph paper ran out, not at the end of a repeat.

DESIGNING WITH CHARTS

Most knitting books give the essential equipment for a knitter as needles, yarn, needle gauge, stitch holders, inchtape. They forget the first thing for any traditional knitter – a book or sheet of graph paper and a felt pen. You don't usually need to dot out a whole pattern, just enough to work from. You do need to keep a note of tension, size of needles, measurements, stitches cast on, any increases or decreases, and I always keep a note of the type of yarn, and keep a wrapper for all the information on it. It is especially important to keep notes when you want to knit two parts to match – knitting nowadays may often be asymmetrical, but this should always be intentional.

To start, either measure an existing and suitable garment or your subject (first catch your nephew, as it were). Make a note of the vital lengths: for a jersey, overall length, chest measurement and length of sleeve underarm are the vital ones, though one can take many more and be very refined. However, most traditional jersey knitting is sensibly square and relies on knitting to stretch a

little to fit, which it does very well. If in doubt, add on an inch or two; many jerseys are never worn because they are too small. I cannot recollect one which was never worn because it was too large. Caps, stocking feet and gloves do not follow this rule. They must fit well and are easily tried on before they are finished.

Having noted your measurements and knitted your sample, work out the number of stitches to cast on by dividing the measurement (say 50 cm [20 in.]) by 10 (the size of the sample), and multiplying by the number of stitches counted in the sample (say 20). This gives the number needed for the garment (in this case 100). If you are knitting something which should fit more tightly at the cast-on edge, such as a jersey or cap or pair of mittens, reduce the number by one in eight or maybe one in ten (fashions vary: some people don't reduce at all) and use a smaller needle size for the welt. As circular knitting has no side seams (indeed it often has no seams at all) there are no extra stitches to allow for them. If a front opening has to be made (see page 127), add on the extra stitches. If all this sounds very simple, it is – traditional knitters have been doing it for centuries and they often began at the age of five or six. So start with something small, keep taking notes and soon you will be designing your own jerseys, and the entire heritage of traditional knitting will be yours.

WINDING WOOL FROM HANKS
If your grandmother left you her wool-winder, you are lucky; it is as useful as a spare pair of hands. If not, you can use a chair back. Separate the hanks very slowly and patiently, keeping each hank in one piece as far as possible. Look for the point where each is tied loosely together and start from there. *Never* pass a stray end through to help untie a knot – that is a guaranteed way of making one. Hang the hank carefully over the back of a chair; I use a round-backed, wooden one with no snags if I cannot find an empty pair of hands. Do not wind tightly as you may damage the wool. Keep the ticket (tuck it in the ball, perhaps) to keep track of type of yarn and dye lot etc.

CASTING-ON
Having carried out the few but vital preparations (chosen a pattern, knitted a sample, measured and calculated), it is time to cast on. Casting-on is important in Scandinavian knitting, both to give extra strength and for pure decoration. A decorative, cast-on edge will normally not curl over and is a common alternative to a ribbed welt or cuff. Use a larger size needle for a more elastic edge and change immediately to a smaller size in the first knitted row. There are two main methods: knitting-on and twisted cast-on.
Knitting-on
This is the least satisfactory in many ways and not used much in Scandinavia. Make a running loop at the end of the yarn, place this on the left-hand needle and knit into it with the right-hand needle. Place the loop so formed back on the left-hand needle as the second stitch and repeat. If knitting in circular fashion (normally the case), begin the second round by knitting into the first loop made.

i

ii

29 *Twisted cast-on i simple foundation loop; ii twisted foundation loop.*

30 *Results of twisted cast-on.*

½S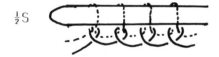

½Z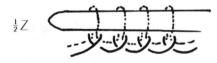

1Z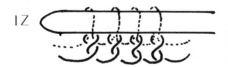

1½Z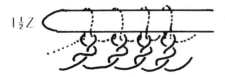

A slightly better method of knitted cast-on requires the right-hand needle to be removed from the second and subsequent loops and to be inserted between the loop and the previous stitch, and the next stitch is then knitted on. Do not tighten the new stitch until the right-hand needle is inserted to make the following stitch.

Twisted cast-on

This is used a great deal in many variations in Scandinavia and gives a firm but elastic edge. This method can also use two (or more) colours and is the method of choice for two-strand knitting (*see page 22*). Again, use a size larger needle than for the body of the work. Twisted cast-on can be done in (a) two stages or (b) one stage, with similar results.

a *Two stages:* the first row, or foundation row, is completed first and then knitted to form the complete selvedge. Using a single needle (or two in place of one) held in the right hand, anchor the yarn with a running loop made near the end, pull the yarn over the left thumb and pick up a simple loop (*Fig. 29[i]*) or a twisted loop (*Fig. 29[ii]*). When you have made the right number of loops, knit a second row, always working through the front of the loop, especially with (i), for otherwise the stitch will collapse into an awkward length of yarn and you will have to start again. The tension can be difficult to regulate with this method.

b *Single stage:* the foundation row is formed one stitch at a time and immediately knitted off. Two lengths of yarn are used at once. They should be joined and anchored with a running loop. At the completion of the casting-on, drop this loop off and pull the end to undo it; do not count it as a stitch. As above, pull the yarn over the left thumb, pick up a loop by method (i) or (ii) and then knit off the needle using the other length of yarn. If using only one ball of yarn, make the initial loop some distance from the end, allowing around three times the length of the knitting in the free end. This is the best method.

Whichever way you work a twisted cast-on, you end up with a foundation stitch with a Z-wise twist. The higher the degree of twist, the firmer and less elastic the edge. The results can be summarised as follows:

½ Z-*twist:* pick up loop as in (i), knit off immediately;
1 Z-*twist:* pick up loop as in (ii), knit off immediately, *or* pick up loop as in (i), complete foundation row and knit back;
1½ Z-*twist:* pick up loop as in (ii), complete foundation row and knit back.

Decorative variations can be found by the dozen; with a needle and two or three pieces of wool you can work them out in minutes. Several can be seen in illustrations in this book. For example:

Use two different colours, one for the foundation loops and one to knit off.
Use two different colours and alternate them in each row, twisting them round each other as you do so; this gives a nice twisted edge.
Use three different colours, joining all together to start (but drop

off loop later); pick up loops with yarn A and knit alternately with B and C, twisting them regularly. Or make yarns B and C the same colour to give a twist. Or use three lengths of the same colour. For a firmer edge pick up loop (ii); for a more elastic edge pick up loop (i).

Use four different colours for really colourful work and twist all three or, to get deep into this, twist them two by two.

Dala Floda cast-on: from Dalarna in Sweden comes yet another way of picking up the foundation stitch which gives a half S-twist. The diagram is self-explanatory; the foundation yarn goes over and then under the needle and is then knitted off with the other yarn. No more complicated version of this has been uncovered; no doubt many exist!

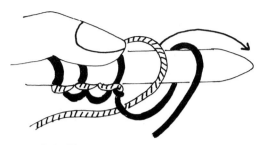

31 *Dala Floda cast-on.*

32 *Circular knitting on stocking needles; knitting into the first cast-on loop to begin the first round.*

CIRCULAR KNITTING

Almost everything, except shawls and insoles, is better knitted in the round, either on a one-piece needle, such as an Aero Twinpin, or on a set of four or more needles with points at both ends. The single needle must be *short* enough to hold all the stitches without stretching the knitting at any point, and the double-ended needles must be *long* enough to hold the stitches without any fear of their falling off. There is no very good reason for only four needles to be used at once. Continental knitters use sets of five, often of good length, and indeed any number can be used so long as they are all of the same diameter. For larger pieces, however, a circular needle is better. You will need sets of short needles for cuffs, collars, etc., and also in a larger size for sleeves. When buying needles, remember that in general the shorter lengths of circular needle and the longer lengths of double-ended needles are the more useful.

Circular knitting is essential for caps, gloves, mittens and stockings, but is also quicker and much more elegant for jerseys. Those described on pages 128–131 were knitted by complete newcomers to circular knitting, now firm converts.

Method

Cast on using two needles, or both ends of a circular needle. Begin the first round by knitting into the first stitch cast on. Make sure the work is not twisted before you do this.

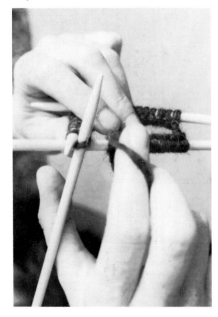

33 *Jersey knitting on a circular needle.*

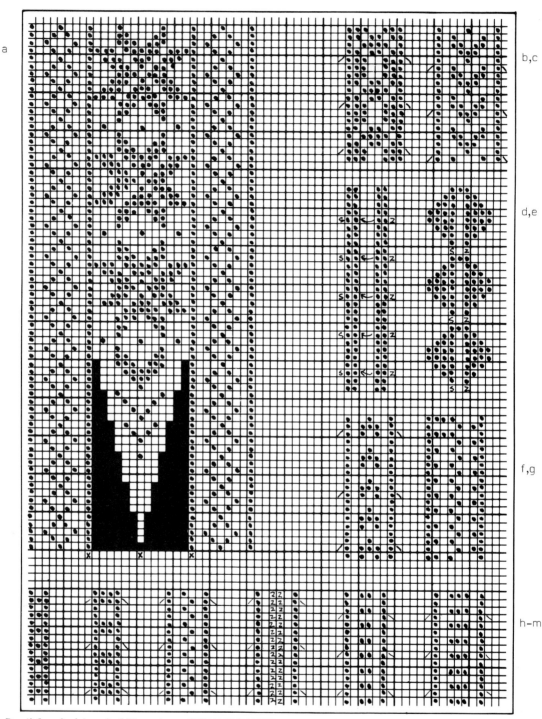

a *Detail from back 'seam' of Norwegian
stocking. Reductions are worked between
bands and the centre panel which must be
the width required to shape the calf;* b to f
jersey side 'seams' from nattrøjer *in purl-
and-plain; shaping can be placed at sides;
twisted stitches (S) and small cables
(moving arrows) add texture;* g, i to m
*stocking back seams from various countries,
all in plain and purl;* h *mitten side
decoration usually in black and white.*

CORRUGATED RIBBING

Corrugated ribbing is used occasionally in Scandinavia. It is not an
elastic form of knitting and tends to curl over, but is decorative
and gives a firm edge. The curl can be corrected by sewing on a
ribbon inside, or knitting a facing with a slightly smaller needle.

Method

Knit with one colour and purl with the other. The plain stitches
may be varied in colour to good effect. The normal is one-and-one
but two-and-two and larger variations exist though they tend to
pull up markedly (*see Fig. 113 on page 101*).

34

KNITTED HEMS
Method

Cast on by the twisted method and the simplest loop (*see page 32*). Work the depth of the hem using a small-sized needle. Mark the edge with a row of purl knitted through the back of the loops, or make a picot edge by making a row of holes (K2 tog M1 by winding yrn; rep). Change to normal-sized needles, knit the same length again and then knit in the loops picked up from the cast-on edge. Alternatively, slip stitch into place (*see Fig. 111 on page 99*).

SHAPING
Increasing

Increasing is always invisible in Scandinavian knitting. Either knit again into the stitch below the next stitch on the left-hand needle (i.e. a stitch from the previous row), or lift the strand between two stitches, twist it to avoid a hole and knit it.

Decreasing

Decreasing is often done on either side of a decorative band centre back of stockings or centre underarm on sleeves. On the right, knit 2 together using the colour from the outer stitch of the band. On the left, slip the outer stitch of the band, knit 1 and pass the slipped stitch over.

Where there is no pattern, it is normal to pair decreases or work them into a pattern. *For a right-sloping decrease:* knit 2 together; *for a left-sloping decrease:* slip 1, knit 1, pass the slip stitch over.

Double decreases are useful for crowns, yokes, etc. There are many methods, but the simplest to give a symmetrical effect is: slip 2 (together and knitwise) knit 1 and pass both the slipped stitches over. The middle stitch should then lie on the top.

FINISHING OFF

CASTING-OFF

There is not much one can do about casting-off, except to avoid it wherever possible by leaving stitches on holders, picking up, or grafting. Normal casting-off must be familiar to everyone: knit two stitches and pull the first knitted over the second using the tip of the left-hand needle; knit one more and repeat. If knitting with two colours (or two strands of the one colour) use each alternatively. If knitting in rib, cast off in rib. Use a larger size needle. In other words, try to keep it loose. Tight casting-off is not only hard on the ears; it can break and shorten the life of a jersey. Double casting-off (*Fig. 35*) is a good way to close the shoulders of a jersey (*see page 126*).

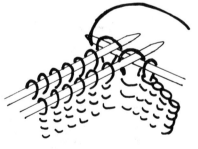

35 *Double cast-off.*

GRAFTING

Grafting is a way of joining two sets of stitches by darning in a thread with a sewing needle to imitate a row of knitted stitches. The two pieces then look continuous. The join is quite flat and invisible and can be used for such joins as the shoulders of a jersey and the toe of a sock.

36 *Grafting.*

Method

The work is done with the two edges to be joined lined up on their respective knitting needles. The number of stitches should be equal on both needles. Use a piece of matching yarn about four times the length of the seam to be joined and thread this on to a blunt darning needle or bodkin. This thread will imitate the knitted stitches and thus loops in and out of each stitch twice. Start with the first stitch on the front needle, as if to purl it, and pull the yarn through. Insert the yarn in the first stitch on the back needle, as if to knit it, and pull it through. Work down through the first stitch again, as if to knit it, and slip this stitch off the needle. Work purlwise into the next stitch on the front needle and leave this one on the needle. Work purlwise into the back stitch and cast it off. Work into its neighbour knitwise, draw the wool through and leave this stitch on the needle. To summarise, the sequence is as follows:

finish front stitch knitwise;
prepare front stitch purlwise;
finish back stitch purlwise;
prepare back stitch knitwise.

Always start by preparing one front stitch and one back stitch. Do not pull too tight or the join will no longer be invisible.

37 *Making a cord.*

CORDS

The following two methods give a strong flexible cord – both are worked with the fingers and are used particularly to attach tassels to cuffs of mittens and peaks of caps so that they can be fastened over the waist-belt, round the wrist, or hung up to dry.

Finger-knotting

Take two lengths of yarn (or two double lengths of different colours), knot the ends together and make a slip knot, as for casting-on, immediately above the knot. Keeping this slip knot on your right first finger, pull through a loop of one yarn, pull the preceding loop tight, pull through a loop of the second yarn, pull the preceding loop tight and repeat. A neat, rounded and textured cord is produced which can be made to any length (*Fig. 37*). Do not pull too tightly as this hides the pattern which the loops make.

Twisted cord

Take several strands of yarn, in one or more colours, six times the length of the cord to be made. Fasten together with a knot at each end. Holding one end in each hand (or fastening one end to a door knob or radiator knob) twist the ends in opposite directions, pulling outwards at the same time, until the entire length is firmly twisted. Keeping the yarns firmly stretched bring the two ends together and hold together while letting the mid-point go. If the original twist was S you will now have a Z-plied cord.

Finish off with a separate tassel sewn on, or by knotting the end, fluffing out the ends of the yarn used and trimming.

Cords may also be made by plaiting three single or double strands together. All three methods are used in Norrbotten, north Sweden.

TASSELS

Tassels are used on the ends of cords to decorate mittens, the cords being used to hang up the mittens or to attach them to the person. Small tassels also appear at the ends of fingers of Sunday gloves, but you are most likely to use them on caps. One method is illustrated (*Fig. 38*). This is finished off with a cord (*see opposite*).

The further north you go, the larger the tassels get, until the Lapps' hats (sewn from cloth, not knitted) almost disappear under a mass of red plumage. The large tassel is made as follows:

Method

Wind a length of yarn round a firm flat object such as a book about 12 cm (5 in.) across. Use all the colours from the pattern or more. Tie firmly at two opposite points and then cut into two unequal parts so that the tied points are in the centre of each part. The longer part forms the outside and the shorter the inside. Taking the cap, sew on the longer part, spreading out the strands in all directions and fastening them down with broad stitches. Sew on the shorter half, at right angles, to equalise the thickness, and clip to shape as required.

POM-POMS

Method

I think everyone learns to make pom-poms in kindergarten. Take two rounds of cardboard, with holes in the centre and wrap wool round and round until the hole is filled up. Clip round between the pieces of cardboard and, before it all falls to bits, tie firmly with a very strong thread (I use buttonhole twist, but some nylon yarns are very strong). Remove the cardboard and trim to shape.

PILE LININGS AND BRIMS

Tufted textiles have been used in Scandinavia since long before the days of knitting. The Vikings wore fleece-lined cloaks, and tufted bed-rugs and boat-rugs have been made up to the present day all over Scandinavia. Various methods have been used. The simplest is simply to knit in, or stitch in, a short length of raw fleece. Looped linings can also be knitted in using a 'John Thomas', a short, thick length of dowelling, round which the yarn is wound at every stitch. This may or may not be left uncut, and can be used to make a decorative fringed edge as well. Sewn stitches are found, such as the carpet stitches probably learned from the East where they have been in use among nomad tribes for thousands of years. (The Scythian tombs of Siberia contain some magnificent tufted rugs.)

Until the nineteenth century, pile linings were entirely functional and short lengths of undyed fleece were used as a lining for everything from silk shirts to country caps. (Old Danish caps were renowned for their white fleecy lining.) However, it became fashionable to turn the brim of a cap to the outside and the 'floss' had then, perforce, to be in dyed wool, generally red, to match the red caps which seem to have been worn by sea-going men all round the coasts of Europe. Now, in coastal Norway and in Setesdal, one stage further has been reached and both the caps and the pile brims have matching patterns, one knitted and one sewn and the tufted lining has disappeared.

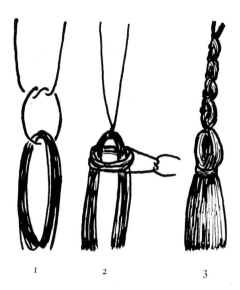

1 2 3

38 *Stages in making a corded tassel.* **1** *wind lengths of yarn to the desired length and tie at one point with another length of yarn (or a double length) long enough to make a cord;* **2** *bind the tassel at one end;* **3** *work a cord and sew to garment.*

39 *Smyrna stitch; one way of sewing on a pile decoration. The arrow shows the direction of the work. The loops left are cut and trimmed when the stitching is complete.*

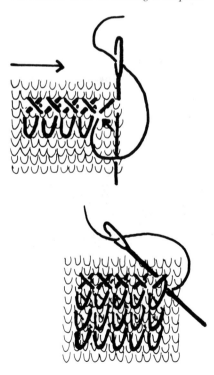

WASHING AND DRESSING

Before washing, gather the neck edge of a jersey to prevent it stretching and tack any front opening or button-holes together. Wash by hand in lukewarm water with mild soap and rinse very thoroughly keeping the temperature even. Wool can be boiled but has to be started in cold water and allowed to cool off slowly. Do not twist or rub wet woollies unless you want them to felt; squeeze them or knead them. Spin-dry, or squeeze out, surplus water and roll up in a large, dry towel for 15 minutes. Stretch out flat on another towel or on a jersey frame and allow to dry well out of the sun and away from direct heat.

FELTING

In Scandinavia people still felt mittens, socks, caps and jerseys intended for folk costume or for work clothes. This can be done with brown soap or in a washing-machine and a normal shrinkage is 5 to 10 per cent.

The liquid soap method

Rinse the knitting in tepid water and squeeze out the surplus. Mix the soap into a thin paste with boiling water. Spread out the garment and cover both sides with a thin layer of soap solution. Work this in well and continue to rub or knead the knitting until it is the right size. This is a good method for a beginner as it is not difficult to judge when to stop. Rinse out carefully and dry by squeezing out all the surplus water (do not wring), rolling up in a large, dry towel and leaving for 15 minutes and then spreading out to dry, or stretching over a frame or shape. When dry, brush both sides (the inside less than the outside) with a very stiff brush (a fine wire brush is ideal).

The washing-machine method

This requires more experience. It is most important that the washing-machine is entirely full of clothes, preferably an entire load of knitwear to be felted. If it is not full, the knitwear will tumble and shrink too much and too unevenly. Go through the entire washing cycle; rinse, spin and then spread out to dry. Brush when dry as above.

TROUBLE-SHOOTING

SPLIT THREADS

Some yarns tend to split as you knit them. There is no cure for this but to unpick the work, so keep checking as you go along.

HOLES AND LADDERS

If these are actually in the knitting, the dropped stitch must be retrieved with a crochet hook and worked back up. However, if a hole develops at the corner of a thumb, it can be cured by darning it together inside. Ladders caused by work stretching underarm or elsewhere can be pulled together by treating the first 'rung' as a new stitch and pulling it up through the others with a crochet hook exactly as if it had been dropped.

KNITTING TOO SMALL

It can sometimes be stretched on a frame (but tends to shrink back in wear).

KNITTING TOO LARGE

Temporary or permanent tucks in jerseys can be made by turning them inside-out and machine-stitching them up inside the side seam (or centre underarm) at both sides, keeping the size of intake the same at both sides. At sleeve level, taper this off to meet the sleeve seam or continue down the sleeve, keeping the work flat and the stitching even. The fabric at the sleeve join may be cut through if the reduction is permanent or sometimes unpicked if the sleeve is sewn in. Lastly, the extra fold at the bottom edge is tacked in to keep it flat and out of sight.

SWISS DARNING

A way to imitate Fair Isle, add motifs or correct mistakes. It can be worked easily, with several colours in a row, and is usually done following a chart, working stitch by stitch and row by row. Use a blunt bodkin or darning needle and yarn (if anything slightly thicker than yarn) used in the knitting and work on a stocking-stitch base.
Method
Leaving an end of yarn on the wrong side of the work, come up through the stitch below the first stitch to cover. Pass the needle behind the stitch from right to left, down through the stitch below, and up through the next stitch. To work back along the row, turn the work upside-down and bring the yarn up through the stitch above the one you wish to decorate.

UNPICKING WORK

Keep checking your work as you go along particularly if the pattern is complicated. Hold it at arm's length occasionally to check for the overall effect. If you have made a mistake, there is usually no option but to unpick the work. This is a bore but not such a bore as spoiling a whole jersey. If there is more than a row or two to unpick, draw the needles out of the work, unravel it down to the point where you went wrong and then pick up the stitches again. I unravel the knitting back to the row above and then work around pulling out ten or fifteen stitches at a time before picking them up. This prevents too many loops unravelling into the row below the one I want to start off with again.

If only one row or so needs to be unpicked, work always on the wrong side, using the right-hand or the left-hand needle to pick up the loops below the stitches on the other needle, taking care not to pick up any threads of the top stitches as you do this. Several can be worked at once and this method is almost as fast as knitting. Every five or six stitches the yarn may then be pulled out quite freely from a whole row or part of a row at once. You may find that the stitches have been reversed on first re-knitting (i.e. they hang on the needle with the left-hand half nearer the knitter rather than the right-hand half). This can be corrected very simply by knitting into the back of the stitch wherever necessary (*Fig. 41*).

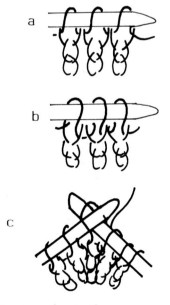

40 **a** *yarn hanging the wrong way on needle;* **b** *yarn hanging the normal way on needle;* **c** *method of correcting* **a** *by knitting into back of loop.*

4 Norwegian knitting

Knitting has been known in Norway for several hundred years but the familiar and attractive stranded sweaters with braid trim are a relatively recent innovation. Even knitted stockings were not used generally until 1830, or later in many country districts. Stranded knitting came into local fashion in a few isolated spots around 1840 or 1850 and has spread to become almost a Norwegian national dress. One of the most interesting areas is Setesdal and the well-known *luskofte*, or lice-patterned jerseys, are very finely knitted in dark wool, with a sequence of narrow geometric borders decorating the neck, shoulders and sleeves. By contrast, the traditional jerseys from Fana, near Bergen on the west coast, though also in white and black or navy, have an all-over pattern of stripes and checks, with a star border across the yoke and upper sleeves. The general coastal area produces a wide variety of stranded jerseys, many very colourful in red, blue and white, with all-over patterns of stars, leaves, etc. Many show very great detail and skill in patterning which suggests a long local tradition or, failing this, some useful influence from further afield – probably the Baltic. These jerseys are often finished at the cuffs with a little knitted band in three

41 *Summer in the mountains; the knitting of winter stockings keeps hands busy.*

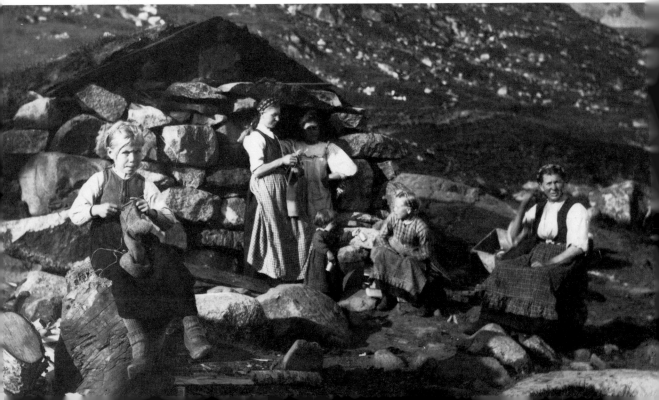

colours, in imitation of a woven braid. The lower part of the body is often knitted with white wool (as are those from Setesdal) as this part was hidden by the bib of the long trousers and there was no point wasting good dyed wool where no one would see it.

SELBU KNITTING

Today when most people think of Norwegian knitting they think of black-and-white snowflakes, stars, reindeers, little ladies dancing, all combined in intricate and beautiful designs. They are in fact thinking of knitting which originated in the small northerly district of Selbu. From this tiny community has come the inspiration for a million mittens and almost as many sweaters.

Despite its great popularity, Selbu knitting is not very old. The people who played a part in its early development lived well into the twentieth century and remembered well the first small beginnings which were to make the name of Selbu known throughout Norway, and its knitting style famous throughout the world. Before this little story began, the normal Sunday wear at Selbu church was mittens made by the age-old and laborious technique of *nålbinding*, 'needle knitting', known since the Bronze Age. They were warm, pliable and long-lasting but rather shapeless and plain, unless decorated with embroidery. The new fashion for black-and-white stranded mittens was adopted almost overnight by the whole parish. Those who doubt the theory of evolution would do well to ponder the story of Selbu knitting.

Norway is a very long country indeed, stretching from the latitude of the north of Scotland right up to beyond the Arctic Circle. Most of the population live on the coast and in the southern part of the country. The district of Selbu is, even by Norwegian standards, quite far north, almost on a level with Iceland. In the old days, it was better known for its millstones than its knitting but this changed around 1900 when the millstone industry died. The origin of Selbu knitting was still remembered clearly in Selbu when Peder Morset (later well-known as a

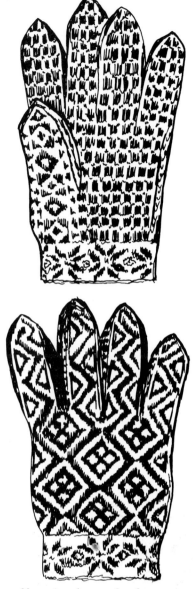

42 *Norwegian gloves c 1870 from Fyresdal, Telemark.*

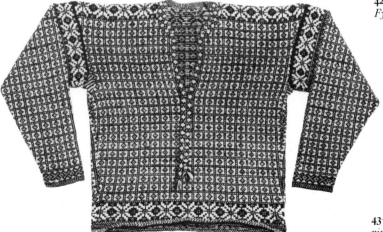

43–49 *Norwegian coastal jerseys from the nineteenth and twentieth centuries.*

B

(Opposite page) TOP: modern version
of traditional, two-colour, panel jersey with
centre panel on left and shoulder panel
(repeated on other side of centre panel) on

right. In natural white and natural medium
brown wool.
BELOW LEFT: a cuff pattern from a
nineteenth-century Norwegian jersey. BELOW

RIGHT: a slightly more robust version c
that given above, from the days (186c
when wool was 2-ply, and knitted on t
thin needles.

45 *Front and back patterns from Norwegian coastal jersey dated 1860.*

46 *Patterns from coastal jerseys.*

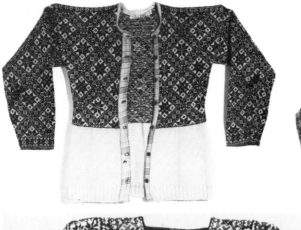

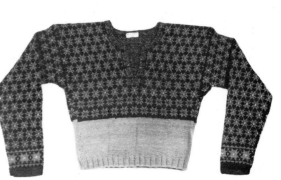

50 *This Selbu mitten has a pattern which seems to be copied from a printed pattern recorded on gloves from Snåsa, North Trondelag, a district adjacent to Selbu. It is not easy to knit.*

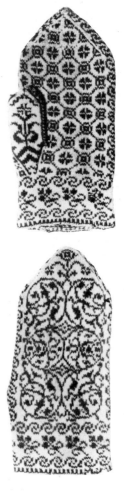

resistance leader) wrote an article for a Trondheim newspaper in 1926. The first person who knitted a pattern of any kind in two colours in Selbu was a girl called Marit Emstad, who was born in 1841 and died in 1929, three years after this article was written.

When Marit was fifteen or sixteen, she was working as a mountain milkmaid for a farmer called Jo of Kjøsnes. One of his other farm girls (Ingbaer Sessengsgjare) knitted a pair of stockings for her employer as a Christmas present. They had a pattern knitted in with two colours that looked like 'a black snake up the leg'. Jo, pleased with his stockings, asked Marit if she could not knit something similar.

She took up this challenge and by the following summer had managed to knit a pair of mittens with white as the main colour, covered all over with black stars copied from bridal embroidery. This would have been in 1855 or 1856.

As previously mentioned, up to that point, the traditional Sunday mittens in the district, as in most parts of northern Scandinavia were made by *nålbinding* (a darning technique using a single needle and a short length of wool). There was a sensation at the local church when Marit and her sister, greatly daring, turned up one morning wearing black-and-white knitted mittens. If, at this point, the other women had disapproved, no one would ever have heard of Selbu or its knitting. But Marit and her family were liked and respected as clever needlewomen and the result was that every woman in the parish went home with only one idea in her head: to knit herself a pair of black and white mittens with an

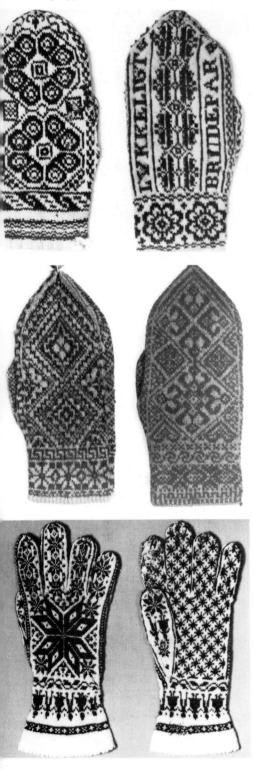

51–53 *Selbu mittens and gloves.*

even better pattern.

Very soon this became the normal fashion for Sunday wear and a new item was added to the local folk costume. Patterns were copied from older motifs used in embroidery, tapestry and even wood carvings. Other patterns are said to have been copied from nature: beetles, pine-tree branches, ears of corn and dogs.

For many years after this first introduction of knitting to Selbu, the patterns were used mainly for mittens. These were used as wedding presents. In 1936 it was still the custom that every bride had to give a pair of mittens to every man attending the wedding and a pair of socks to the bridegroom, his father, his brothers and brothers-in-law and his godsons and god-daughters. However the bride did not have to knit all of these herself as she in turn was given presents of mittens by all her girlfriends. Before a girl contemplated matrimony, therefore, she often had a hundred pairs of mittens and twenty pairs of socks hanging in the bridal loft (the Selbu equivalent of her bottom drawer). This custom died out only during the Second World War.

COMMERCIAL DEVELOPMENT

The later part of the Selbu story is a familiar one – it has been repeated in different parts of Scandinavia at different times and has many echoes in British knitting history as well. The production of mittens for sale started in a small way in the 1890s. By 1900 the local millstone industry was in serious decline and the production of mittens for sale became more important. But it did not really take off in a big way until the period between the two wars when it became fashionable to wear Selbu mittens even in the main street of the capital, Oslo. Also, the increasing popularity of skiing as a sport gave this new fashion great impetus.

At this point Selbu knitting began to change from genuine folk knitting to a more standardised and centralised process. Fewer and fewer patterns were knitted, yarn became thicker and thicker, and quality began to decline. There was some justification for this in the fact that merchants paid for quantity regardless of quality, and paid very poorly as well. But even the small amount earned was useful in such times of great need and every person in every household spent as much time as they could knitting. As knitters had done in other places hundreds of years before, they gathered together in different houses in turn to knit for as long as possible by the little light available. They also knitted as they walked to market with their ball of yarn fastened to a hook in the waistband of their skirts. One woman could knit so fast that she could complete a pair of mittens on the way to market, call in at a farm to wash them, hang them on her basket to dry and start a new pair. By the time she got to the market the first pair would be dry enough to exchange for more yarn and some groceries. Then she knitted the five or six miles home. Apparently this prodigy still had time to stop and talk to everyone she met on the road.

In another household there was always unfinished knitting lying around which was literally thrown at any visitor who sat with idle hands. Even men knitted during the Depression years. Hands more accustomed to the heavy outdoor work of forest and farm perhaps

46

did not make for the neatest knitting, but they were happy if they earned enough spare cash to keep themselves in tobacco. Some men, particularly the younger ones, are said to have been very expert.

Quality, however, continued to deteriorate to the point where 'Selbu' knitting meant poor knitting. Some knitters used over-large needles and others, in time-honoured fashion, stretched small mittens to have them valued as adult mittens and be paid accordingly. Patterns were badly placed and stitches were dropped. To protect their trade the local shop-owners (not the local knitters!) set up the Selbu Handiwork Cooperative in 1934 and at that point Selbu knitting was no longer a folk activity in any sense, but purely a commercial activity, with standardised patterns being printed and knitted for sale all over the country.

In the old days every pair of mittens was quite different and, although it is not possible to give copies of even a small percentage of the patterns used here, fairly typical examples are given to show the detail and complexity which some knitters achieved. There is enough pattern material on the back of many single mittens to decorate an entire all-over jersey in the much thicker wool used today!

TEXTURED KNITTING

There is another, and older, tradition in Norwegian knitting – that of textured knitting. The 'damask-patterned' jackets it shares with Denmark where this particular tradition took stronger root. There is an interesting collection of seventeenth century silk knitted jackets in the Bergen Museum. The original pattern is all but hidden under a mass of later embroidery but is the same diamond-and-star arrangement seen in Denmark and, indeed, knitted almost everywhere in Scandinavia in one version or another. There are also traditional jerseys from western Norway with textured patterns – borders rather than all-over patterns and very finely knitted. Details are given on pages 12–13. Some have a decoration running along the front and back of the sleeves, a curious change from the more usual practice of decorating the seam position under the sleeve, but also found in English knitted jackets of the same period (eighteenth century). One red jacket has the lower part of the sleeves knitted in white, a certain indication that this part would not be seen when worn (it was probably covered by silk cuffs).

SPETATRØJE (OR LUSKOFTE) FROM SETESDAL

Setesdal is a long, picturesque, rather isolated valley in the south of Norway. Until as late as 1830 men there still wore the costume of four hundred years before, with baggy pleated mediaeval breeches, leggings and low-cut shoes. When conservative Setesdal changed, however, it did not do things by halves. Trousers were a new fashion and, in common with several other districts in Norway,

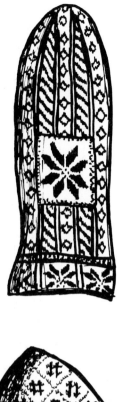

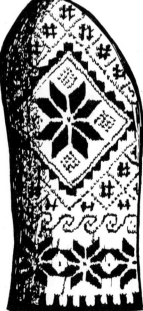

54 *In these early Selbu mittens, the stars, which are now such a standard part of the pattern, look to have been added almost as an afterthought, fitted into an all-over pattern.*

55 *(This page) Pattern
from back of Selbu mitten.
The tension of original was
about 38 stitches to 10 cm
(4 in.). Weaving-chart
origin easy to spot, as in
many Selbu patterns.*

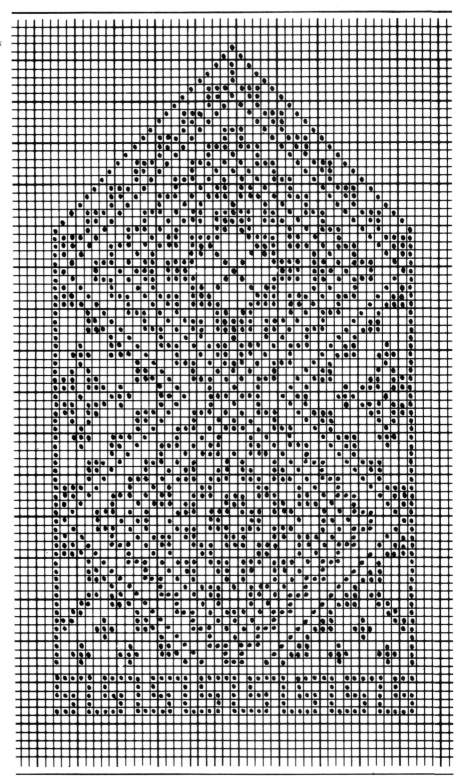

56–59 *(Pages 49–52)
Selbu motifs in mittens.
Could the large central
patterns be 'beetles'?*

58 LEFT: *a number of borders: those at the top are made up of 'filled diamonds' which can be extended to make a border or an* allover pattern; RIGHT: *patterns from thumbs and thumb gussets.*

59 *The little dancers are also knitted in Faeroe; the largest animal was knitted into a mitten in 1895.*

Setesdal adopted them into its folk costume with enthusiasm. The Setesdal version was longer than most, narrower than most, so that the lower edge had to be fitted with a placket and buttons, and further decorated on the seat with a very large leather patch. A token jacket, only a few inches long in the back, completed this curious outfit. From around 1860 a further innovation was adopted in Setesdal – a knitted jersey with a small, all-over pattern from which it gets its two names: spetatrøje (spotted jersey), or luskofte (lice jersey). The success of this design is such that it is still what most people think of when they think of a Norwegian jersey (though today's descendants have wandered quite a way in 120 years) and the patterns used are as popular now as they were then.

In the original costume setting, the simple black-and-white patterns provide a foil for the brilliance of embroidered and bound

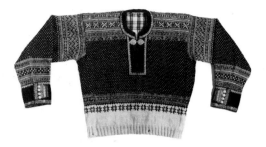

60 *Setesdal jersey from Valle. Note the sequence of large and small patterns, cloth cuffs and neck facing, set-in sleeves and white welt.*

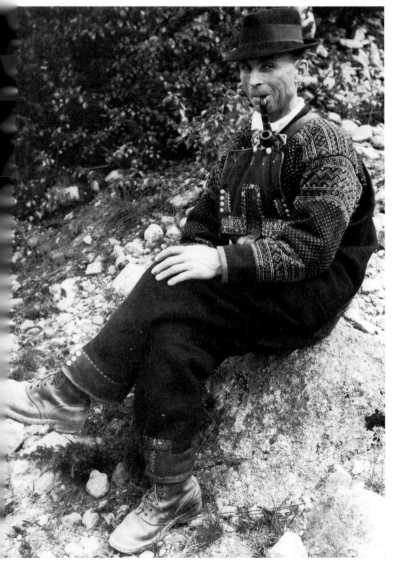

61 *A native of the valley wearing a genuine* lusekofte *(photographed in 1931).*

53

62 and **63** *Setesdal jersey patterns.*

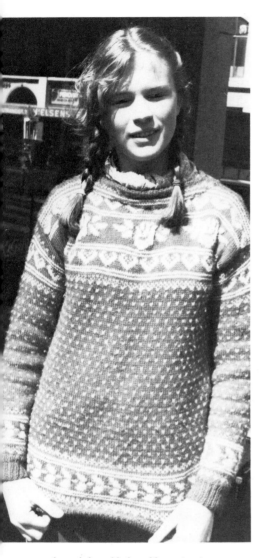

cuffs, neckband and front facing, all finished with silver or pewter buttons. The knitting is often so fine that it looks like embroidery on fine dark cloth.

It is possible to distinguish different styles within the valley. The Valle jerseys are the most familiar, with each small pattern set off by double lines and a larger diamond-and-cross pattern in the centre of the yoke. The lower edge of the jersey, which was completely hidden by the bib of the vast trousers covering it, was always knitted in plain white but the edge, which might just show under certain circumstances, was decorated with a small black pattern on the white – often a row of stars (*Fig. 60*). White wool was never used where it showed – that would have been a shameful admission of poverty and lack of skill. It is, therefore, quite wrong to copy a Setesdal jersey to wear today and incorporate a white edge; the original knitters would have been shocked! One wonders what they might have knitted today, using the patterns and skills they had in the past.

The jerseys from Bykle generally use only zig-zag patterns in a less formal layout with a heavy double zig-zag at the top of the sleeves. Valle jerseys also used this pattern but were always careful to follow it with a smaller pattern edged with the standard double lines; not so in Bykle. The Bykle jerseys also have a number of small patterns above the white edge but no patterns on the edge itself. An interesting refinement in one Bykle jersey is that the ribbing at the lower edge, a wide eight-and-eight rib, is gradually phased out through 9 plain, 7 purl; 10 plain, 6 purl, and so on, the idea possibly being to make it lie flatter.

It was normal to have quite different patterns at the yoke, top of sleeve and cuff. All the patterns (with a very few, probably modern, additions) are in very much the same style and combine without effort. A unity of design comes from this and from the double lines always used (at least in Valle) between patterns. Sometimes, though not always, smaller patterns were arranged symmetrically around the larger yoke pattern and the shoulder join was always in the middle of a small pattern, usually a simple zig-zag or row of small diamonds. There were several ways of moving

64 and **65** *Modern Norwegian jerseys which show their debt to the district costume of Setesdal (see Figs 62 and 63 for charts). Photographed in the Fish Market, Bergen, in 1982.*

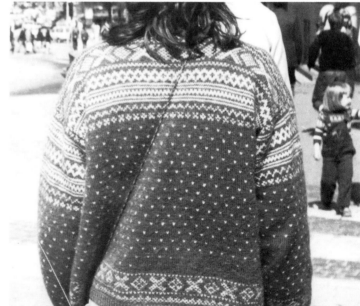

65

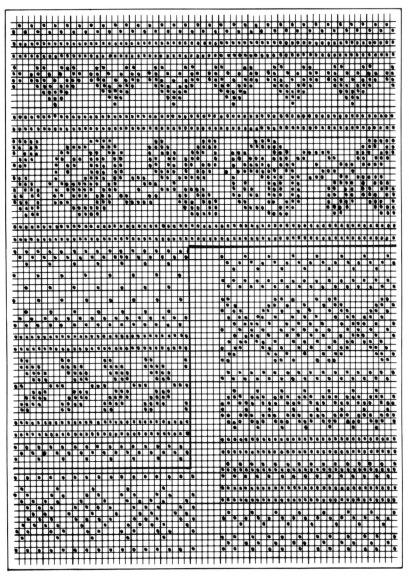

harmoniously from the pattern border to the lice-seeding (which has a repeat of four). Several are shown on the charts together with a small area of seeding.

A modern and effective variation at the edge of the yoke is to emphasise this rather than disguise it by knitting a double row (*see page 133*). This is especially effective on round yokes as are the other patterns given here.

66 *Patterns for jerseys shown in Figs 64 and 65. I have substituted a rather easier-to-knit 'rose' border collected in Shetland in 1975 for that used in the jersey in Fig. 64. The other uses a good combination of traditional Setesdal patterns.*

CABLED STOCKINGS

Stockings, generally white or black but sometimes red, were decorated with a variety of relief patterns, from simple purl-and-plain stars to complicated cables that would do justice to an Aran sweater. This subject needs, and deserves, a book of its own, but one or two outstanding regional types will be described here. Notable areas were Tovdal and Setesdal in Aust Agder, Telemark, Halandsdal, Hardanger, Numedal and Sunnhordland.

Most of the patterning emphasised the area over the ankle, normally embroidered in cloth hose to strengthen the ankle gusset with a 'clock' or bell decoration. Clock patterns were knitted in, often with no shaping at all and increasingly distant from the ankle, so that a band of pattern runs up the leg almost to the knee with a small diamond or star at the top. The position of the back seam in a sewn stocking was always decorated, sometimes with a pattern which imitated stitching, but the *snitkrok* or 'cut-cable' of the Setesdal stockings was a small cable and purely decorative.

KROTASOKKAR

Setesdal, not surprisingly perhaps, has its own very typical form of textured stockings, white for men, black for women, the *krotasokkar*, or stockings with twisted patterns. The patterns covered the entire leg, with a large 'ankle' pattern reaching almost to the top of the calf (*Fig. 67*). The patterns are in fact much simpler than they appear, being made up mainly of twisted plain stitches (*vridd moske*), a popular stitch in textured knitting in Scandinavia, alternating with purl stitches. There are small cables (known as *holekrok* – whole twist; *flete* – pleat; *vre* – twist; every household seems to have had its own names), but these involve only three or four stitches and a single travelling stitch. These patterns are best shown on a chart and would make nice Aran-type designs. Note that all the plain stitches are generally knitted in twisted stitch, even where this cannot be shown (as in the cable patterns).

Fig. 68 shows a top pattern, a diagonal arrangement of two twisted plain and two purl, separated by one complete row of purl and two rows of twisted plain from the body of the stocking. Two types of *krot* pattern are given, each a four-stitch, four-line repeat

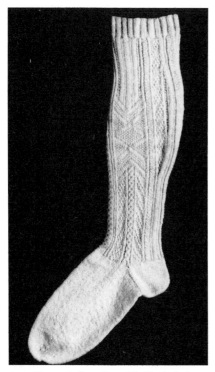

67 *Krotasok from Setesdal. Typical piece of textured knitting showing the various small cabled panels and the 'ankle' pattern now high up the leg. The heel is turned in an unusual way with the heel flap knitted together underneath and almost no shaping.*

68 *Krotasokkar patterns.*

and separated by the small moss-stitch pattern. Below is a type of moss stitch used in panels and a small three-stitch cable.

1 *Holekrok* (whole cable)
2 *Vre* (twist)
3 *Perle* (moss-stitch)
4 *Flette* (plait)

Fig. 69 shows a vertical zig-zag; a complete *oklekrot* or ankle pattern (note that it repeats around row C), and a number of other small patterns and cables all used normally in vertical panels.

Symbols used: S twisted plain stitch
 • purl stitch
 · ordinary plain stitch (in one pattern only)
 R repeat
 C centre row
 Arrows show moving stitches in cables.

TELEMARK STOCKINGS

Among the many other regions of Norway with distinctive stockings the finely cabled designs of Telemark are particularly beautiful. They follow a fairly standard pattern, with side panels of complex cables and smaller panels separated by vertical rows of twisted plain and purl stitches. The cables are in plain stitch, not twisted plain stitch, and a cable needle is used (*Fig. 70*).

69 *A complete* oklekrot *and various other small patterns and cables.*

59

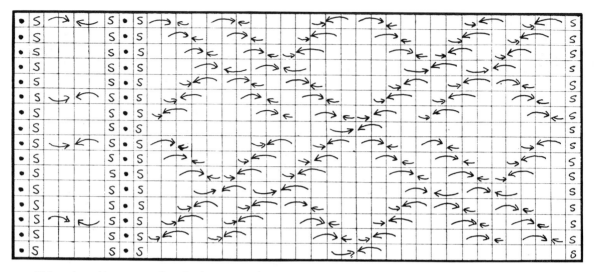

70 *Telemark stocking pattern. S: twisted plain stitch; large dot: purl stitch; plain square: plain stitch; arrows show direction and width of cables, two over one being the normal width.*

PURL-AND-PLAIN

Most decoration involved the ankle clocks, and several are shown on p. 15 in the form of charts. Twisted plain stitches are often used in preference to ordinary plain stitches; they are tighter and therefore thicker and warmer and also more highly decorative.

STOCKING CAPS

The patterns given here are from the attractive, woolly caps from Telemark. Close-fitting round the head but with a long peak, finished off with a tassel, these caps were often knitted for special occasions and could have date and initials knitted in. They were usually only in two colours, e.g. red on black, light blue on dark blue, white on black. The brim is either knitted in one piece with the cap and the work reversed at the fold so that the right side shows when the brim is folded up, or is decorated with a thick tufted border, sometimes in blocks of different colours, the so-called Smyrna border (*see page 37*). The patterns are repeated in fairly random fashion, with the smaller ones nearer the top of the cap, and all separated by a repeated small border which gives the design a pleasant balance.

In a different style are the earlier and much finer caps from Nordhordland – brilliant bands of red stars, with yellow, green and blue touches, are edges with red, white, yellow and green bands, all on a black ground. The edge is not tufted but embroidered in red, green, white and yellow in a pattern with flat blocks of colour. The patterns, however, are less striking than the colours used: mainly standard eight-pointed stars, or eight-leaf roses as the Norwegians think of them.

71 *Norwegian stocking cap.*

72 *Patterns from four Norwegian stocking caps: the lower right pattern is used just above the pile brim.*

5 Swedish knitting

Sweden makes up the eastern half of the Scandinavian peninsula and, like Norway, is a very long country. In the winter it is also a very cold country and, hidden away in its forests and country places, are a number of remarkable and very varied textile traditions, including many old techniques. They survived here when forgotten elsewhere in Europe, and some have only recently been rediscovered, such as *nålbinding*, (which is not knitting) and two-strand knitting (which is, and which was described in Chapter 2). A recent competition sponsored by a wool firm and called simply 'Make a Glove' produced entries in every conceivable knitted style, each appropriate to its purpose, and also in *nålbinding*, crochet, Ceylon stitch (*maskesting*) and even felting. The

73 *Swedish girl wearing a cloth bodice with nicely knitted sleeves in the nineteenth-century tradition. The pattern uses the same motifs as the top pattern in Fig. 75, with minor adaptations and rearrangements, and has attached cuffs with separate cuff pattern and even a fringe round the wrist.*

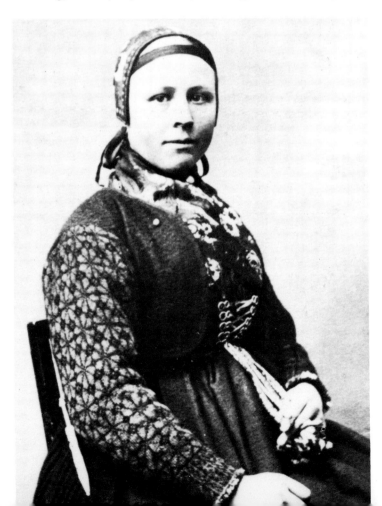

South showed a vigorous combination of old stranded patterns with modern design flair; Dalarna produced its finest tradition of two-strand knitting – restrained, elegant and very, very warm; the North was allowed to indulge its love of bright colours. Many older Scandinavian knitting traditions may be known mainly from museum specimens but in Sweden the craft is alive and well and can teach us a great deal.

ORIGINS OF SWEDISH KNITTING

There is a long-standing debate about whether Denmark or southern Sweden (Halland and Skåne) was first in the field with knitting. As both traditions are so similar it may be of little importance. I am not sure that Sweden can match the 1580 knitting-needle holder from Copenhagen, but again that was part of an upper-class needlework kit, not evidence that the maid wore knitted stockings (she almost certainly did not). The wealthy Dutch Amager wives on their island near Copenhagen certainly wore knitted sleeves, but employed (and taught?) Swedish maids to knit them. They were conservative and very correct people; they had probably worn knitted sleeves with similar patterns in the Low Countries. Did they use Swedish maids because Danish maids could not knit? Did the patterns come from Sweden with the maids? Or was this contact one which lead to a knowledge of knitting in Sweden? (*See Figs 89–90*).

It seems true that both countries (and many others, such as Norway and England) first learnt of knitting from exotic silk imports. A pair of German gloves is the earliest knitting preserved in Sweden, but the court also wore knitted silk jackets, perhaps English-made, in the seventeenth century. Around the same time, the Dutch wife of the governor of Halland is credited with introducing hand knitting in wool on a commercial scale, establishing a tradition she could not have foreseen continuing for three hundred years. It did not develop there on a large scale until the eighteenth century, however, when it became common for people in the south of Sweden to wear knitted stockings. Many details of these early knitted stockings are copied directly from the old cloth hose – clocks, for example, knitted in relief to imitate the embroidered clocks which decorated the ankle of the earlier hose, but also served to cover the gusset seams and strengthen them. A back 'seam' is always knitted in, sometimes expanded to a band of decoration some inches wide! It serves no purpose at all in a seamless stocking, except the necessary one of elegance. It also gives a point at which reductions can be made least obviously.

In northern Sweden, in country places, it was much longer before knitted stockings were worn – they battled against the elements with combinations of cloth leggings, short socks, shoe hay, cloth bindings, over-leggings and snow socks (worn outside the shoes). Many of these now curious garments were made of *nålbinding*, not knitted. *Nålbinding* had the reputation of being longer-lasting, thicker, warmer, and requiring more skill than knitting.

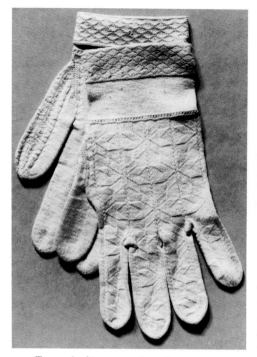

74 *Textured white cotton gloves from southern Sweden.*

The other main area of traditional knitting was the knitted jackets. There seems to be something of a gap between the import of silk jackets with their purl-and-plain textured patterns and the sight of the population wearing them but, given the speed at which woollen knitting wears out, the ease of replacement and the masterful appearance of the earliest known jackets and stockings, this gap may be more apparent than real. Gotland sweaters, for example, are mentioned early on but no one knows exactly what they looked like. The earliest jackets were probably plain white and intended as undergarments and/or nightwear and, as such, not thought worth preserving – a great pity as the undergarments and nightwear of today are very often the fashion of tomorrow. The white jacket in the Victoria and Albert Museum is from the eighteenth century but preserved because it was made of cotton, a very rare and valuable fibre at the time, and not because it was knitted. It seems likely that the early jerseys or night-jackets in Sweden were very like those in Denmark, as many show similar early design features. When they became outer or day wear they were simply dyed in a piece to match local taste.

Quite soon, knitting became not only an established domestic occupation but a well-organised exporting industry. Halland seems to have supplied most of the Swedish market but the Baltic island of Gotland, with its enormous population of sheep (a modest farmer had at least three hundred and an average flock was a thousand *lambi*) became an entrepôt from which knitwear, particularly sweaters, were sent out to Sweden, Norway, Finland and Russia. There are other small islands nearer the Estonian coast – Runö, Ormsö, – with Swedish populations (up to 1945) and vigorous knitting traditions. If Estonia itself, with its enormous wealth of domestic knitting, did not export directly, its patterns and designs were certainly exported indirectly from these small islands and from Gotland. This may have been true of the textured single-colour knitting; it was certainly true of the stranded knitting which developed later.

STRANDED KNITTING

A great deal of nonsense is written about the antiquity of 'Fair Isle' type patterns – the great age of stranded knitting was the nineteenth century. Before then, was the age of white knitting in cotton or wool, often in openwork, but always white and much influenced by Empire styles. Before that again, knitting was single-coloured but textured, an older tradition which persisted until recently in Denmark and in Britain outside Shetland.

This can be seen clearly in Scandinavia and nowhere more so than in Sweden. The centre and north of Sweden was slower than the rest to adopt knitting, probably because they saw no need. When they did begin to wear knitted jackets in the nineteenth century, these were all stranded. The outstanding example is Delsbo *(Fig. 76)*, with its outer jacket patterned in red, green and black wool and white cotton, but other districts have equally distinctive designs. These differing styles of folk costume show very clearly how localised an affair it was. The patterns of one

75 TOP: *'damask' pattern (i.e., knitted in purl-on-plain) from eighteenth century, knitted much later on sleeves with stranded patterns in northern Sweden. The original does not have, and does not need, the additional diamonds. For stranded knitting these were added and the 'flowers' were moved closer together.* CENTRE LEFT: *all-over pattern from Brearad in Halland; original in white on blue ground.* CENTRE RIGHT: *carnation and flower motif from Arstad; carnation knitted in alternating red and green on a black vertical stripe, while the flowers would be knitted in black on alternating red and green bands in the adjoining stripe; the stripes change with a zig-zag as shown. This avoids a strong vertical pull and is a useful way of working with vertical patterns in stranded knitting. The little flowers will not, of course, change in complete sequence as they are smaller than the carnation motifs.* BELOW: *a Delsbo motif, knitted usually at the waist; a Delsbo border from a woman's jacket (large dots: red; small dots: white, on a green ground); a tulip border from Härjedalen; and a permanent posy from a woman's jacket, Delsbo.*

76 *Border patterns from Swedish traditional caps and stockings. These are knitted in all possible combinations of red, white and dark blue, many variations incorporating all three colours, not always symmetrically. They are separated by horizontal stripes and sometimes the patterns are alternated with one of the smallest patterns, not always regularly and not always the same pattern. A very good way for a beginner to try stranded knitting – all you need to know is the number of stitches to cast on and how to knit in stocking stitch. You can add on patterns until you have enough or fill in with a series of little squares or diagonal stripes. You don't need to work in red, white and blue. Small articles, like caps or leg-warmers, can be knitted from left-overs or from remnants. Even a change of shade (if you run out of yarn) will be much less noticeable when the background colours and patterns are changing every few rows.*

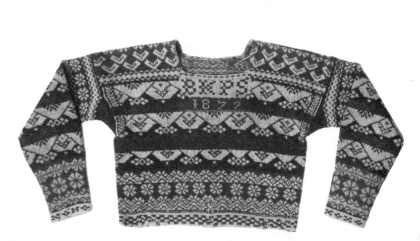

77 *Delsbo man's jacket dated 1872; knitted in red, black and green wool.*

78 and **79** *The complete charts for the jersey in Fig. 77.*

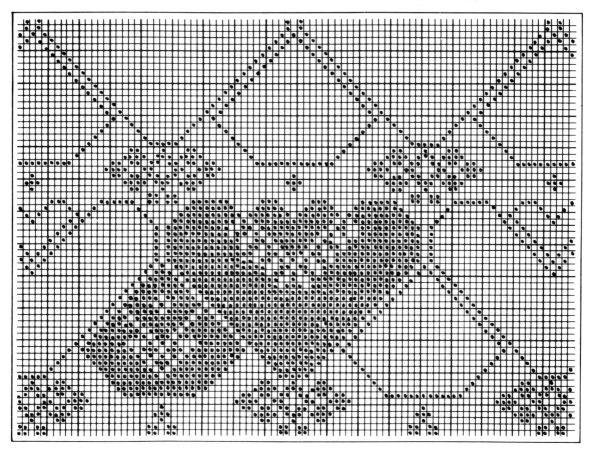

district were worn – indeed they could only be worn – by people living in that district. This has lead to a great variety of stranded knitting, not only in Sweden, but wherever it developed as part of the folk tradition in the nineteenth century.

DELSBO JACKET *(Figs 77, 78, and 79)*

Figs 78 and 79 show the complete charts for this one jersey; enough pattern material for half a dozen more! The arrangement of patterns is best understood by reference to Fig. 77. Lower edge (and cuff) are knitted in garter stitch (in round knitting, alternate rows of plain and purl; in flat knitting, all plain). Note that the *first* time a new colour is used in a row compared with the previous row those stitches should be knitted not purled to avoid bits of stitches showing through on the right side. The small borders are then knitted up in sequence in red on green until the ground colour changes to black and the large (very large) pattern is introduced. The first two rows, in this version, are in green on black and do not show up in the black and white photograph. Neither does the top half of this enormous heart, which has led many knitting writers into very odd versions of the Delsbo pattern. The large pattern alternates bands of red on black and green on black; there is a border pattern at the shoulder and two rows of small hearts before the shoulder is joined by another row of flowers. Sleeve patterns are different and given at the right. The cuff has a smaller pattern but is also in garter stitch. The only detail not shown on the chart is the zig-zag change (about one-third of the way up the jersey) from a green ground to a black ground.

 This version has no white details; some patterns with white are given from elsewhere.

ULLARED JERSEY FROM HALLAND *(Figs 80, 81, 82)*

In 1950 an old lady still remembered her grandmothers knitting these jerseys through the winter. They had to be knitted very tightly to be warm as well as wind-resistant and were worn by men working in the forests. They were felt to be stronger and better than the single-colour jerseys which, by then (perhaps 1850) were old-fashioned. Most of those preserved date from around the 1890s and follow a similar layout, always in red and black and often with a panel centre front with the wearer's initials and the date. Cuffs and neck edge were often strengthened by a crocheted edge. The all-over diagonal pattern is set within a definite frame made up of a border pattern knitted at the lower edge, up either side on the 'seam' line and across the yoke. A recent copy of this indisputably Swedish design was promoted in Norway to celebrate the Norwegian Homecraft Union's ninetieth birthday; it was some time before the similarity was recognised.

Who did the knitting? We know that in Halland, as in Mid Jutland or, later, in Selbu, where relatively coarse work was done for a mass market, that literally everyone who could knit did so. As a visitor to Halland said in 1796 'Alltid star hon och stickar' – 'They are always knitting'. In drawings of the period women from the

80 *The arrangement of the patterns given in Figs 81 and 82 for a Halland jersey. The neck (copied from a jersey in the Nordiska collection) seems too small – normally it would be one-third of the all-over width. The neck edge and cuffs have been finished off with a crocheted edge and the lower ribbing is mainly in black with three broad red stripes across it.*

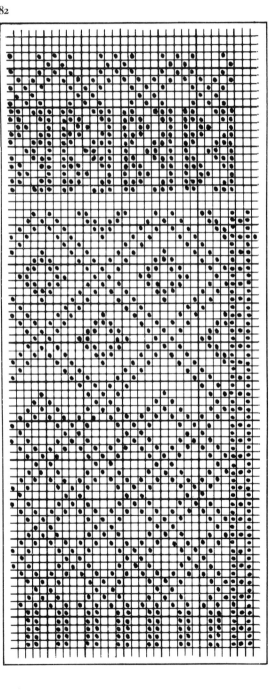

81

82

exporting areas are always shown with knitting in their hands.

In these areas of Sweden knitting parties – *bingegillen* in Halland dialect – were organised as everywhere where similar cottage industries grew up.

The specialised knitting of jackets, however, always seems to have been the responsibility, and indeed the monopoly of a few women in each parish. A style would be repeated, sometimes over centuries, because 'they knew no other', and so seventeenth-century styles could still be knitted in the twentieth century. When these fine styles were translated into the more fashionable stranded knitting of the nineteenth century and worn in other districts, quite complex designs were reproduced with only minor variations over, in the case of Delsbo, some seventy years, again because only a few people were involved in the knitting. Delsbo knitting went out of fashion long before it went out of use; folk costume is now seen maybe only in mittens – not much more is regularly knitted at home for home use. However, the treasures of the past are still an inspiration to us today.

Some oddities did, however, occur. The fishermen and sealhunters of Radmansö parish in Uppland wore 'immoderately wide, long trousers of coarse linen', a white pointed cap made of *nålbinding* and a woollen sweater, also mainly white, so that they looked like seals themselves. These sweaters belonged to a tradition, perhaps originating outside the Baltic in Iceland or Faeroe, but certainly common within it. They were white with small seeding patterns in alternating blue and red bands, and were both knitted locally and bought commercially. Those knitted locally seem to have been done in two-strand knitting, very closely knitted and thick.

Halland jackets have been mentioned; they were practically identical to the Danish *nattröjer* and, like them, were dyed red, green or blue after being knitted. Skåne, and several other southern provinces, had similar jackets known as *spedetröjor* which seems to mean a 'speckled jersey', though they are said to have been black, red or green according to the parish.

When stranded knitting was first used in other parts, such as Dalarna, it was very often for separate sleeves sewn on to a cloth bodice. The knitted part was treated very like patterned cloth, and the whole garment was usually dyed after being put together. So a red and black sleeve was first knitted in white and black and then fulled and dyed red, together with the cloth part of the jacket. In Hälsingland not only the sleeves but the adjoining parts of the bodice were knitted. This must be a later tradition as the wool was dyed before being knitted, so that we have striking patterns in red, green, white and black; not all-over patterns as in Delsbö, but vertical panels with a carnation and other floral motifs. The colours change every short distance so that the vertical panels are divided into squares, a way of varying a pattern well known later in Halland knitting and also in Fair Isle.

Jämtland, a western district adjoining Trondelag in Norway (where Selbu was active as a knitting centre from 1856 onwards) has a similar tradition. Today, great borrowing from Selbu is obvious in the local knitting, but as this is true of most of Europe

81 *Halland jersey.* TOP: *a common cuff pattern (also used, without the four-line edge, at the shoulder, the join being in the centre of a large diamond);* BELOW: *the arrangement of patterns at the armhole edge: this shows the yoke pattern, border patterns and side 'seam' pattern which divides at the armhole opening, one dark stitch running up each side. The sleeves, as seems always to be the case in old jerseys, were picked up around the armhole edge and knitted* down *to the cuff.*

82 *This neatly designed jersey (Halland knitters are very tidy-minded people) has a corrugated welt (about 5 cm [2 in.] of 2 dark plain; 2 light purl) and the small diamond pattern starts immediately above the welt. The only decoration at this point is the small 'seam' pattern which divides to decorate the armhole and is also used underarm on the sleeves (which are picked up and knitted down). The large diamond is used only across the shoulders with the join at the point where the chart stops. The top detail is from the cuff. The only other decoration is a knitted plaque on the front with the initials O.A.S. and the date 1896.*

it proves very little. Selbu knitting may originally have borrowed from Jämtland; nothing travels more easily than a knitting pattern. The only obstacle in the past was the local concept of a 'suitable' pattern. Each district positively cultivated its distinctive dress as an important part of its identity. So, although such items as mass-produced working jerseys were worn over wide areas, the finer decorative work for holiday wear was made locally in each community right through its lifespan and worn nowhere else.

BINGE AND BOHUS

Two twentieth-century developments in southern Sweden must be mentioned: *Binge*, or the Halland Knitting Cooperative, started in 1907 by Berta Borgström in Laholm as winter relief work, and *Bohus Stickning* (Bohus Knitting), which was started for similar reasons in the adjoining province to the north in 1939 by Emma Jacobsson. The moral here may be that the good die young; Bohus Knitting stopped production of its marvellous knitwear in 1969 while Binge, as far as one can discover, still produces its rather tedious 'traditional' patterns after almost 80 years. However, although Binge may be commercially more viable, it is heartwarming to notice that knitters in Bohuslän today produce some of the most exciting home-crafted knitwear in the world.

The Binge workers seem to have started off on the right foot by making up a pattern catalogue. Unfortunately, where they did not entirely approve of a pattern, or could not quite understand it, they adapted it or invented a better one so that, although the Binge patterns today are believed to be 'traditional', most are traditional only within that organisation. This is a pity, as I believe there were still many genuine patterns around in 1907 which were ignored and now seem to have disappeared. The Träslöv pattern, for example, was recorded by Binge in 1910 as 'an old sock pattern, not used for forty years'. It is, in fact, a pattern imported from Gotland. Binge did not use it until 1960 when an old man from Träslöv came to

83 *Swedish all-over patterns.* TOP: *a pattern recorded by* Binge; *a general type common in other parts of Scandinavia and also in Shetland. Note that the little arrows either all point towards a central point or away from it. Note also that the crossing as copied is not continuous; this may be a* Binge *'adaptation', as in Shetland and Norway it is a continuous diagonal.* BELOW: *three small Halland patterns from the* Binge *sample book which look authentic. They are all knitted in red on black. They appear to show cuff or yoke details with typical Halland tidiness – the cuff patterns are always separated by a plain row or a row of dots. That at the lower right is a detail from an Ullared jersey (see also Figs 81 and 82).*

84 *The Träslöv pattern, used in Sweden for mittens and stockings but probably originally from Gotland.*

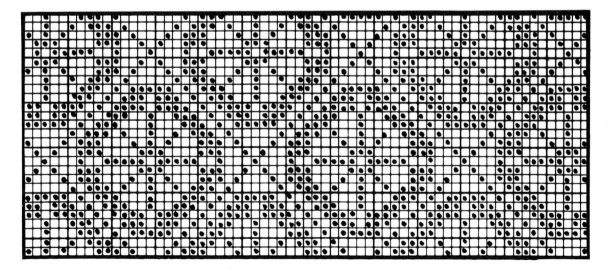

sell mittens he had knitted 'in the old style' with this same pattern.

Binge has survived because of increased centralisation and standardisation, but at what cost to creative knitting! Knitters collect wool – almost entirely red, white and blue – from the Centre, and bring back their knitting done according to charts. Even the famous 'double caps' have to be done according to charts, though, in the early days, as a mark of honour, a particularly expert knitter might be allowed to improvise a little so that they were more *folkligt*, or folksy. So much for a tradition going back generations! Today's double caps are sadly predictable and sadly lifeless.

Bohus Stickning, on the other hand, was, from the outset, a new tradition and complete records exist of all designs and their development. They created more marvels in wool over their 30 years than would seem possible for one small workshop, using home knitters and operating on a shoestring. Not only did they encourage the preservation of the local sheep, by then in serious danger of disappearing as a breed, but they also used imported softer Finnish wool and angora to produce their own fine blends. Their marvellous colours have become a by-word but, equally important, they understood knitting. Nothing, on the face of it, could be less traditional than their first round-yoked jersey in blue and brown shades, produced by Ann-Lisa Mannheimer Lunn in 1949. But it is perfectly crafted and seamless and its value is confirmed by the millions of round-yoked jerseys which have followed it.

By the time the Bohus market hit difficult days in the 1960s the women of Bohuslän were becoming more prosperous and, when the founder retired, it seemed an appropriate, if sad, decision to disband the operation. It is good to see that in Sweden today it lives on in the inventiveness and vitality of the knitting tradition there.

NORRBOTTEN KNITTING

When brightly dyed wool was first sold in Norrbotten in 1910 the local knitting, mainly of mittens, exploited this to the full. They like bright colours in Norrbotten and, though the local plant dyes are still known, the preferred colours are the three primary colours plus bright green, white and black. We might prefer to limit our range a little but this kind of knitting becomes addictive (*see also page 20*).

Many ideas are shared with the Lapps, who also like bright colours, but, in the nineteenth century, pedlars, known as 'bag Russians' came to Norrbotten from St Petersburg and Russian Karelia and brought designs with them which one assumes were copied. Certain patterns now are found in different places, probably as a result of contact at markets and church feasts. There is a continuous tradition of several hundred years in the Årjiplog mittens with a travelling stitch design forming diamonds on the back (*see also page 140*).

85 and **86** *Norrbotten patterns. It has occasionally been necessary to show four different colours in these charts but not possible to indicate which they might be. Like Hobson's horses, you can use any you please so long as they are bright red, bright blue, bright green and bright yellow. Touches of white and black are allowed and in fact these patterns are very effective, and perhaps more to sober, British taste, if knitted in the four bright colours on a black or white ground. They are all from traditional mittens from the very far north of Sweden.*

6 Danish knitting

Knitting seems to have been popular in Denmark before any of the other Scandinavian countries. It probably spread up from Germany and the Low Countries. One result of this early popularity is that old patterns, dating back to the seventeenth century or even earlier, were knitted continuously up to the early years of the twentieth century. Knitted jackets became part of everyday wear long before they became popular in Norway or Sweden but, with the resistance to change typical of folk costume, very few stranded patterns came into use.

The oldest fragment of knitting preserved in Denmark was found in a seventeenth-century level during excavations in Copenhagen. It is in wool, probably dyed with indigo and, even more remarkable, uses the same purl-and-plain diamond-and-star pattern used for centuries afterwards (*Figs 3 and 102*).

Even older evidence of knitting comes from a knitting-needle holder, part of a silver betrothal present and now in the collection of the National Museum in Copenhagen. Not only is this a rather rare item in Denmark, but it can be dated to 1570 or 1580, the earliest evidence of knitting in Denmark, and also evidence that the right-handed method was used at that date. This is still the normal method in southern Europe, France, the U.K. and the U.S.A. Right-handed knitting was used everywhere in Denmark until 1900 (according to Minna Holm Clausen), except for the knitting areas of Jutland where left-hand knitting had been used for as long as surplus knitting had been produced for sale.

KNITTING AS A COTTAGE INDUSTRY

Central Jutland is a poor region of moor and sandy heath and, for hundreds of years, supported a large population of sheep and, depending on them, a large number of poor knitters. As with similar cottage enterprises in Britain and elsewhere, this began in a small way and eventually grew into a substantial export industry employing 40,000 people. At first, only the wool from the small, local sheep was used. The old way of collecting this was to wait until it began to shed naturally and collect it as it fell off, or pluck it off. This gave a fine, long fibre which could be combed into the finest yarn. When wool was destined for felting (for woven cloth, for example) the sheep would be shorn twice a year. However, when quantity became more important than quality, the sheep were shorn once a year for knitting yarn and the wool was carded, not

87 *Although part of the Danish National Museum collection in Copenhagen, this knitted silk jacket was probably imported from England in the seventeenth century. Perhaps woollen jackets were imported as well, but certainly the style was immediately copied in wool and was knitted with remarkable consistency and worn all over Denmark well into the twentieth century. Very similar jackets are found in Sweden and parts of Norway. Points of note are the split welt and the tufted pile lining.*

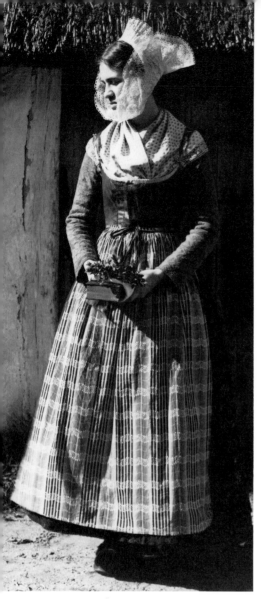

88 *A Danish costume complete with neckerchief, bodice and nattrøje. There is a star and diamond pattern on the sleeves.*

combed, so that long and short fibres were spun together into a mixed yarn. Only in the more prosperous areas such as the west of South Jutland, where the sheep were larger, could the wool be left for a whole year and then combed for finer work.

Both men and women spun. Towards the end of the seventeenth century it is recorded that a man and woman from the Shetlands went to Faeroe to teach the people there to use a spinning-wheel, ever since known in Scandinavia as a *skot-rok* or Scottish wheel. H.P. Hansen says: 'The *skot-rok* was formerly well known throughout Scandinavia especially in Danish and Norwegian prisons'! This was the hand-propelled wheel known in Scotland as the 'muckle wheel' or 'great wheel'.

In Mid Jutland everyone knitted whenever they had a spare moment, both men and women. Children helped from the age of five or six. They knitted long stockings, leggings, socks, undergarments, mittens of various kinds and gloves. These were all fulled or felted by being scrubbed at length on a scrubbing board. Garments were then dyed, if they were to be dyed, and shaped by drying on wooden blocks. There were blocks for all the different sizes of stockings, for mittens sleeves and long-johns. Mittens – *luffevante* – sometimes had two thumbs to equalise wear and half-mittens were also knitted with two or four finger openings. One type of legging was known as *stumper* and had no soles, being tied under the foot.

Knitting parties were organised here as in many other places where cottage knitting became a commercial proposition. While their hands were busy, the old stories and legends were told and retold, and the ancient folk tales of the place were kept alive to be written down hundreds of years later.

Knitting for sale outside the area began in the seventeenth century. Young farmers went individually to Copenhagen to sell knitwear on the streets. Certain places, such as Amager Square, became unofficial markets and inevitably local cloth merchants began to complain. A licencing system was then introduced and many of these young men became official stocking traders and prospered, to the general benefit of their home areas. This prosperity was greatly increased by an Act of 1741 which gave Mid Jutland the right to sell its knitting anywhere in Denmark, a privilege which was not withdrawn until 1932.

However, a decline began in the nineteenth century when home-spun stockings began to go out of use as stockings of any kind went out of fashion. Trousers, the new town wear, soon replaced knee-breeches even in country parts and the relatively few stockings still sold were knitted on machines in such centres as Herning, where knitting is still an important industry. Door-to-door hawking of knitwear, an ancient custom, was also banned, and so an era came to an end. In its hey-day, however, it had been a great blessing to a very poor region of Denmark and stockings were exported not only to the capital but also to Norway, where Danish merchants settled in the nineteenth century and, much earlier, to southern Sweden. There has been much discussion about the origin of knitting in southern Sweden, but it seems most likely that the influence came from Denmark rather than the other way round.

FINE KNITTING IN DENMARK

The *nattrøjer* of Denmark are the direct descendants of the textured (purl-and-plain) silk shirts worn (as a passing fashion) by the upper classes in the seventeenth century. Jackets with knitted arms and woollen 'nightshirts' are mentioned in inventories of 1690. Particularly among poorer people, undershirts and nightshirts were identical and worn in cold weather by night as well as by day, hence the Danish name of *nattrøjer* – night jerseys. Similar textured jackets were worn in southern Sweden (in Halland) and in parts of western Norway, as well as in Denmark, from which they were possibly exported at first and then copied locally. A strong influence can also be deduced in English and Scottish seamen's jerseys or gansies (from Guernsey, where they are said to have originated). This is supported, to some extent, by the likelihood that the earliest *nattrøjer* were worn by both men and women. Soon, though, they became an exclusively female article of dress.

Most were worn under cloth bodices and were often decorated with sewn-on silk ribbon or appliquéd decoration of colourful and splendid silk cloth round the neck-line and cuffs. Styles varied from district to district. In some districts knitted sleeves were sewn on to cloth bodices, not necessarily for reasons of economy, as this was the standard style among the wealthy and well-dressed wives of the Dutch Amager farmers. In general, large and elaborate patterns were placed where they would be seen and smaller all-over patterns, particularly two-by-two checks in purl and plain, used where they would be out of sight or covered by silk trimmings. Many show signs of having been altered, mended to increase their life, or adapted to a new style. New sleeves are often sewn in. Necklines may be cut away and bound, the old pattern still visible on the inside. These alterations could suggest that the parts were always sewn together; however I do not believe this was so as finely crafted knitted joins can also be seen on intact jackets.

In every peasant costume, every item had to be 'right' for the time and place, the place often being as restricted as one single parish. As the making of these Danish jackets was so highly skilled, it seems very likely that, as in Sweden, each parish was supplied by its own knitter, perhaps a childless widow or spinster who supported herself with knitting. These skilled knitters would have confirmed the old traditional styles while occasionally adding small improvements or changes of their own which in turn would be copied by the less talented.

As a simple rule, the longer jackets are older and more likely to have been worn by both men and women. The Empire style (or Gustavian style, as it might be called in Sweden) of around 1800 pushed up waists in peasant styles all over Europe and in Denmark led to tiny, short, knitted jackets with all the components of the older styles but half their length.

The most popular colour was red, with blue and green also being common and black rather unusual. As a rule, the jackets were dyed after being knitted. Dying became a commercial activity and jackets were sent in from country districts to towns to be dyed in batches. Blue, being expensive and difficult to use, was always

considered a luxury, for holiday wear or for the privileged and rich, such as the Dutch Amager wives, who wore jackets of finest worsted dyed deepest indigo.

The patterns used (mainly the so-called *krammønster*, or pedlar's pattern) added a little to the thickness and warmth and tufts of wool 'floss' were often stitched inside, particularly on the arms. As these were usually sewn to points of the pattern, they probably helped to emphasise it as well. The patterns used are shown on the charts (*Figs 101 and 104*). Most are fairly simple though their arrangement on a jacket could range from the very simple (an all-over small check, for example) to the very complex. There could be a welt pattern, a small border just above the welt, an all-over pattern on sleeves and bodice, a 'seam' pattern at each side, two bands of pattern at the cuff and extra decoration at the armhole edge, neck edge and on the shoulder strap, if knitted. For everyday wear they were certainly simpler. Although quite a large number have been preserved, they are certainly the most special

89 *A typically elaborate and spacious all-over pattern from an Amager sleeve with alternating floral and geometric patterns. It has had to be condensed a little to fit on to the page; in the original there are 14 clear rows between the two rows of pattern elements. These 'flowerpots' are familiar from sampler patterns.*

90 *A complete pattern from an Amager sleeve (LEFT) repeated with the bird of the next panel opposite the candlestick of the previous, which must have made for difficult knitting. (X on the chart marks a crossed stitch which gives a cable effect.) The motifs on the right alternate on another design, set between a winding vine pattern (not shown) or can be used (with candlesticks, lions, etc.) in a variety of all-over styles. The sequence of small diamonds was used as a 'seam' decoration. (Opposite page).*

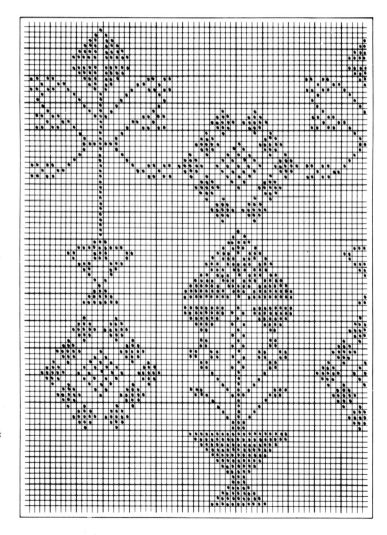

91 *An unusual Danish woman's jersey, from the nineteenth century, to judge by the Empire style, but with some very Estonian-looking patterns. Much of the decoration at the neck has been covered by the brocade facing, and the stars on the sleeves are emphasised with travelling stitches, another unusual touch. Fig. 91 shows the chart for the ribbon-folded cable panel. The other patterns include a travelling-stitch trellis and a very small cable.*

ones, and hence the most complex. A number of regional variations are interesting.

In Røsnaes, they wore a green jersey and skirt in spring, a red outfit in summer and a blue one over the winter. Sleeves were short and tight, patterned at the bottom with ribbing and at the top with an all-over small purl-and-plain check. In Nordfalster knitted jerseys were worn up to 1850 – red for feast days and green for work-day wear. The simplest ones were patterned only at the neck edge, welt and cuffs. Some had patterns only on the arms and the best had patterns knitted all over the bodice and sleeves. The

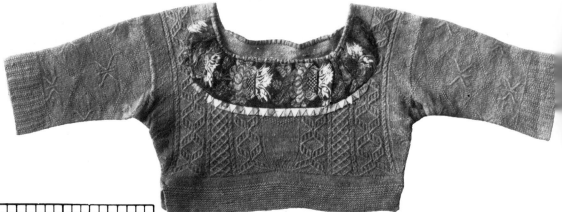

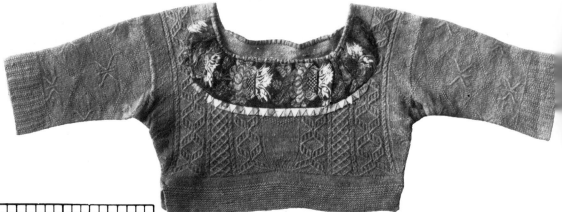

92 *Chart for a single element of the main pattern of the jacket in Fig. 91: a ribbon-folded cable panel worked in four repeats. Symbols used:*

S *twisted purl stitch;*

⬛ *travelling stitch (left over right);*

◨ *travelling stitch (right over left);*

☐ *all on a purl ground.*

district around Roskilde was prosperous and they knitted birds into their patterns together with stars and squares which they called *gramaser*, probably a variation of *krammønster*.

The knitted sleeves of Amager deserve special mention. They were knitted with very complex purl patterns in fine, heavy, tightly spun, dark blue wool and sewn on to a dark blue or black cloth bodice to make a *klokkeliv*, or clock bodice; the patterns may have been copied from stocking clock patterns. The Dutch Amager community had retained many features of Dutch regional costume and combined restraint with subdued splendour to an unusual degree. As knitting was considered an unsuitable occupation for the women (who preferred lacework and fine embroidery) it was done for them by seasonal Swedish maids who were probably supplied with standard patterns. These included peacocks, stars, candlesticks (?), crowns and angels, and are not like anything else in Denmark, nor in Sweden for that matter. (*See Figs 89 and 90*).

Men began to wear patterned outer jerseys in the nineteenth century. Before that they had worn only knitted undershirts in white or, at best, striped. Only one region, Sejrø and around Praestø in Jutland, seems to have developed a stranded jersey – the *skråtrøje*. This had dark blue patterns, usually geometric arrangements of stars, on white. The side seam was often decorated (though knitted in one piece), or knitted-in like a pattern which divided below the armhole and decorated both sides of the armhole

edge. A similar decorated band was knitted into the underarm
seam and is an elegant feature of this stranded knitting.

Otherwise in Denmark, knitting was mainly of stockings in white
or *pletgarn* – yarn plied from one natural and one dyed strand. The
colour of stockings was always most important but varied
considerably from region to region and over the years in any one
place. A notable feature is that everyday costume repeatedly
became festive wear, as old styles were up-dated and gradually
went out of use.

Danish men wore knitted caps, generally bright red with a red
pile brim added later and, sometimes, a white pile lining. They had
come in originally as night-caps, but were being worn during the
day as early as 1550. The red caps were popular from around 1785
up to perhaps 1860 when they became old-fashioned and
disappeared.

In south Fyn a very unusual type of cap, the *nikulørhuen*, or cap
of nine colours, was worn. It has contrasting stripes with dark blue
as the main colour and several other colours knitted into the
stripes. Even with poetic licence, it is difficult to see the nine
colours of the name but blue, white, yellow, red, green and pink
can be seen. The early ones are very curious – the yarn for the
pattern stripes has been tied-and-dyed, hence all the shades and
the rather irregular occurrence of the small colour motifs in the
pattern. Later examples used separately dyed yarn, but copied
faithfully the irregular effects produced quite accidentally by the
tied-and-dyed wool. There is nothing else quite like them in
Denmark, though finished white knitting in Sweden was
occasionally tied-and-dyed to give a white-on-blue pattern.

Gloves and mittens have been mentioned already. Even in Mid
Jutland some finer gloves were knitted for home use and three
pairs of gloves and mittens are described on page 143. At the other
extreme, fishermen's mittens could be knitted from human hair or
dog hair, which is hard, water-resistant and very strong. Women
also wore knitted underskirts, extremely thick and heavy objects,
which are said to have been able to stand up on their own and
which were dyed red for winter wear. Three-cornered shawls in
green, red or dark blue were also worn. Those worn in Amager are
said to have weighed $1\frac{1}{2}$ kg ($3\frac{1}{2}$ lb)!

Lace-knitting was taught in the nineteenth century, but white
knitting was never part of traditional knitting in Denmark. Indeed,
it plays no great part in Scandinavian folk knitting at all, although
simple hole patterns are found, and white gloves and white
stockings are worn here and there, particularly on Sundays. By and
large, white was never a desirable colour in folk knitting, and
Denmark was no exception.

Finally, mention must be made of a very splendid and exotic
pair of gloves in the collection of the National Museum of
Denmark which are described in detail in the mitten pattern on
page 145. These are almost certainly imported from Estonia and
demonstrate that inspiration was not lacking for Danish knitters;
but, having once established a costume which suited them, they
seem to have seen no reason to change it until it went out of use
altogether.

93 *A pattern from a rare patterned Sejrø
jersey from Denmark, knitted in blue and
white with a checked welt and stars all over.
The tension is incredibly high and the checks
were probably not meant to be seen.*

94, 95 and 96 *Copies of Danish gloves
from the province of Mid Jutland.*

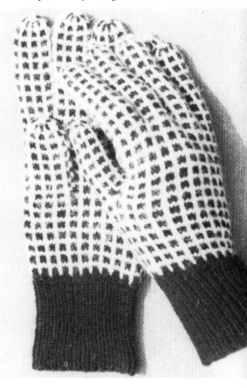

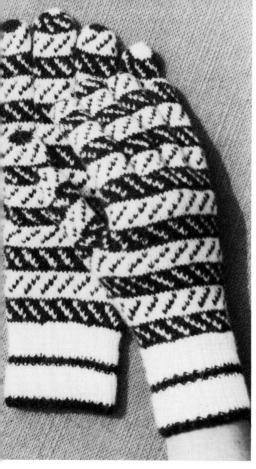

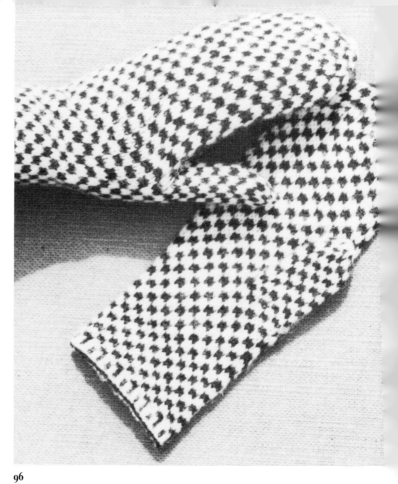

95

96

98 *Estonian glove from Eesti Rahvakunst by K. Konsin. This shows a fringed cuff with a pattern in purl stitch and a large border pattern almost identical to that on the glove in Copenhagen.*

97 *Estonian-style mitten.*

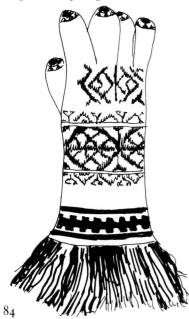

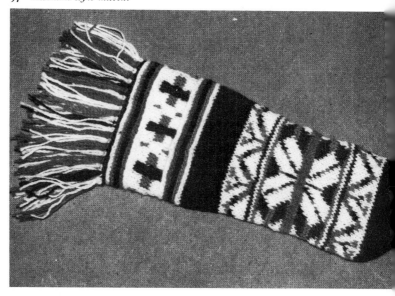

84

TO KNIT A NATTRØJE

Although some unusual examples (such as that shown on page 82) are patterned with cables and travelling stitches, *nattrøjer* generally use only plain and purl stitches. The pattern is usually in purl on a plain background. As horizontal lines of plain tend to disappear against a purl ground, most lines of division, for example in stars, are either vertical or diagonal. Also, purl stitches stand out better when isolated and many patterns therefore show alternating purl and plain stitches.

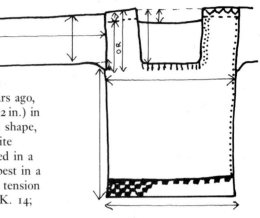

99 *Knitting a* nattrøje: *measurements to make.*

The shape of *nattrøjer* has changed considerably over the centuries and, if knitted today in the style of a hundred years ago, would be of little use to anyone – many were only 30 cm (12 in.) in total length. Fig. 100 (lower right) shows an older style and shape, but the patterns can be adapted to any shape or used in quite different ways. The sampler in Fig. 7, for example, is knitted in a silk and wool mixture. Generally, the fine detail shows up best in a fairly closely spun wool with a shiny finish. As a guide, the tension of one old one was 32 stitches to 10 cm (4 in.) on 2 mm (U.K. 14; U.S. 0) needles.

With the best will in the world it is not possible to give stitch-by-stitch instructions. The size will depend entirely on the style planned and the number of stitches, on the tension of the knitter with the yarn of her choice. So, first measure carefully, drawing out a detailed diagram which shows overall length from shoulder to cast-on edge, width at lower edge, width at other places if it is to be shaped, depth of sleeve so that the armhole edge may be prepared, length of sleeve, shape of neckline and depth of shoulder (from neck edge to armhole edge). Modern instructions show a completely unfitted shape; this may be modern fashion, but old

100 *Details of 'night jackets' from* TOP *and* LEFT *Lolland and* LOWER RIGHT *the Ålborg region of Jutland. Features to note are the split welt with diced pattern; the circularly knitted bodice with all-over pattern (usually the same as used for the sleeves); lower border pattern and decorated side 'seams'; decoration along the armhole edge, over the shoulders, on the underarm gusset and round the neck edge; and the patterning at the cuff. The neck edge was to be covered with brocade or ribbon and was therefore left fairly plain. These are all probably 'feast' jackets. Many were decorated more sparingly with diced patterns, simple 'nets' and zig-zags, with a few stars only on the sleeves.*

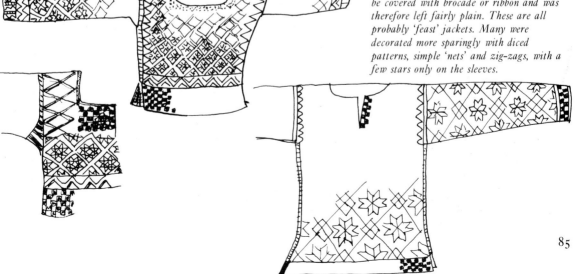

85

jackets are often closely fitted with increases underarm on both sides on either side of the underarm 'seam', and many also have a small triangular underarm gusset.

Once the tension has been worked out from a knitted piece (using the wool of choice and the right needles to give a fairly firm texture) the number of stitches or rows needed for each section can be worked out by simple arithmetic (divide the distance by 10 and multiply by the number of stitches, or rows, per 10 cm [4 in.]). The patterns can then be selected from those given on pages 87–91.

Many simpler versions are possible. Patterns may be used only to decorate welt and cuffs or armhole edges, but certain areas always receive special treatment. Figs 100–103 show charts of various patterns from *nattrøjer*.

THE WELT

This was always cast on in two sections, front and back, and knitted in two flat pieces. There seems no reason for this unless it was a primitive shaping device in the days when such jerseys were hip-length. Some old types of gansey have the same feature and they were worn 'frock' length, almost to the knees at times. The welt pattern is almost always a check, or garter stitch, or a combination of both, but the fancier cuff patterns could be used here to advantage. The original welt, we should remember, was knitted very plain as it was seldom, if ever, seen in public; traditional knitters were very conscious of their public image!

Welt patterns *(Fig. 101)*

The lower patterns in Fig. 101 are, logically enough, welt patterns, usually finished off top and bottom with one or more purl rows. Sometimes the entire welt is knitted in alternating plain and purl rows (seen from the right side – as the welt is traditionally knitted as a flat piece the result is the same as garter stitch). The zig-zag patterns in the centre are often used at the lower edge of the bodice. The top patterns in Fig. 101 are from cuffs – they can also be used for welts but are often more decorative. Ribs such as the 2-purl, 1-plain rib shown, are rare.

THE BODICE

This was then started by joining front and back in one piece and overlapping the back welt on top of the front by two stitches on either side. Often a small border pattern, set off by a purl row, was worked first. The side 'seam', above the split in the welt, was always marked, if only by a purl stitch in every round or every second round. Often, there was a much more decorative pattern which might continue eventually up the armhole edge to meet at the top of the shoulder. The main part of the bodice usually had an all-over diamond-and-star type of pattern, centred back and front. The space at the neck edge was usually filled in with small checks, or a rib, or with moss stitch (P1, K1, rep; K1, P1). At armhole level five or six stitches were left for the gusset and back and front knitted separately. If there was much shaping at the side, it took place on either side of the seam band and did not usually form part of the main pattern, but had its own small pattern, often shared with the seam band (*Fig. 103*).

101 *Welt and cuff patterns.*

Stars and nets *(Fig. 102)*

Nets are generally double with large-scale stars and single with smaller ones. All the stars shown in Fig. 102 have been scaled down from much larger originals – perhaps ten-sided – and can be any size to fit, though some design details are lost when they become less than four-sided. Horizontal divisions tend not to show in plain-and-purl knitting, hence most divisions are vertical or diagonal. The type of star shown at the top of Fig. 102 can have a great variety of 'fillings'. Some types are shown lower right. The netting may occasionally have only one diamond at each junction; or small diamonds may be used as an all-over pattern with no stars. The detail lower left shows the best version of a double net junction though a variety occur. Double net may also be used as an all-over pattern. The star bottom centre is from the sleeve of the jersey illustrated in Fig. 91. The diagonal lines indicate travelling stitches and 'S' is a twisted plain stitch. The main part is of course in purl. Further nets and alternative motifs are shown in Fig. 104.

THE SHOULDER

This could either be joined by grafting or casting off together or, less commonly, by knitting a shoulder strap (another feature shared with British gansies). The width of this piece varied a lot, from the total distance from neck opening front to neck opening back to a narrow piece of 5 cm (2 in.) or so. Stitches from front bodice and back were left on stitch holders, and a new piece cast on and knitted at right angles to front and back. A number of separate patterns are given for shoulder straps *(Fig. 103)*. Some form of diamond or zig-zag repeat was common. At each end of each second row the stitches left front and back were knitted in (purl 2 together or slip the last stitch of the shoulder piece, knit the next and pass the slipped stitch over).

THE SLEEVES

These had decorated cuffs and often the same pattern as the bodice, or a slightly smaller version of it *(Fig. 104)*. They were knitted in circular fashion, usually without much shaping. A small triangular gusset was added underarm and the sleeve sewn in. Nowadays, a sewn-in sleeve is the more common method, but it would be equally possible to pick up the sleeve stitches around the armhole opening, plus those left for the gusset and knit down to the cuff.

102 *Stars and nets.*

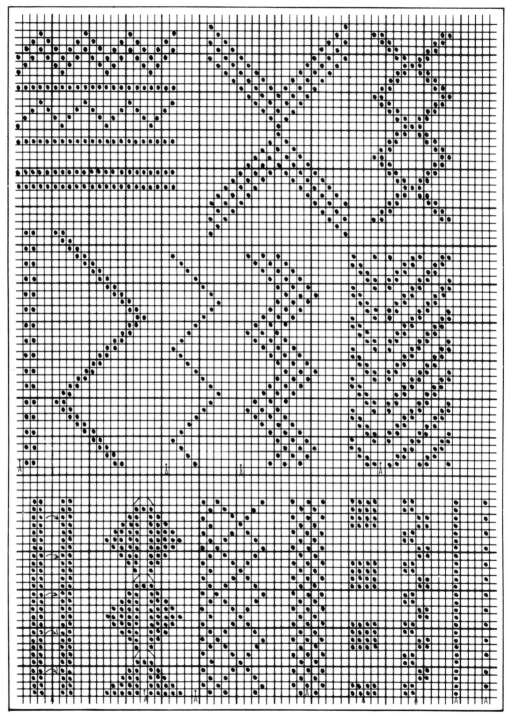

103 TOP LEFT: *cuff patterns;* TOP RIGHT: *decorations from shoulder straps;* CENTRE and BELOW: *side 'seam' decorations. As elsewhere, 'A' marks the centre of the side.*

The diagonals CENTRE RIGHT *were often used to fill in gussets or other underarm increases on either side of the main bodice pattern.*

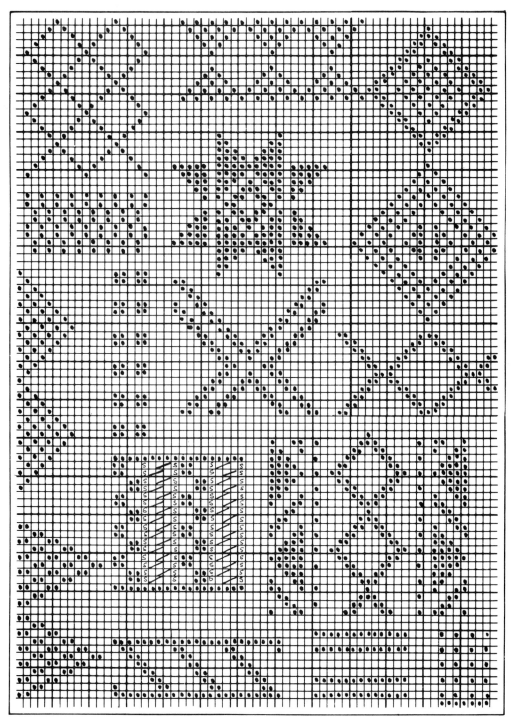

104 TOP LEFT: *all-over net (Danish)*; TOP
CENTRE: *cuff pattern; also used as bodice
pattern at lower edge;* RIGHT TOP: *two
motifs used in place of stars in Norway* TOP
and Denmark; LEFT: *a Danish cuff pattern*
and two armhole decorations from Sweden;
CENTRE: *a neck edge which gives a ribbed
effect; a detail of two nets;* BELOW: *four
Danish cuff and welt patterns and a sleeve
pattern, also Danish.*

7 The North Atlantic Islands: Faeroe and Iceland

These rugged outposts of Scandinavia have a rich and lively knitting tradition which has played an important part in their farming and fishing for centuries. The word *faeroe* means 'Sheep Islands' and, without sheep and their wool, life on these islands would be almost impossible. The climate of both Faeroe and Iceland is exactly what one would expect of places at the far north end of the Gulf Stream – at best, windy and wet and, at worst, very cold and dark as well. It is not surprising, therefore, that wool is all-important and that homespun and hand-knitted stockings, socks, undergarments, jerseys, caps and mittens have been knitted in great quantities.

FAEROE

Faeroese sheep (closely related to those of Shetland and of the old Short-tailed race) have an interest of their own. Irish monks probably brought the first sheep and Norsemen added more, but they all died out in the eighteenth century and new stock was brought from Shetland. These are hardy little beasts and live outdoors, each on its patch of hillside, all year round. They are identified at annual round-ups by lug-marks, distinctive notches cut into their ears, and also used in Shetland until recently. These northern sheep are colourful characters and in Faeroe no attempt has been made to breed for white. There are still large numbers of grey, black, red-brown and multi-coloured sheep, one common oddity being a white face with large black patches over the eyes.

The quality of the wool is said to depend on the weather over the winter. If there has been a lot of rain and wind there will be a higher proportion of hairy fibres in the fleece; this gives a strong knitting yarn. A mild winter with good grass is said to favour fine wool, used for finer knitting (in the old days, especially for underwear). Many Faeroese sheep are still not clipped. They 'skubber' the wool off themselves as the new fleece grows in the early summer and it can be gathered or pulled off easily. Only the head and neck may need to be shorn. Traditionally, the wool was spun and knitted unwashed, so it was necessary to wash knitwear well before wearing. Rough pieces of grass may occasionally go through even the industrial processes of today and should be picked out when knitting.

Not for nothing is wool described as the gold of the islands! It was not only invaluable in clothing the family but wool, ready for

spinning or already woven, or knitted into coarse stockings, could be used to pay rent or taxes or even court fines, or bartered for other goods. This trade in knitwear was particularly important in Iceland. To give a few figures: in 1624 Iceland exported 72,000 pairs of stockings and 12,000 pairs of mittens. In 1743, when jerseys were first mentioned, 1,200 jerseys, 200,000 pairs of stockings and 110,000 pairs of mittens were exported. At its peak, in 1764, 250,000 pairs of stockings were exported, and, as late as 1849, 8,000 jerseys. Every available pair of hands was employed in this work: even children of eight were expected to produce their quota.

A feature of the northern sheep is that in the one fleece there are thicker, hairy fibres and much finer, woolly ones, and in the old days, for home use, it was desirable to separate the two qualities of fleece for different purposes. Coarse hairy yarn was obviously more useful for outer wear such as sweaters and working mittens. The finer qualities were kept for underwear, Sunday stockings, and so on. The strong hairy wool, when carefully carded and combed, could be spun into beautiful glossy yarn which dyed well and was exceptionally hard-wearing. Jerseys, in those days, could be worn by more than one generation and still be worth keeping.

In the old days in Faeroe and Iceland, people wore wool from head to foot. They wore knitted caps, underclothes, jerseys, jumpers, jackets, trousers, mittens, gloves, long stockings, shorter stockings, socks to wear outside shoes in winter, leggings, shoe linings and finery to wear on High Days and Holy Days. Most of this was done on sets of circular needles, made of fairly fine steel wire. Still today, knitting is very much in evidence both in towns and in remoter communities, and jersey knitting shows the regional style more than most other items these days.

Most knitting was felted in former times and, today, working mittens and sometimes jerseys are still felted. This may seem curious, as we, in this country, go to some trouble to avoid this effect, but it adds greatly to the protection offered by knitwear against wind and rain. So caps, mittens and stockings were all knitted rather large and loose and then felted and shaped in one process. The instructions given on page 38 are not for the beginner, but neither do they date back to the nineteenth century – they are from an article published in 1976.

Knitwear assumed more prestige when deep-sea fishing grounds were opened up and larger boats headed for Greenland waters. The Greenland trip lasted four months and seven complete changes of clothing were considered a minimum. It could be a matter of survival, as well as household pride, to have an ample store of home-knitted woollen clothing. One proud woman was able to provide jerseys for sixteen soaked fishermen and covered the seventeenth in her own woollen shift. These fishermen's jerseys, worn under their oilskins, had their own small patterns. Outer jerseys, when these were first worn, were generally plain navy with straight necks; schoolboys around the turn of the century also wore navy jerseys.

It is not long since today's formal wear was used as everyday clothing, and that, in turn, was replaced by standard shop-bought

28

8

10

10

clothes. This is a trend also evident in many other places. Today, men's festive costume has three layers: a tailored jacket, a shorter jacket and a splendid and colourful embroidered waistcoat. It takes careful inspection to see that the middle layer is in fact knitted. It has a tailored collar and twelve buttons and buttonholes in almost eighteenth-century style, but the cuffs are often finished in one-and-one rib and the pattern, usually in light blue on dark blue, has been knitted in. It is, in fact, tailored from a felted knitted jacket, once a feature of folk dress in many corners of Scandinavia and as far away as Estonia. The eighteenth-century style may give a date for this development; certainly Linnaeus, the Swedish scientist, reported in 1741 that the men on Gotland were wearing knitted jackets. The Faeroese version is cut open in front, edged with a red band and equipped with twelve buttons carved from bone or cast in tin (pewter).

Women in Faeroe wear patterned, short-sleeved jerseys as part of their costume. These also are felted, opened down the front and laced up with a decorative chain. When this was still common wear, jerseys were worn in red, green and blue in various combinations, with touches of white. Older women and those in mourning generally wore dark blue, never red. For more formal occasions a long-sleeved version was worn, as in Denmark. A link with Denmark is seen in the use in Faeroe of the *krammønster* of the Danish *nattrøjer*, but here it is knitted in blue on red. One border, knitted in three colours, is copied from a Danish cross-stitch border in the same three colours.

The big development in patterns seems to have been early in the twentieth century. Fortunately, local people noted these patterns and Hans Debes finally published a collection of more than 100 patterns, collected from all over the islands. Some are very localised; indeed many of the women's patterns were characteristic of one small district, or even a single farm, and were named after the person who first knitted them.

I say 'knitted' and not 'invented' as most, if not all, have been taken over from patterns familiar to the knitters in other contexts. Housewives, after all, were accustomed to a wide range of needlework. Lacework, weaving of all kinds and embroidery, as well as an increasing variety of imported, ready-made textiles and magazines, were familiar to Faeroese knitters, as to those in other places at that time. They were already happily working cross-stitch patterns copied from net; it was just as easy to try knitting them. Faeroese women's patterns show their origins more easily, however, than those used on the large, coarse seamen's jerseys. My theory is that some of the men's jersey patterns are old seeding patterns, knitted over a wide area; some are direct imports from the Baltic; some are local inventions (hammers, shears and so on), and some (the large zig-zags) may come from a type of semi-ornamental, semi-functional type of needlework known as decorative darning. Charts exist for this which look exactly like Faeroese jersey patterns!

The striped patterns from underjerseys appear to be older than the others. Striped jerseys occur also in Denmark and Norway but Faeroese stripes have more decoration than elsewhere. The various

105 (*Opposite*). *Patterns from Faeroese men's formal jackets. Always knitted in pale blue (shown here by the dots) on a dark blue ground and then felted, brushed and tailored into shape with collar and front opening.*

106 *Pattern from formal jacket worn by men in Faeroe, in pale blue on navy. Here on size $3\frac{1}{2}$ mm (U.K. 9; U.S. 5) needles in Shetland 3-ply, giving a tension of 24 stitches and 24 rows to 10 cm (4 in.).*

107 *Faeroese women's jersey pattern (shown in Fig. 108) is in red and blue double knitting. A type of pattern well known in Sweden, Gotland and Estonia.*

34

26

6

108 *Faeroese women's jacket patterns, once working wear, now reserved for formal occasions. Knitted in blue on a red ground. The top pattern is also found in Danish textured jerseys (in purl and plain). The cuff patterns are copied from cross stitch or woven binding (see also Fig. 107).*

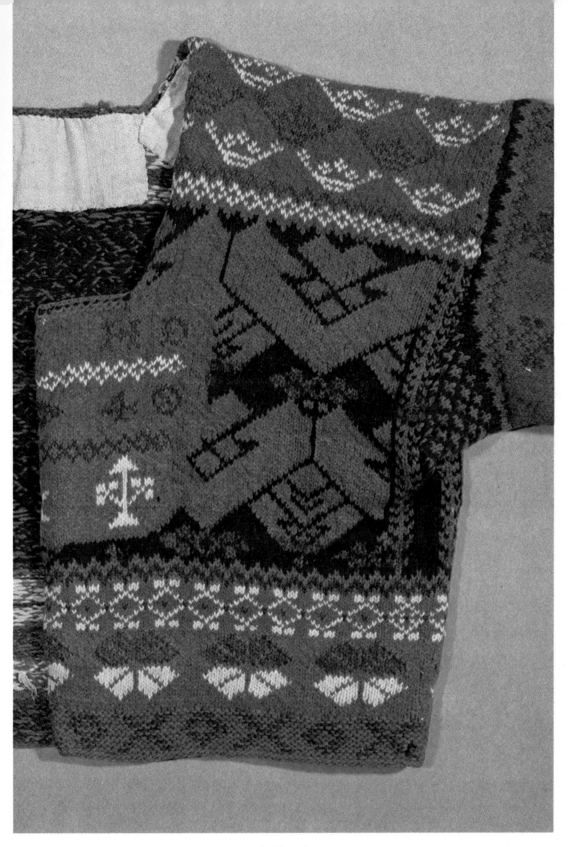

1 *Delsbo jacket*

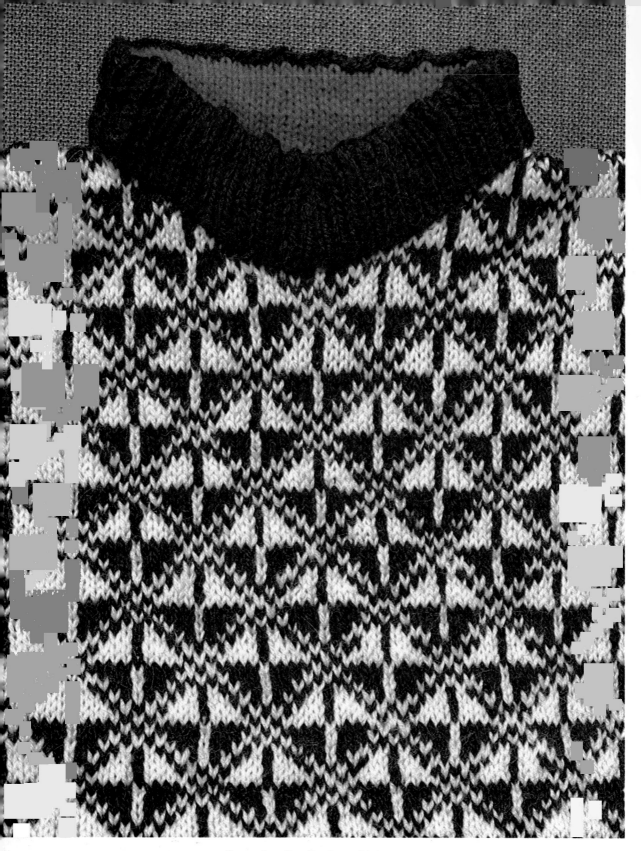

2 *Jersey using a Scandinavian stocking pattern*

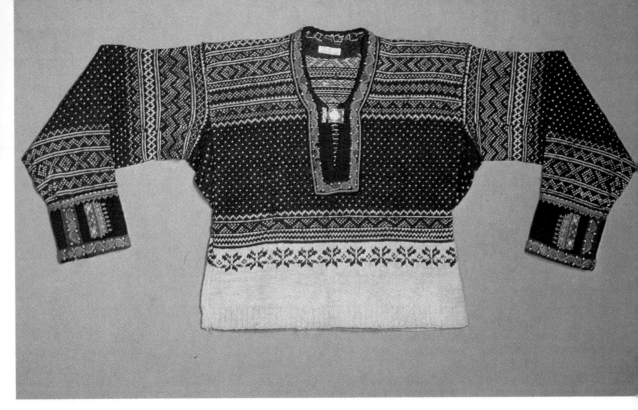

3 *Setesdal jersey*

4 *Reproduction of an Estonian-type mitten in the collection of the National Museum of Denmark*

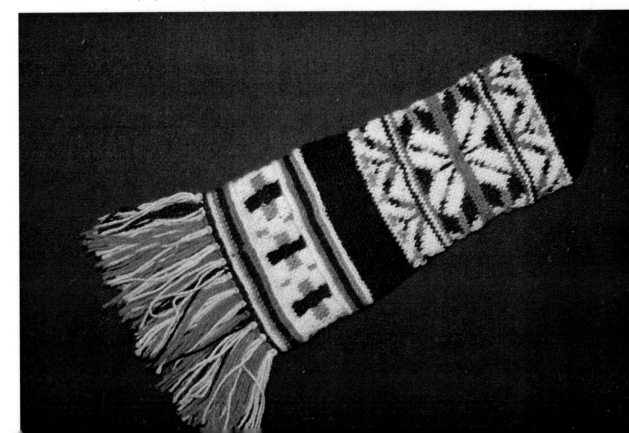

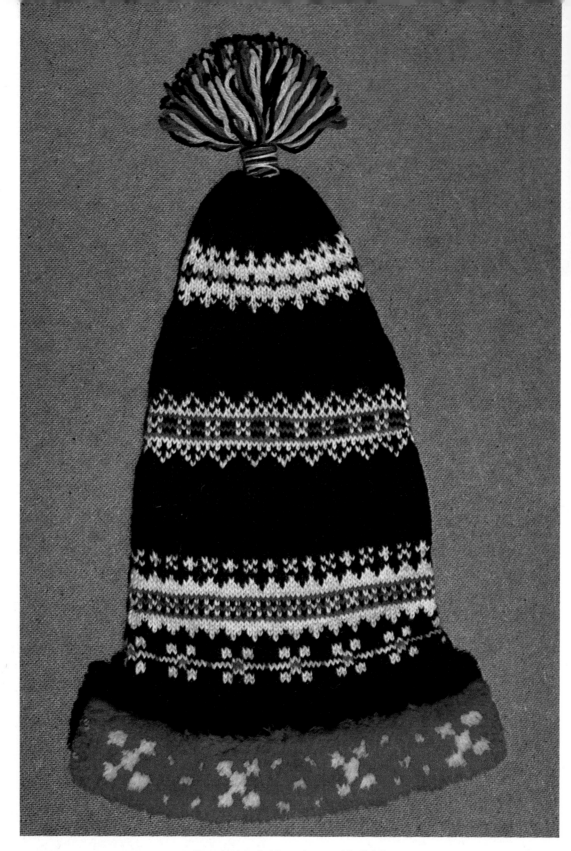

5 *Reproduction of a Norwegian cap with pile brim*

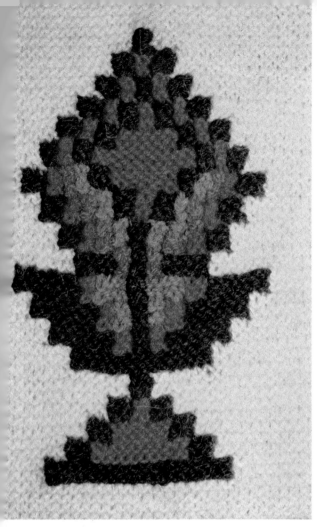

6 *Reproduction of pattern from Icelandic insole*

7 *Traditional two-strand and multi-coloured knitting from a Setesdal sock, here used for the brim of a cap*

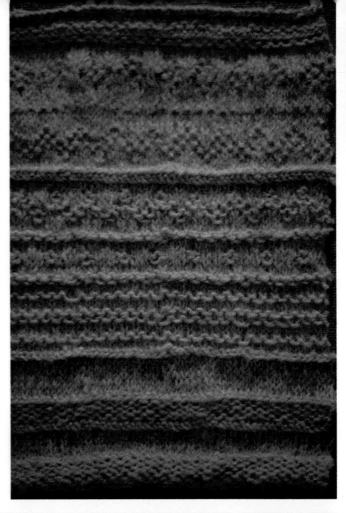

8 *Two-strand sample in thick Shetland wool*

9 *Traditional Faeroese woman's jersey pattern with corrugated cuff in two colours*

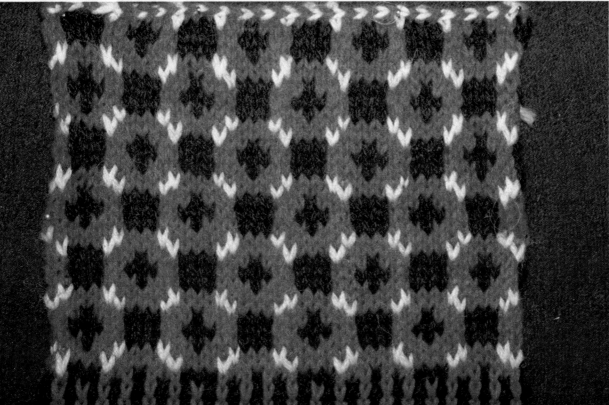

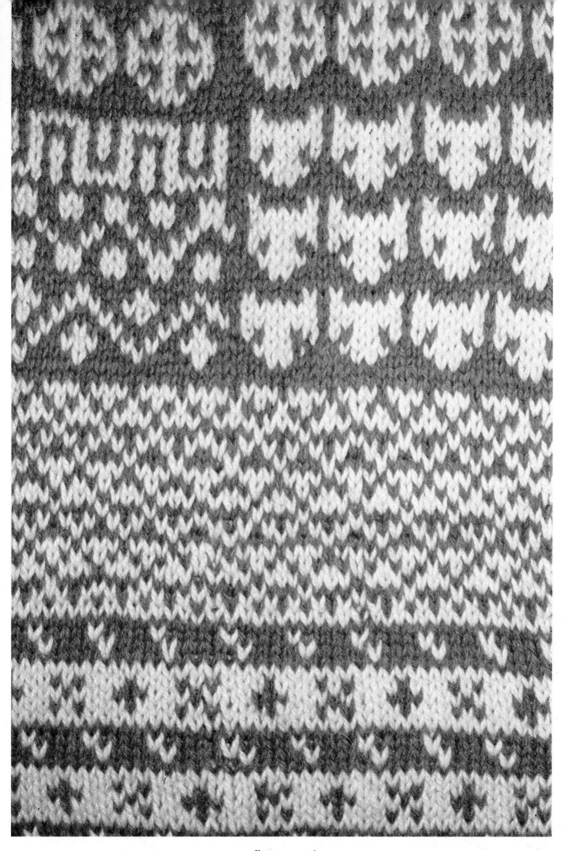

10 *Faeroese sampler*

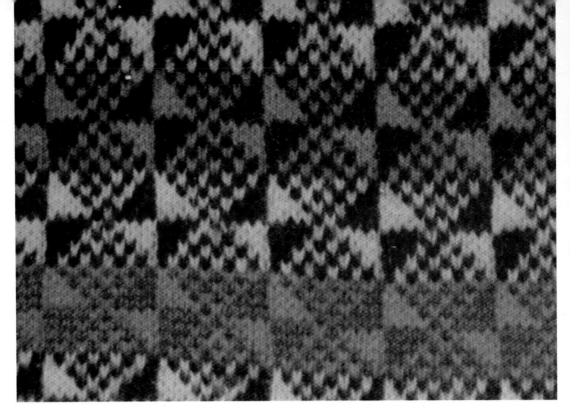

11 *A typical Baltic pattern discovered in the Shetland Museum on a fisherman's cap*

12 *Jersey pattern from Swedish mitten pattern*

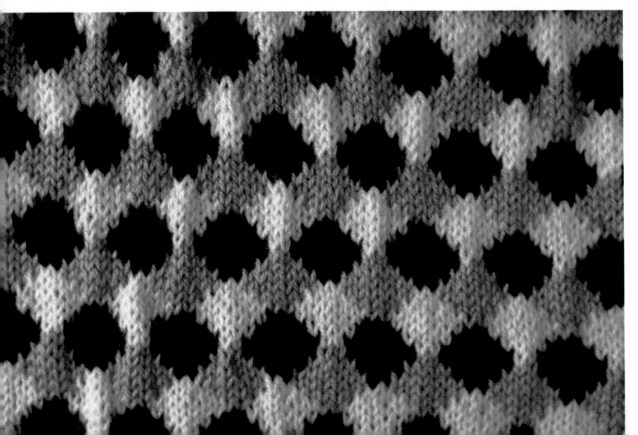

109 *Traditional patterns from Faeroese women's jerseys, all knitted in blue on red.* *The lower border pattern is from a man's cuff.*

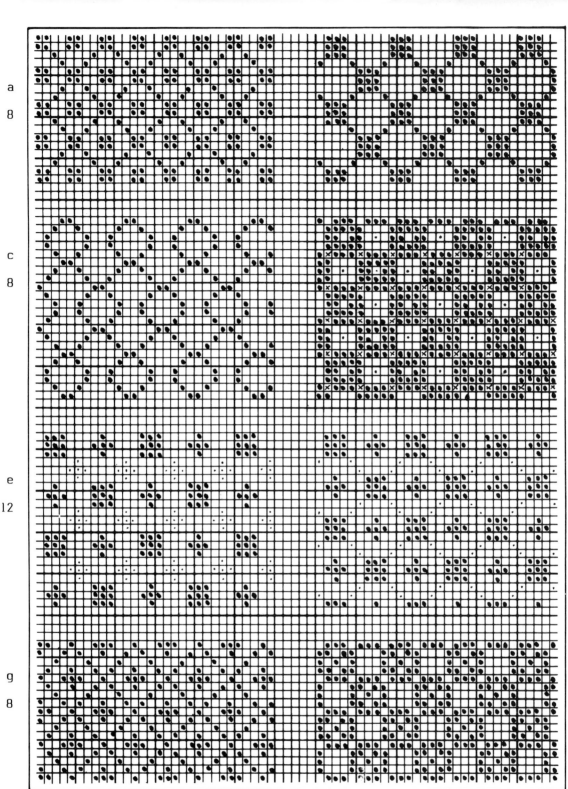

110 *More traditional patterns (see also Fig. 113). Colours as follows. Large dots: blue; small dots: white; small crosses: green; background colour: red.*

III *More traditional patterns from Faeroese women's jerseys (see also Fig. 114).* **a** *red on blue (large dots: red, no dots: blue);* **b** *navy (large dots) and white (small dots) on red;* **c** *red on blue;* **d** *navy (large dots) and red (no dots) with white touches (small dots);* **e** *and* **f** *women's cuffs in navy (large dots) and red (no dots) with white (small dots);* **g** *and* **h** *borders from men's cuff's;* **i** *Faeroese dancers, also knitted in Norway, but here they epitomise the old Faeroese ring dance — hour-long and accompanied by saga-like songs.*

112 *Traditional patterns from Faeroese fishermen's underjerseys.* (Batsmannsundirtroyggjumynstur *in Faeroese). Decorated stripes (which therefore are largely double and so warmer) in pale blue (large dot) on white.*

a *from Dalsgardi;* **b** *from Nolsoy (see also Fig. 117);* **c** *from Gjogv;* **d** *from Mula;* **e** *from Skala (see also Fig. 115);* **f** *from Blastastovu in North Ragøtu;* **g** *from Gardshorni (see also Fig. 116);* **h** *man's cuff pattern.*

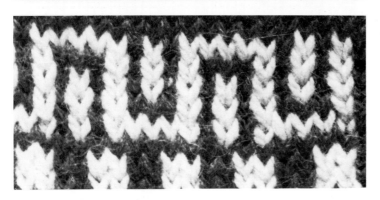

113 *Faeroese woman's formal jersey in three colours: blue and white on red. Corrugated rib for cuff after double twisted cable cast-on. Knitted in double knitting wool on size 3½ mm (U.K. 9; U.S. 5) needles; tension of sample 27 stitches and 27 rows to 10 cm (4 in.).*

114 *Two Faeroese border patterns originally used for the fringed cuffs or wristlets worn by men.*

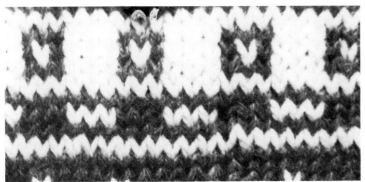

115 TOP: *Faeroese underjersey pattern, repeated in rows (see also Fig. 112);* BELOW: *All-over pattern from seaman's jersey.*

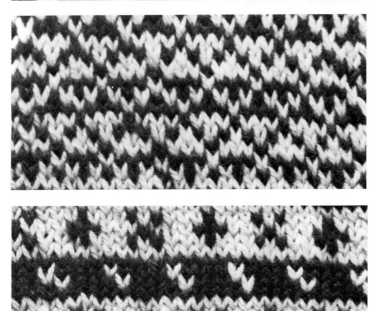

116 *Faeroese underjersey pattern (see also Fig. 112), originally in pale blue on white; here in lovat and natural double knitting.*

117 *Faeroese underjersey pattern (see also Fig. 112), closely related to a patterned stripe used on the west coast of Norway but more elaborate.*

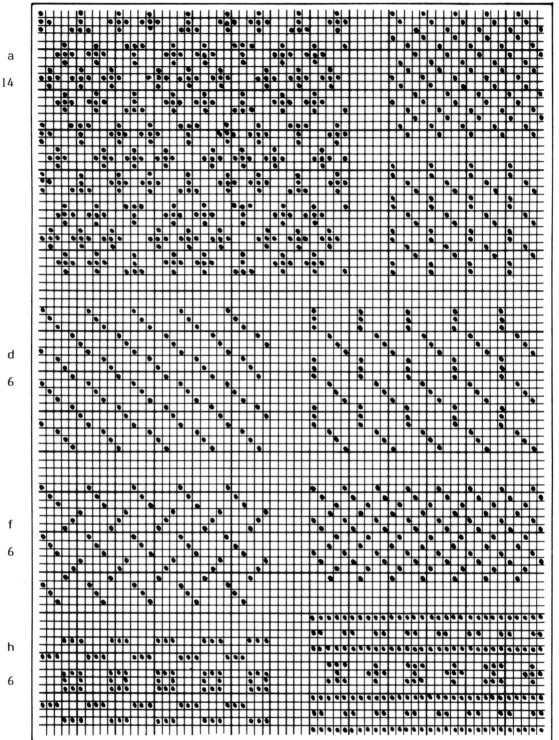

118 *Men's jersey patterns from Faeroe.
The 'check and bar' patterns appear in
different versions both in Faeroe itself and
on 'export' jerseys as far afield as Halland
in Sweden (where they were known as
'Jutland jerseys' though the commoner name*
was 'Icelandic jerseys');
a *southern star pattern;* b *small check;*
c *small check and bar;* d *large check;*
e *large check and bar;* f *large check to and
fro;* g *small check to and fro;* h *and*
i *border patterns (for men's cuffs).*

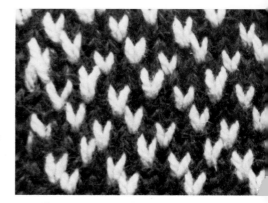

stovu patterns, which I believe indicate a locality or farm, have the look of small weaving charts re-used as all-over patterns (if woven they would be repeated symmetrically, not continuously, as when knitted).

One pattern is certainly older than the twentieth century – the bar and little check (*Figs 118 to 122*). There is no doubt that this is a Faeroese pattern – one very old jersey, knitted in a striking (and apparently traditional) lichen purple (*cudbear*) and white, uses this pattern. In Halland, in south-west Sweden, it was knitted in red and blue, alternating in bands on white in thick yarn. There these jerseys were called Jutland jerseys, while in other parts of Scandinavia they were known, a little more accurately, as Iceland jerseys. However, they probably came from Faeroe (though one must remember Iceland's earlier importance as an exporter of jerseys – how frustrating it is to know nothing much more about them). The Bergen Museum has a jersey with this same pattern, this time knitted in red on blue. It seems to have been a popular one with those knitting for sale. Today in Faeroe it is usually knitted in the natural colours of the sheep. This has a great deal of charm but I personally find the blue and red on white a refreshing change.

119 *Faeroese seeding pattern – 'small check to and fro' (see also Fig. 118g).*

120 *Faeroese pattern of 'small check and bar' (see also Fig. 118c), knitted in Antartex Original Thicknit,, on 6½ mm (U.K. size 3; U.S. size 10½) needles, with tension of 14 stitches and 13 rows to 10 cm (4 in.).*

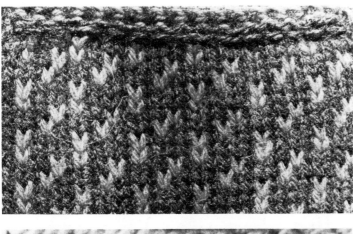

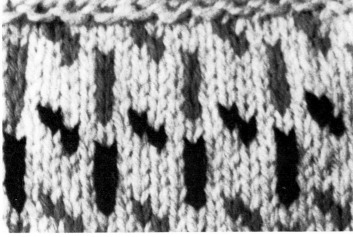

121 *Another version of 'small check and bar' (known from Faeroe), here in red on blue from Norway. In double knitting on size 3 mm (U.K. 10; U.S. 4) needles. Tension of sample 28 stitches and 29 rows to 10 cm (4 in.). Cast-off in alternating red and blue preceded by two rows of chain stitch in two colours making a 'hole' pattern (see page 23).*

122 *The 'check and bar' pattern (see also Fig. 118) copied here from a Swedish version in red and blue on white known there as a 'Jutland' jersey pattern. May originally be from Iceland which was a major exporter of sweaters in the nineteenth century. Knitted in white Antartex Original Thicknit and double thickness double knitting in red and blue. One row chain stitch before cast-off done purlwise. Needles size 5½ mm (U.K. 5; U.S. 9); tension of sample 16½ stitches and 18½ rows to 10 cm (4 in.).*

ICELANDIC KNITTING

Of Icelandic knitting we know rather less; certainly many traditions and patterns were shared with Faeroe. It is, incidentally, likely that knitting was brought to Iceland by the Dutch. The Icelandic word *pryon* (to knit) is unlike every other word I know for 'to knit' (and there are a great many) except the Dutch *breien*. There was a connection with Scotland also, the traditional black brimless

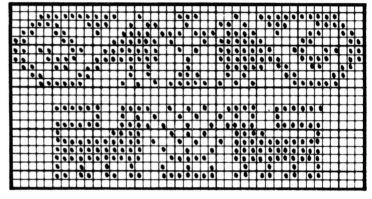

knitted cap of the women being called a *skothuffa* – a Scotch bonnet! Women also wore knitted jackets called *peysa* and men wore sleeveless knitted waistcoats called *brjostadukar*, literally 'breast cloths'. Around 1840 large, loosely knitted cardigans were

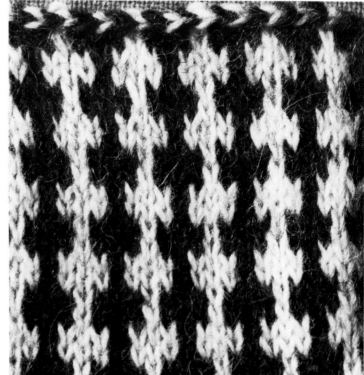

123 *Icelandic textile patterns, taken from netting made around 1700; birds have fantastical tails, possibly originally leaves; copied from cross stitch. Origins of many knitted patterns can be firmly linked to other decorative textile work such as this (see also Figs 135 and 136).*

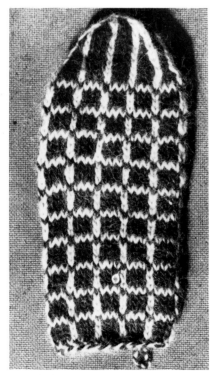

124 *Icelandic pattern from 1840 jersey used with Icelandic Lopi Light for traditionally shaped mitten. Twisted cast-on; loop for hanging (the other mitten has the button); simple set-in thumb. (See Fig. 144b).*

125 *Icelandic pattern from nineteenth century, copied from an old cardigan in the National Museum of Denmark, Copenhagen. Traditional (clumsy) double cable cast-on. Knitted (quite loosely) on size $4\frac{1}{2}$ mm (U.K. 7; U.S. 7) needles with Lopi Light giving a tension of 20 stitches and 20 rows to 10 cm (4 in.). (See Fig. 144a).*

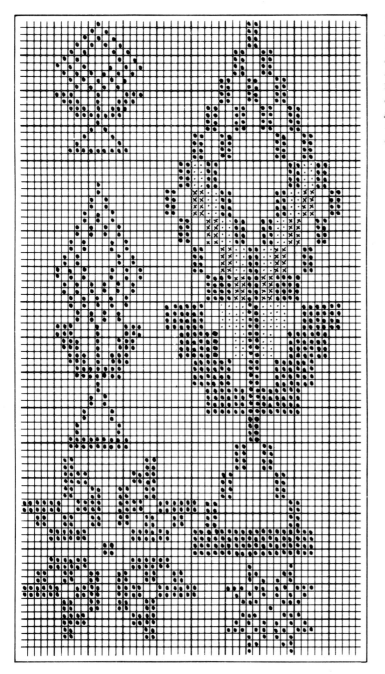

126 *Charting for garter stitch. The three flower-pot versions show the original small pattern, the smallest possible adaptation for garter-stitch knitting* BELOW, *and the pattern as knitted in the sample* RIGHT. *Colours: natural dark brown (large dots); red (no dots); blue (small crosses); green (small dots).* BELOW LEFT: *a simple star suitable for garter stitch, expanded from the small star* BELOW RIGHT.

knitted in coarse, hairy wool in two natural shades. The tension was only 14 stitches to 10 cm (4 in.) which gives them a surprisingly modern air. At the other extreme are the fine woollen insoles worn by women inside their thin skin shoes. A great deal of highly skilled knitting went into these humble objects which must have been seen by no one except the wearer and which were very quickly spoiled in wear.

INSOLES IN GARTER STITCH *(Figs 126 to 128)*

These insoles are worked in flat pieces, on two needles, knitting backwards and forwards, always in plain stitch. This gives garter stitch. The much tighter tension of garter stitch makes these a little warmer in wear. It also means that, to adapt a pattern for garter stitch knitting, you will need two rows in place of one. Wool may be stranded across the back, or a new ball may be used for every different colour, or it may be woven in *(see page 19)*. Every time a new ball of wool is brought into play, it should be wound round the yarn used previously to avoid a gap. All the patterns are two-line repeats which makes working back much easier. Always work the first row of any pattern change with the right side facing and in the return row simply copy the colours.

The flower shown in Figs 127 and 128 was worked in four colours: red, green, blue and natural dark brown on a white ground. It would make a nice motif for a loose jacket all in plain white garter stitch. The wools used were white Lopi Light; Welsh Black Mountain Jersey weight; red, blue and green remnants. Knitted on size $4\frac{1}{2}$ mm (U.K. 7; US 7) needles, tension is 20 stitches and 37 rows to 10 cm (4 in.) and the overall length of the flower is 21.5 cm ($8\frac{1}{2}$ in.).

Adapting a pattern for garter stitch

Small-scale patterns are best and, to give a sharp effect, knit two stitches through four rows *(see Fig. 126 for one example)*.

127 *Icelandic insole – right side.*
128 *Icelandic insole – reverse side, showing yarns worked in.*

Iceland, almost accidentally, has become a knitting success story in recent years. First the circular yoke was applied in Iceland to the traditional (or, by 1950, not so traditional) local jerseys, using Norwegian and other patterns. This was a tremendously popular innovation in the 'fifties and 'sixties. Then, an enterprising Icelander discovered she could knit with *lopi* which had not been thought of before then as suitable for knitting. It represents only one stage in the spinning process; the wool has been carded and teased out for spinning but not yet spun. *Lopi* has proved such a success that 'Icelandic' jerseys, most of which have only the remotest connection with Iceland, are as common now as Fair Isle jerseys were once. The idea of circular and seamless knitting has come back into favour and *lopi* is now as likely to have come from the back of a British or Falkland Island sheep as from an Icelandic one.

The 'genuine' article can still be found by discriminating visitors to these northerly islands, but the style and inspiration of their patterns is available to everyone who can read the charts in this book and has time to sit for five minutes with a pencil and paper before they begin to cast on. Figs 129 to 149 show the wide variety of possibilities from Faeroe and Iceland.

129 Faeroese jersey pattern, 'Hills and Valleys', knitted in two shades of Lopi Light on size $4\frac{1}{2}$ mm (U.K. 7; U.S. 7) needles. Tension of sample 20 stitches and 24 rows to 10 cm (4 in.). (See also Fig. 137a.)

130 Faeroese all-over jersey pattern, 'Wheels'. (See also Fig. 141a.)

131 'Kittens', an all-over pattern from a Faeroese fisherman's jersey. (See also Fig. 145e.)

132 Faeroese all-over man's jersey pattern, 'Diagonals' in Antartex Original Thicknit, in dark brown and dark grey, on size 7 mm needles (U.K. 2; U.S. $10\frac{1}{2}$). Very close to present-day Faeroese style. (See also Fig. 146e.)

133 All-over pattern worn by old fisherman in photograph in Faeroe c. 1900. Dark wool: 3-ply Swaledale; light wool: rare Z-spun Jacob. Knitted on size $4\frac{1}{2}$ mm (U.K. 7; U.S. 7) needles. Tension of sample 20 stitches and 20 rows to 10 cm (4 in.). (See also Fig. 147c.)

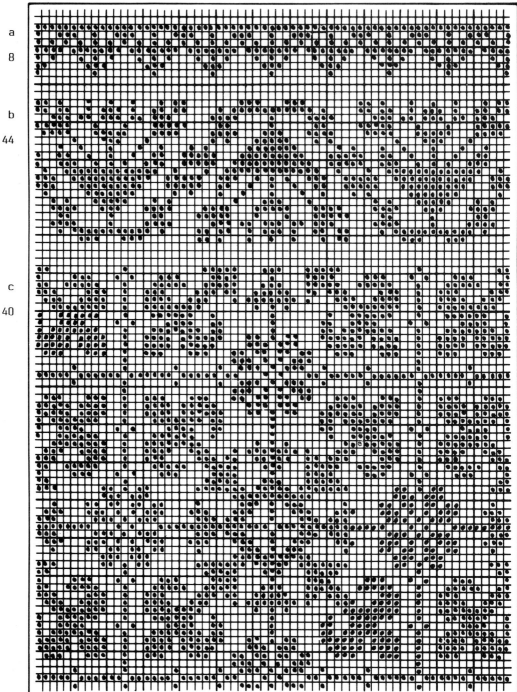

134 *Eighteenth-century Icelandic knitting patterns* **a** *and* **b** *two border patterns described as for knitting, from a pattern book dated 1776 in the collection of the National Museum of Iceland;* **c** *an all-over pattern, from the same source, for a man's knitted waistcoat. This is more likely to have been knitted in a textured purl-and-plain pattern as in contemporary jackets in other parts of Scandinavia.*

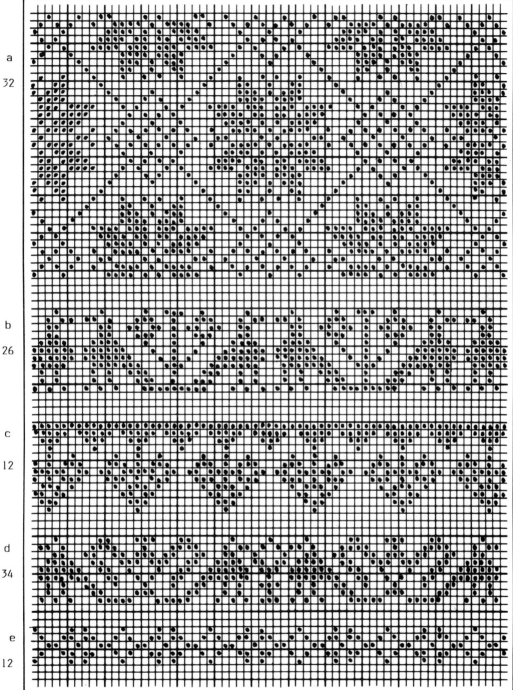

a
32

b
26

c
12

d
34

e
12

135 *Eighteenth-century Icelandic knitting patterns* **a** *a pattern for a man's knitted waistcoat from a pattern book dated 1776 in the National Museum of Iceland, which was probably intended to be knitted in purl-and-plain as in the contemporary silk and wool* *jackets in Denmark, Norway and elsewhere;* **b** *to* **c** *four borders from the same source. These may have been intended for the patterned cuffs or wristlets known to have been knitted in Norway, Faeroe and Shetland and probably in Iceland also.*

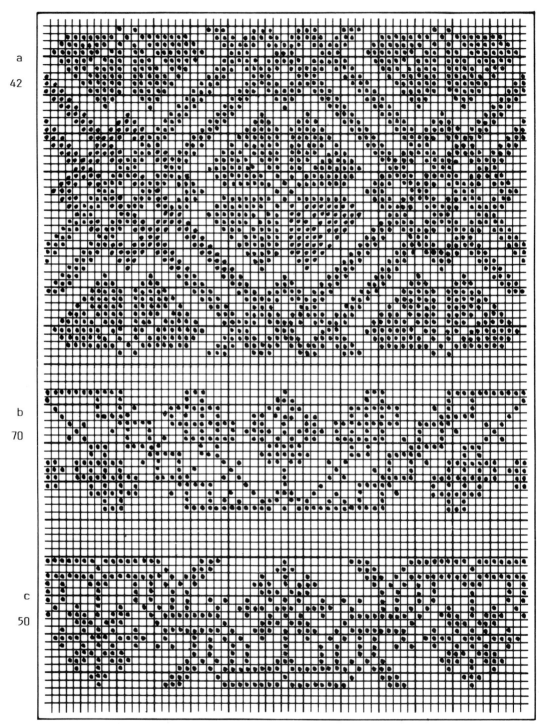

a
42

b
70

c
50

136 *Eighteenth-century Icelandic knitting patterns.* TOP: *an Icelandic pattern intended for a man's knitted waistcoat (probably self-coloured in purl-and-plain rather than* stranded). *From a pattern book of 1776 in the National Museum of Iceland.* BELOW: *two border patterns from the same source.*

137 *All-over jersey patterns from Faeroe and Iceland* **a** *hills and valleys (Faeroe) (see also Fig. 129);* **b** *Iceland check;* **c** *sea wall (Faeroe);* **d** *chess board (Faeroe);* **e** *leaves (Faeroe);* **f** *squares (Faeroe);* **g** *border for man's cuff (Faeroe);* **h** *border from all-over jersey (1975); one band light on dark; one band dark on light, using the small pattern shown to change background colour (Faeroe).*

138 a Rossagronnin *(Faeroe)*; b *little
stars*; c *open stars*; d *sheep tracks
(Faeroe)*; e *half stars*; f *large stars*;
g *goose back (Faeroe)*; h *Annike's pattern
(Faeroe)*. *All used today as all-over
patterns on very thick, warm, working
jerseys in natural colours. The 'little stars' is
also knitted in Halland where it is known as*
'French lilies', *and done on white in
alternate rows of blue patterns and red
patterns, or on a red ground with alternate
rows of white patterns and blue patterns. It
may have been introduced there in this form
as an Iceland 'export' jersey in the
nineteenth century.*

139 *Faeroese men's jersey patterns*
a *hourglasses;* **b** *half moons;* **c** *baskets;*
d *shelter (a man in a hut);* **e** *pot-hooks (to hang over an open fire);* **f** *staircase.*

140 *Faeroese patterns described as*
'seeding' – a small pattern used to fill in
areas between larger patterns, or for palms
of mittens, etc. **a** *Hs;* **b** *diagonal seeding;*
c *Todnes pattern;* **d** *lice pattern;* **e** *cribs;*
f *grandmother's seeding;* **g** *hen's seeding;*
h *flea pattern.*

141–149 *Faeroese seamen's jersey patterns, traditional and modern.* **141a** *wheel pattern (see also Fig. 130);* **b** *Sunnuvustovu pattern;* **c** *forks;* **d** *shears;* **e** *Sjurdarstovu pattern;* **f** *hammers;* **g** *Arnastovu pattern;* **h** *Eydunsstovu pattern. The* stovu *patterns come from small localities or farms. Most have the look of being copied from simple weaving charts.*

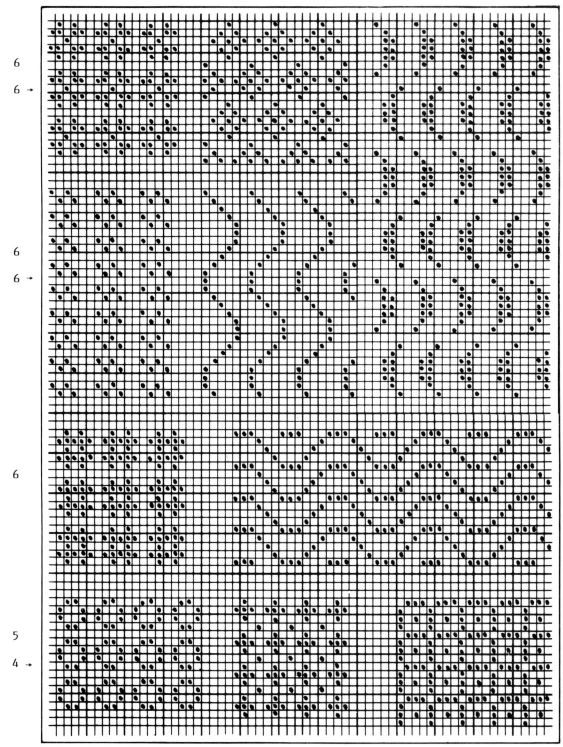

142 TOP ROW: *Flowers, wreaths, half moons (see also Fig. 139);* SECOND ROW: *double check, bends;* THIRD ROW: *prickles, waves;* BOTTOM ROW: *circles: Nornastovu pattern, Maggustovu pattern.*

143 a *Katrina's pattern;* b *stork's bills;* *Billu's pattern, seen in Lerwick, 1975;*
c *Marjuna's pattern;* d *deer;* e *Billu's* h *goose foot prints.*
pattern; f *chopping blocks;* g *version of*

144 **a** and **b** *patterns from Iceland*
c. *1840 (see page 104);* **c** *shields (Faeroe);*
d *panes of glass (Faeroe);* **e** *fence posts*
(Faeroe); **f** *windows (Faeroe);* **g** *day and*
night (Faeroe); **h** *helmsman's pattern*
(Faeroe); **i** *border from man's cuff (Faeroe).*

145 a *Jogvanstovu pattern;* b *Sunastovu pattern;* c *Gomlustovu pattern;* d *Arantsstovu pattern;* e *kittens (see also* Fig. *131);* f *dogs walking;* g *border pattern from man's cuff.*

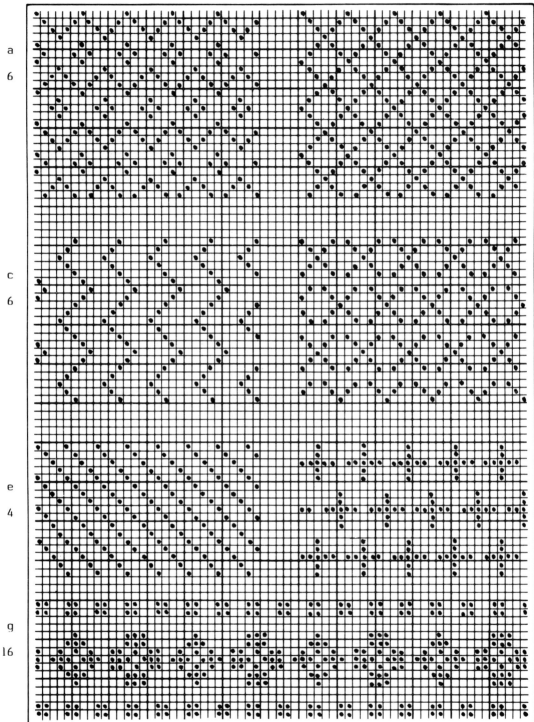

a b

6 6

c d

6 6

e f

4 6

g

16

146 **a** *Kollafjord zig-zags;* **b** *diagonal net* **d** *shanks;* **e** *diagonals (see also Fig. 132);*
(which can also be seen as large stars on a **f** *crosses;* **g** *border pattern from men's cuffs.*
dark ground); **c** *tracks in the snow;*

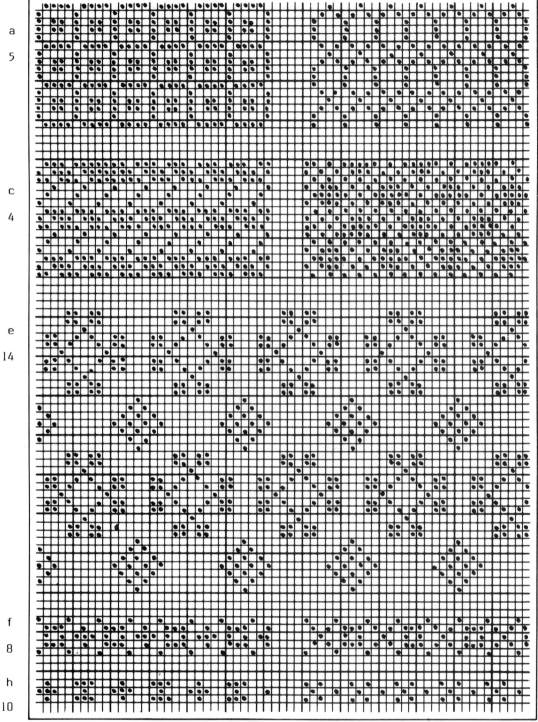

a *Barbostovu pattern;* b *Billustovu*
pattern; c *from photograph of old Faeroese*
fisherman c. *1900 (see also Fig. 133);*
d *large stars in net;* e *modern jersey pattern*
from c. *1950 photograph of schoolboys;*
large patterns knitted in dark and small in
light on medium ground. f *to* i *patterns*
from men's cuffs.

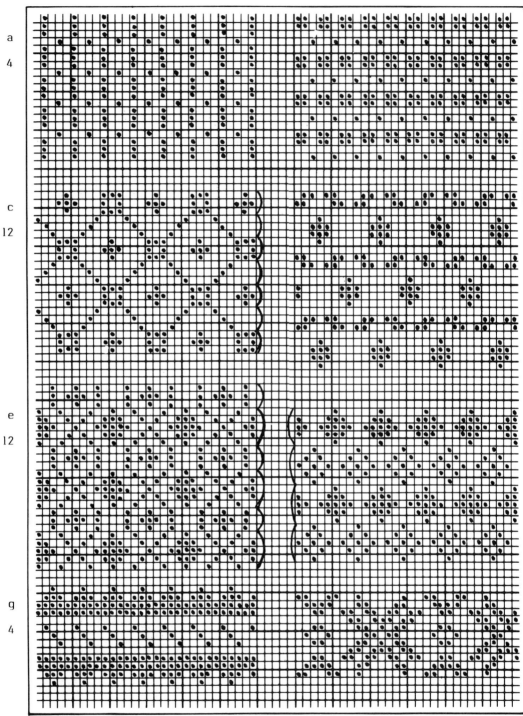

148 c and e *are in colour variations as*
marked – alternate bands of dark and light
patterns on a medium ground; d *and* h *are*
typical of the non-traditional patterns used
today on 'Faeroese' jerseys knitted for
export, using local naturally coloured wool.

Many are of Shetland origin. For a large
collection of suitable border patterns see S.
McGregor, The Complete Book of
Traditional Fair Isle Knitting, *Batsford,*
1981.

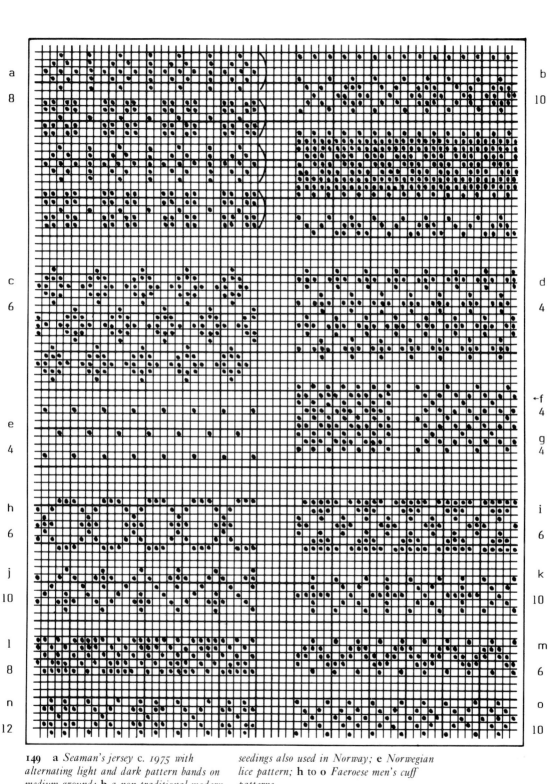

a		b
8		10
c		d
6		4
e		←f
		4
4		g
		4
h		i
6		6
j		k
10		10
l		m
8		6
n		o
12		10

149 **a** *Seaman's jersey c. 1975 with alternating light and dark pattern bands on medium ground;* **b** *a non-traditional modern pattern;* **c** *large open stars;* **d** to **g** *various* *seedings also used in Norway;* **e** *Norwegian lice pattern;* **h** to **o** *Faeroese men's cuff patterns.*

8 Jerseys

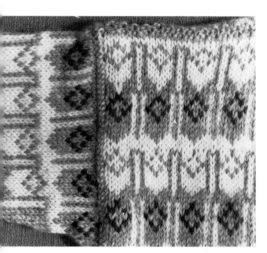

Jerseys in Scandinavia have always been knitted in the round and cut afterwards where needed to give openings. Traditional workers seldom looked for short cuts but appreciated skill and elegance in a design. Their jerseys show this to a high degree. The number of stitches to cast on is, therefore, the total number for back and front. If facing stitches are needed for a front opening, these (usually six or eight) are knitted in as an extra piece with no part in the pattern.

As I have said in Chapter 3, first measure your target, particularly if he or she is still growing. Children can add six inches to their length in six months while their chest measurement does not change at all. One of the beauties of home-crafted jerseys is that they can be knitted to fit any size. If in doubt, err on the large size especially for children. A jersey for an adult can be copied, as far as size goes, from an existing favourite. Generally, you need overall body length, underarm length and chest measurement, the chest measurement of the jersey generally being at least 5 cm (2 in.) more than the actual chest measurement.

Sleeves now in Scandinavia are usually knitted up from the cuff.

150 *Norwegian jersey construction; sleeve and shoulder join. Note how stitching regularly into the row on the body gives a decorative edge just above the purl row on the sleeve. The shoulder join is stitched in zig-zag fashion between two purl rows. There is a small underarm gusset to allow the inside facing to lie flat. It is increased on either side of the underarm stitch once in each of the last six rows to give 12 stitches. The purl row for the sleeve edge is then knitted and the facing knitted in a flat piece with an opening underarm to allow for easy fitting. The front facing is knitted up from stitches left at the ends of the ribbing plus four cast on, on the inside, which cover the cut edge.*

151 *Norwegian jersey construction; the inside of the sleeve shown in the previous illustration.* LEFT: *the cast-off edges from the top of the body with shoulder facings and seam.* CENTRE: *the cut edge of the armhole is covered by the facing knitted on to the top of the sleeve; a further refinement is to reverse the knitting to give a smooth (plain) surface on the inside here.*

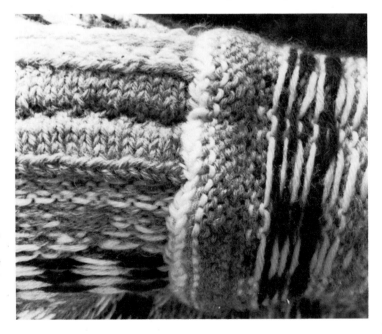

This seems to have come in with printed patterns, knitting cooperatives, tourism, and so on. It is not traditional, on the whole. There are advantages in knitting down from the armhole opening, notably that the lower part of the sleeve can be replaced if worn, or lengthened easily.

GENERAL NOTES

WELT

Choose your style, check your tension with a large enough sample, make your calculations and notes and cast-on! Welts are usually ribbed, today, and usually narrower than the body for a better fit; a two-and-two rib is found in Faeroe and much larger ones in Norway – five-and-one; or even eight-and-eight. Use needles half a size smaller than those used for the sample (for the main pattern). Begin the pattern by knitting one plain row, on the larger needles and increasing as necessary. Then set the pattern, a very important row. Check it very carefully. Any mistake here will ruin the rest and is best corrected at once.

BODY

Whether for a jersey or front-opening cardigan, the body is knitted on circular needles in one piece right up to shoulder level. Special arrangements are made for armholes and front openings. The armhole may simply be cut from the jersey body with no special shaping, or stitches may be left underarm for a more fitted line. For a fully dropped shoulder an extra six or eight stitches are cast on at each side at armhole level and knitted up as a separate facing, taking no necessary part in the pattern, though the yarns are knitted across them. This leaves a continuous pattern right up the edge of the armhole opening; often a single dark stitch emphasises this edge or the 'seam' decoration divides and is carried up front and back at the armhole edge. The extra stitches are then secured by two rows of machine stitching round the potential opening, cut down the centre and folded inside as a facing.

152 *Jersey construction* **A** *the finished jersey showing approximate proportions: neck opening one third of width, sleeve opening one third of depth;*

A

B

B *the body knitted in the simplest way up to shoulder level (with no extra armhole stitches) ready to prepare the armholes;*

C **D**

C *armhole prepared by stitching and cutting, shoulder joined;*
D *sleeve ready to be sewn in Norwegian fashion;*

125

E

E body knitted for fitted shoulders; stitches left underarm on holders (lengths of yarn); F armhole opening prepared ready for picking up stitches; neck opening also; shaded area to cut away;

F

SHOULDER JOIN

At shoulder level the stitches are divided roughly into thirds front and back and those at each side joined to form the shoulder seam. There are numerous ways of doing this.

1 Grafting
This gives an invisible join. (*For method, see page 35.*)

2 Norwegian method A
When shoulder seam level is reached a row of purl stitches is worked in the background colour and then a final four rounds or so in the same colour before casting off loosely. The shoulder seam is then joined by a zig-zag running stitch in matching yarn through the loops of the purl stitches.

3 Norwegian method B
Arrange stitches at each side alternating front and back on one needle. Lift the second stitch on the needle over the first and knit the one left. Repeat to give two stitches on the right-hand needle. Cast off the one previously knitted. Repeat. This gives such a decorative ridge that it is often worked on the outside of the jersey.

4 Herringbone join
Using a bodkin, begin on the left and take the needle through the stitch off the back needle and then through the stitch off the front needle and so on.

5 Swedish method
Hold the needles together with the purl side of the work outside (this gives a more invisible join; if you wish to make a feature of the join, work with the right side out). With the help of a third needle, knit through front and back stitches and, whenever there are two stitches on the third needle, lift the first over the second to cast it off.

NECK OPENING

This is usually the middle third front and back. The back is seldom shaped. The front may be shaped by stitching and cutting or by leaving a few centre stitches on a length of yarn and casting off regularly on both sides. It may be left unshaped (the old-fashioned type of neckline), in which case it can be finished off inside with a knitted facing (bias knit for better fit). To knit a bias facing, cast on eight stitches. *Row 1:* increase 1 in the first stitch, knit to the last two stitches, knit 2 together; *row 2:* purl. Repeat.

In double knitting around 100 stitches are picked up from the neck opening. The facing may be long and folded to the outside for a polo neck or shorter and folded to the inside and hemmed into place. It is usually done in one-and-one or two-and-two rib, but the fold may be marked by a row of purl (knitted through the back of the loops) and the inside knitted in stocking stitch on a smaller needle. I added a red facing to the navy and white jersey in Fig. 157

SLEEVES
Traditional method
Old jerseys often have sleeves knitted down from the shoulder. This is still the method used in Shetland and for gansie knitting in Britain, and is certainly older than knitting up from the cuff,

though this may have been done for separate sleeves. Stitches are knitted up all round the armhole opening from the row just at the edge of the pattern, and any left for shaping underarm are added in. The sleeve is knitted down with regular reductions underarm and finished off in modern style with a ribbed cuff. In the old days, a separate cuff pattern was knitted in and the edge was sometimes fringed in imitation of the earlier fashion of wearing knitted wristlets or cuffs with jerseys. These have been recorded in identical styles from Faeroe to Estonia and were also worn in Scotland. Norwegian jerseys were often bound with braid and some cuff patterns reflect this fact.

Modern method

To knit up from the cuff is the modern method; at the level of the armhole a row of purl stitches may be knitted and a further four or five plain rows, or the work may be turned inside out and four or five rows knitted; this allows the right side of the work to be seen as the facing on the inside. In rows 2 and 4 increase two stitches in the middle underarm so that the edge will fit, or knit a flat piece open underarm. Cast off loosely. Sew in the arms, using the extra piece knitted to cover the cut edge of the armhole, and matching underarm seam with side seam and centre top with shoulder join. If a purl row has been knitted, use the loops to join to the armhole edge. Alternatively, take a length of matching yarn and, holding the needle parallel to the top of the sleeve, pick up one stitch in the fifth row from the top of the sleeve and then the stitch at the edge of the shoulder pattern in the body, and repeat right round. Then, on inside, hem round facing for a neat edge.

FRONT OPENINGS

In a double knitting pattern about 220 stitches are cast on in place of 200 for a jersey: 10 per cent more. The ribbed edge is knitted backwards and forwards in a flat piece. Then 11 stitches on each side at beginning and end of this strip are put aside on stitch holders, and the remaining stitches are knitted round in pattern, with the addition of six to eight plain stitches centre front for the opening. Start the repeat of a new pattern on the far side of this plain section, i.e. at the right side of the front, and plan the design so that the right side and left side match. Shape neckline and finish shoulders as before.

To prepare the front opening, sew two double seams down either side of the centre line on the spare stitches and carry on round the neckline if you wish to shape this in any way. Cut away the spare knitting at the neck. Go back to the stitches left on either side at the top of the ribbing and cast on an extra four stitches on either side, on the inside, to make a facing for the cut edges. Knit up, working the front edge in a one-and-one rib and the facing stitches in stocking stitch. Knit until the strip is approximately 2.5 cm (1 in.) shorter than the length of the body to the neck opening. Cast off the four facing stitches and put the other stitches on a needle holder. Knit the button band first and then knit the buttonholes in the other side to match.

Neck edge facing

Pick up stitches around the edge and join on the stitches from the

G *stitches picked up round armhole opening and neck opening; note position of stitching around armhole;*

H *method for front opening: flat-knitted rib; stitches left at either side for later knitting of front bands; front opening, neck shaping and armholes stitched and cut open, and surplus material cut away ready for band to be knitted up and sewn on, and collar and sleeves to be picked up and knitted.*

153 *Fana jersey photographed in Bergen (see also Fig. 154). Easily adaptable to any double knitting or thicker yarn.*

154 *Fana jersey; patterns shown for lower edge (checks); stripes and stars for yoke and top of sleeves. Shoulders join in centre of a dark stripe and the neckline may be shaped, as shown, with a complete star pattern just below, or knitted straight up and faced with a bias strip (see page 126).*

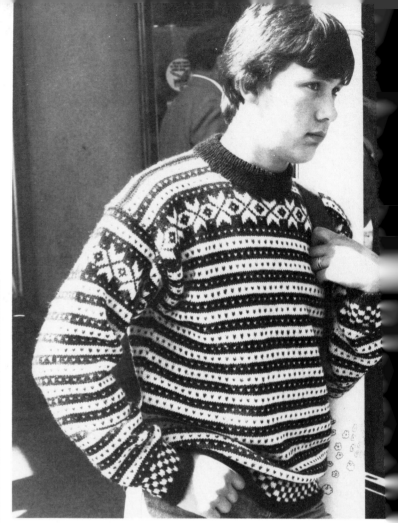

front bands on either side. Knit in one-and-one rib for 5 cm (2 in.). Cast off loosely and sew the facings inside with a slip stitch to cover the cut edges.

Single-thickness band

For a neater, single-thickness band cast on only five stitches for the band at each side and add on the four to knit up in stocking stitch for the facing on the inside.

TRADITIONAL SEAMLESS JERSEYS

BOY'S JERSEY *(Figs 153 and 154)*

This uses a small Faeroese pattern with a repeat of six in both directions. Three colours are used but only two in any one row. It was knitted to fit a rather thin lad of seven and the actual measurements are chest 68 cm (28 in.); length from shoulder to bottom edge 48 cm (19 in.); underarm seam 40 cm (16 in.), plus fold-up cuffs of 4 cm (1½ in.). It is knitted to a tension of 23 stitches and 24 rows to 10 cm (4 in.) on size 4 mm (U.K. 8; U.S. 5) needles in a synthetic double knitting.

Body

Cast on 152 stitches on size 3½ mm (U.K. 9; U.S. 5) needles and

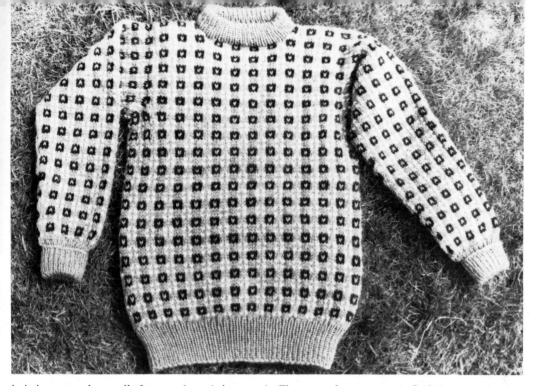

knit in one-and-one rib for 5 to 6 cm (2 in. or so). Change to larger size needles and increase in one plain row to a total of 168 stitches, spacing out the increases. This allows for 14 complete pattern repeats front and back. The pattern should be centred front and back, not a difficult thing to do with such a small repeat. Mark the point where the new round starts by knitting in a short length of contrasting yarn. This also marks the side 'seam' or underarm point. Continue to knit up in pattern for around 28 cm (11 in.) from the top of the rib.

If, as here, a fitted shoulder is required, put 12 to 15 stitches at each underarm point on a needle holder (or a length of yarn tied in a loop). Continue knitting in circular fashion with the remaining stitches without further shaping for another 11 cm (4½ in.). This gives a rather narrow sleeve. If a wider sleeve is needed, then the underarm reduction should be done earlier.

Leave 25 stitches centre front on a length of yarn to be picked up later for the neck facing and knit the last 3 cm (1½ in.) of knitting backwards and forwards, with a further reduction on either side of the centre front to the shape the neck opening.

Prepare armhole opening by stitching and cutting, and join shoulder seams.

Sleeves

Pick up 70 stitches around the cut edge and join in the 12 or 15 left underarm to make up the stitches for the top of the sleeve. Knit down to the cuff reducing regularly over the length of 40 cm (16 in.) to give 52 stitches just above the cuff. Change to the smaller size of needle and knit a cuff of 8 to 10 cm (3 to 4 in.).

Neck edge

Use the stitches left on holders at centre front and centre back, and knit up more on either side from the shaped edges. Knit up on the smaller needles for 5 cm (2 in.), or as required, and cast off loosely in rib. Fold to the inside and hem loosely.

155 *Boy's jersey.*

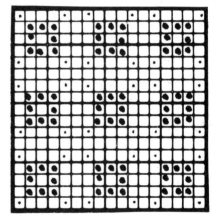

156 *Boy's jersey.*

Tidy up the armhole edge by oversewing and darning in all the ends.

Note: the yarns not in use at any one time do not need to be broken off but, with the small vertical repeat, may be led up the inside of the work. This avoids any danger of holes and saves darning in.

ADULT JERSEY (small size)
This uses a pattern of a type popular all over Scandinavia, though the actual version here I have seen only in Finland and Estonia. It is a very good pattern, however, with its balanced light and dark colours, and knits up into a splendid jersey.

The actual measurements are: chest 96 cm (38 in.); overall length from shoulder seam to bottom edge 66 cm (25 in.); underarm seam 57 cm (23 in.), with a single cuff which could be knitted double if required. It is knitted with wool double knitting yarn on size 5 mm (U.K. 6; U.S. 8) needles for the stocking stitch and $4\frac{1}{2}$ mm (U.K. 7; U.S. 7) for the rib, to a tension of $22\frac{1}{2}$ stitches and 26 rows to 10 cm (4 in.). It was knitted for a rather tall, thin, young person with long arms; the sleeves are only 20 cm ($7\frac{1}{2}$ in.) across at the top. A more normal width for an outdoor jersey such as this would be 22 to 23 cm ($8\frac{1}{2}$ or 9 in.). If you know the overall length aimed at, deduct the sleeve width from this and you will get the point where the underarm reductions or other shaping for the armhole should be made. Alternatively, make the armhole opening one-third of the overall length (for an adult).

Method
Cast on 208 stitches and knit approximately 6 cm ($4\frac{1}{2}$ in.), or more if preferred, in a striped rib. In Faeroese and Swedish tradition, the ribbing has symmetrical stripes in both colours. To introduce these without a mottled effect *knit* the first row in each new colour. Change to the larger size of needles and knit one plain round while

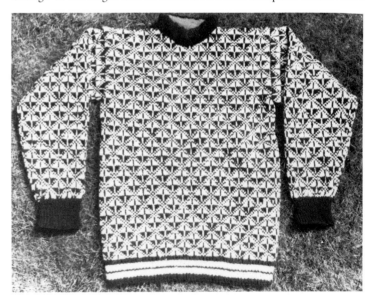

157 *Faeroese-type jersey, in navy and white double knitting with a red neck facing. The sleeves are on the narrow side for most people but the one-piece method (see page 125) can be used for any dimensions and type of pattern.*

increasing regularly to give 228 stitches. This allows for 19 complete repeats of the pattern which is easy to centre front and back. Then knit straight up to the beginning of the armhole. The shoulder is slightly fitted and so put 10 or 12 stitches on a needle holder at either side at this point and continue knitting up in circular fashion without them. Lower the neckline slightly at the front.

Prepare the armhole by stitching, and cut it open. Join the shoulder seam and pick up 90 or 95 stitches, plus those on the holder underarm. Try to match the patterns across the body and top of sleeve, and knit down to the cuff, reducing regularly. Remember to reverse the pattern. It is not symmetrical up and down, and on the sleeves has to be knitted white half first.

Pick up the collar in the same way as for the smaller jersey and knit up in one-and-one rib for 4 cm (1½ in.). Mark the fold by a row of purl stitches knitted through the back of the loops, and finish off inside with a facing of bright red stocking stitch knitted on a size smaller needles.

These two simple jersey patterns are intended both as models, and to give a general idea of the simple processes behind designing and knitting a jersey using any of the patterns in this book. Larger patterns are more difficult to centre and plan but perhaps more interesting to knit. Lots of tricks of the trade exist, such as filling in shoulder spaces and cuffs with their own small patterns. This looks very pretty and well-thought out, but it hides the fact that there does not need to be a complete repeat of the larger pattern at the shoulder, and means that the cuffs can be knitted longer or shorter once it has been tried on. The various types of seeding (very small all-over patterns), given here and there in this book, are ideal for filling in awkward corners and adding a certain Scandinavian panache at the same time. There must be patterns in this book for a million jerseys or more, all different, all worth knitting.

YOKED JERSEYS

ORIGINS
Various fairly wild ideas have been put forward to explain the origin of the yoked jerseys which appeared in the 1950s. They have taken several guises, from today's Icelandic sweaters in *lopi*, to the much finer Fair Isle yokes, still in vogue but dating back to the early days. The beaded collars worn by Greenland Eskimos have been suggested as inspiration, as have seamless raglan jerseys, knitted up and joined into one piece above the armhole. But the first true knitted yoke almost certainly was designed by the gifted designer, Anna-Lisa Mannheimer Lunns (born 1904), who worked for Bohus Stickning. (For more information about this talented group, *see page 74*.) Her yokes not only incorporate every available shade of an enormous range, they also use occasional purl stitches with the deliberate intention of mixing the shades a little further. Bohus patterns, though apparently complex, were knitted by local farmers' wives, and are much simpler than they appear; small

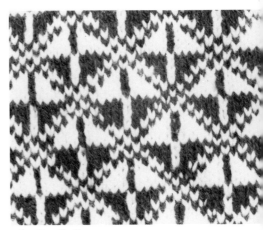

158 *Detail of pattern.*

159 *Adult jersey.*

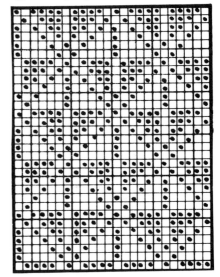

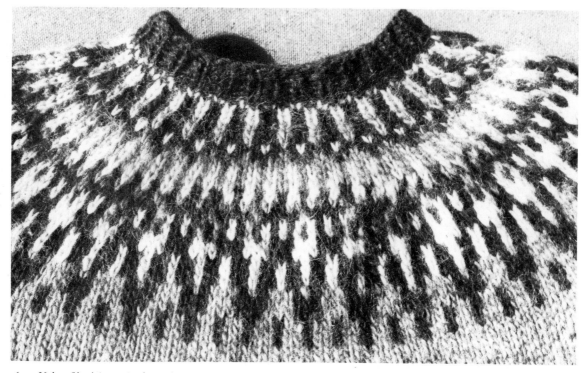

160 *Yoke of* lopi *jersey in the modern idiom (see also Fig. 161), in three shades of wool with only two in any one row and frequent changes of colour. The module reduces from six to four to two.*
161 *Yoke of* lopi *jersey. The black squares indicate 'no stitch', with a reduction worked in the previous row.*

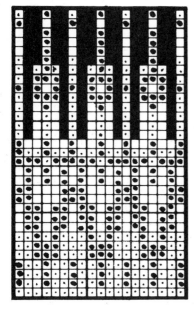

border patterns are separated by four or five plain rows in which the reductions take place, and there is no attempt to co-ordinate the patterns from one row to the next. Very few use more than two colours per row but they change almost every row.

Faced with this range of possibility, it is more than a little depressing to see what the average yoked jersey looks like. Yokes are very easy to experiment on and spectacular designs can be worked with only three colours. Avoid big empty spaces and keep changing colours. I often reduce with double reductions in plain rows or using pattern sections where I can reduce three stitches to one and still carry on a pattern. It is asking a lot of such thick knitting to accept this, but knitting will stretch to fit and can also be gathered in without bunching. However, if something does go wrong with a yoke, it is easy to correct.

Method

Knit a standard jersey body, maybe with a small pattern round the bottom. Stop at armhole level and put about 5 cm (2 in.) of knitting from each side on to a holder (the number of stitches will vary with the tension; the distance is always about the same). Knit two sleeves from the cuff up to armhole level – you can try on the sleeve to make sure it is the right length. Again, put underarm stitches on to a holder. Then (there is a slightly tricky bit here) fit all these stitches together on one circular needle – back, left arm, front, right arm. Knit up a few rows to get a little space and make reductions where these would happen in a raglan-sleeved jersey, i.e. on either side of the four joins. Then start the pattern, fitting in a complete repeat. As you knit up, every so often you reduce, and by a fairly large amount, so that the final bands of pattern are being

knitted with very few stitches compared with what has gone before. If, when you try it on, it is enormously large and the sleeves too long, only the last 10 or 12 rows need to be taken out (in a *lopi* design, that is). More rapid reductions will then need to be put in and the last few rows of pattern left out. Knitting is obliging stuff; it will stretch to fit, but it will do the opposite as well.

YOKED JERSEY WITH SETESDAL-TYPE PATTERNS

This jersey uses an all-wool, Aran-weight, Shetland yarn, with white Aran for the yoke. Tension is 19 stitches and 23 rows to 10 cm (4 in.) on size 6 mm needles (U.K. 4; U.S. 10), but check your tension. It measures 84 cm (36/37 in.) across the chest; overall length to the collar edge is 58 cm (23 in.), and underarm sleeve length is 53 cm (21 in.).

Method

Cast on 156 stitches on a smaller sized needle and knit in two-and-two rib for around 6 cm (2½/3 in.). Change to larger needles, increasing in the first row to 170 stitches, and knit up in stocking stitch to armhole level. Start the cuffs on smaller needles with 46 stitches. Knit in one-and-one rib for 7 cm (3 in.) or so. Change to larger sized needles and stocking stitch, increasing to 46 stitches. Thereafter, increase one stitch on either side of the underarm line every six rows or so, until there are 72 stitches, and continue knitting until the sleeve fits when pulled on. Knit another. Assemble as described above and, on the eighth row from the join, start the yoke pattern. It is in separate bands, and reductions can be adjusted very easily for different sizes. If reduced too quickly it may get a little bunchy, but can be pressed lightly into shape. The neck is finished off in a one-and-one corrugated rib. Then sew or graft the underarm seams and begin the next one!

CHOICE OF PATTERNS

If separate borders are used, and no attempt is made to synchronise the different bands of pattern, there is no problem about the number of stitches or the repeat, so long as it fits into every band. However, if a continuous one-piece yoke is being designed, some repeats are more useful than others. A repeat is always counted from one stitch to the stitch immediately preceding the same point in the next pattern. A repeat of six reduces regularly and is easy to work with. A repeat of eight or nine is also possible but five and seven are difficult as there is no central stitch and a very 'blocky' pattern emerges.

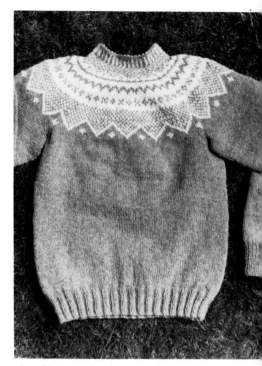

162 *Modern yoked jersey. A type popular in Denmark in the 1950s, it shows Norwegian influence.*

163 *Jersey yoke. Reductions are not shown; they can be done in any plain row and adjusted to suit any tension and size.*

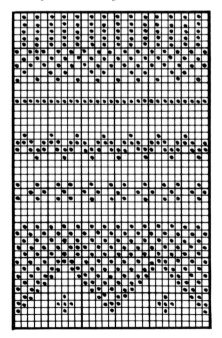

133

9 Gloves and mittens

ORIGINS

Knitted gloves are as old as knitting in Europe. The very earliest were knitted in Spain in red silk and gold thread, and are very splendid indeed. In Scandinavia, gloves were generally worn for holidays and for church and, from 1800 onwards, were often knitted in white cotton with embossed or openwork patterns in the Empire style. Others were knitted in two-strand knitting which gives a flat, even surface very suitable for embroidery. Norwegian embroidered gloves are particularly colourful but many local traditions exist. The two-strand gloves of Dalarna, by comparison, are very restrained in their decoration. Knitted gloves with Fair Isle type patterns seem to have originated in the Baltic, probably in Estonia, though small all-over patterns were also knitted into gloves in Denmark in what seems to be an independent tradition. However, many of the Estonian conventions were taken up elsewhere – in Norway and Shetland, for example – and have had an influence quite undreamed of by the original designers! They were the first to add a large design, such as a star, to the back, and to decorate the fingers with little patterns, both originally embroidered, but soon knitted in. Identical glove patterns are still used today in Norway and parts of Sweden. Of course, the tension of these early gloves was very much higher than that used by most modern knitters and the patterns were much more detailed. There are almost as many stitches around the hand of a pair of double knitting gloves from Norway today as there might be in one finger of a very fine old pair.

Mittens on the other hand (if you will pardon the phrase), were very probably knitted even before gloves, but I doubt if a single example is known before the seventeenth or eighteenth century. They are almost always for work wear, for heavy winter work in the forest or at sea, and, although some very practical and pleasant designs exist, they are seldom the object of much design attention. The best of the Selbu mittens, with large and intricate diamond patterns, are probably the finest ever knitted. But the working mittens of the Lapps, the Norwegians generally, and the various old or up-dated Swedish versions are testimony to a long tradition of practical knitting to give essential winter protection.

KNITTING GLOVES AND MITTENS

In general terms, gloves and mittens have a ribbed or plain cuff or

a longer gauntlet above the wrist. The wrist itself is often marked by a plain piece or a ribbed section between two plain pieces, or there may be shaping down from the gauntlet, often by the use of smaller needles with no change in the number of stitches (which makes the glove warmer as well).

The knitting-in of the thumb is of great importance in gloves which are tight-fitting, but less so in mittens. Most Scandinavian mittens have a simple set-in thumb with perhaps $2\frac{1}{2}$ cm (1 in.) of stitches (six or seven in thick wool, ten or twelve in finer wool) knitted at the appropriate level on a separate piece of yarn. This is knitted in on the row above and removed at a later stage. Stitches are picked up from the row below, the row above and one or two more made (by knitting into a twisted picked-up thread) on each side. The thumb may also be knitted on smaller needles which allows for more pattern details and makes it warmer and longer-lasting.

The best gloves have knitted gussets which start at wrist level, and some also have a gusset knitted down again on the far side. (This is best seen in the Selbu mitten on page 138). To work out the number of stitches for the gusset, one can measure the hand above the thumb and then the hand closed, including the thumb. The difference will give the size of the gusset at its top. The placing of the gusset is of some importance. The thumb is not on the side of the hand but neither does it grow out of the palm. Some Selbu mittens have the thumb too far from the edge. Two or three stitches is usually far enough in to begin. Some gloves have a thumb gusset set into the side seam, perhaps a better method for a glove. In most methods there are increases regularly on either side of a single stitch at wrist level, so that the gusset is symmetrical. However the thumb increases in the Dalarna gloves are along one line only, and seem to work just as well.

When the thumb gusset is long enough (to reach from the wrist to the division of the thumb) the stitches are put aside on a length of yarn, and behind these stitches, where they link up with the palm of the glove, approximately one-third of the total number left for the thumb are cast on. Alternatively, the gusset can be reduced from the same number of stitches cast on and knitted into the palm with every round. For a side thumb only four or five stitches need to be cast on between the thumb gusset and the rest of the hand of the glove, and it is easier to finish off the thumb before knitting the rest of the glove.

Divisions are made for the fingers when the glove is long enough. Remember that, like several other things, gloves can be tried on at the half-way stage. Finger gussets are essential: between each finger three or four stitches are made on each side. To calculate the number of stitches for each finger, therefore, take the total for the hand, subtract three or four for the first finger and divide the remainder by eight (four fronts and four backs). The three or four first taken off form the outside of the first finger, and a gusset is made for the inside. The next two fingers also have a gusset on both sides and the little finger on one side only.

Most mittens in Scandinavia today are very simple to knit and

instructions are given at different headings. Gloves have always been something of a challenge to knitters but the different design ideas given here and there can be applied to anyone's favourite pattern; if in doubt, copy an old pair which fit well.

TO KNIT BETTER MITTENS AND GLOVES

⊗ Use two sizes of needles, one to cast on with and to knit the main part and a set a size or half a size smaller to knit the rib (for a tight fit).

⊗ Use a set of five needles *or* put all the stitches for the back on one needle and divide the palm stitches between the other two (if you are using a set of four).

⊗ Knit a thumb gusset on both sides of the thumb for a better fit and longer life.

⊗ Shape the gauntlet or cuff and the tops of the fingers by changing the sizes of needles used.

⊗ If your thumb (or fingers in gloves) develops holes where stitches have been picked up, darn together on the inside.

⊗ Avoid ugly joins in striped ribbing by knitting one plain row with every new colour introduced (also for jersey welts).

⊗ Remember you have two hands in front of you to use as models.

⊗ Remember to knit a right and a left hand.

⊗ Old Norwegian mittens often had two thumbs: two advantages – it doesn't matter which one you pull on in a hurry and they last twice as long. Tuck the spare one inside when worn.

⊗ For really long wear, knit your mittens large and felt them thoroughly.

⊗ Add a button to one and a button-loop to the other; then they can be hung together over your belt, through a strap, or up to dry. (Lapps use cords and tassels for the same purpose.)

⊗ Reduction at top: at each side knit two together, slip one, knit one, pass slipped stitch over.

⊗ At top, once the stitches have been reduced to 10 or 12, turn the mitten wrong side out, line up two needles with half the stitches on each, and cast off with a third needle (*see also page 126*).

MITTEN AND GLOVE PATTERNS

NORRBOTTEN MITTENS
It is perhaps the cold dark winters that gives the Norrbotten people their love of bright colours which they share with the

Lapps, as they do their land. Only the brightest of reds, yellows, blues and greens will do. I imagine that before shop-bought wool was available they did what they could with vegetable dyes but, although muted shades are attractive to our jaded twentieth century eyes, they have no part to play in folk tastes when brighter alternatives are available. Used as they are, mainly for small things such as mittens, socks and caps, these brilliant colour schemes soon become an addiction. I had to hunt to find suitable wool to knit up the samples. Red was not a problem but the right yellow, green and blue took a long time to find. It does not matter very much if the thickness or quality varies a little from one colour to another so long as all yarns used are synthetic, *or* wool, *or* a mixture.

Cuffs are usually ribbed these days and fitted with a tassel fastened by a plaited cord made out of all the yarns used. This is not purely for decoration as the two mittens can be tied together and hung over the fire to dry. A two-and-two rib is the usual one and the cuff is knitted by most people today to be short enough to tuck under a sleeve. Stripes are knitted-in, either at random or in a symmetrical sequence. The individual patterns used are also often symmetrical, but their arrangement is entirely up to the fancy of the knitter, as are the colours used.

Most of us will probably prefer the versions which use only four colours – say, red, blue, gold and white, or red, blue, green and white. However, once involved in this style of knitting there is soon a return to a simple childish delight in bright colours and I found myself quite happily knitting with five or six colours in the same sample and seeing nothing wrong with it!

Many patterns use three colours in one row. This marks their origin as embroidered or woven patterns, as it does not make for easy knitting. To cope with this technique, which often involves long stretches for one colour used only for centre stitches, wind all the yarns round each other at the back, bringing the one to be used up from under every time (*see Fig. 12 on page 20*). This makes a roll of yarn on the inside, but this is better, especially in mittens, than long loops. I use a similar technique to keep all the yarns moving from row to row: I wind them all round themselves every three or four rows, taking those in use, passing them right round those not in use and pulling fairly tight. This makes for a neat join from one colour combination to another, and leaves no ends to be darned in afterwards.

Norrbotten thumbs are simply set in by removing a short length of yarn and are patterned to match whatever else is happening. Tops are either reduced on each side in Selbu fashion (knit 2 together, slip 1, pass slipped stitch over) or in spiral fashion (divide stitches into four sections and knit 2 together at each point in every second row or so).

These patterns would make a splendid all-over jersey, used with a little restraint. Many could be adapted to yokes or as decorations in other ways. The idea of filling in a space with random border patterns, which we also come across in Finland on their red and white stockings, can be adapted very well to a jersey, though I would suggest trying to work with only two colours per row, particularly if the yarn is double knitting quality or thicker.

164 *One of the most regular features of Norrbotten mittens is the 'rose' pattern also used for mountain socks. It often covers the mittens from thumb level upwards, preceded by three or four bright borders. It may be knitted in two colours only, which is quite common, or in three, as shown in the several variations below on the chart.*

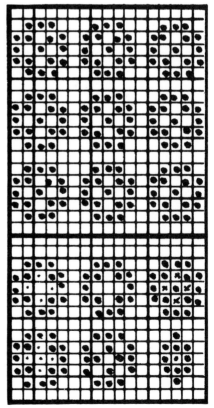

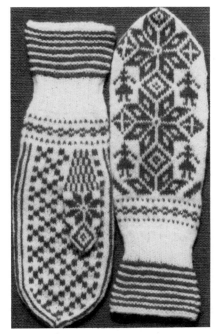

165 *Selbu mittens.*

Method for double knitting

(This is approximate only as thicknesses vary as do tensions.) Cast on 48 stitches on size 3 mm needles (U.K. 11; U.S. 2½), giving a tension of approximately 26 stitches to 10 cm over stocking stitch. Knit 6 to 7 cm (2¼ to 2¾ in.) in two-and-two rib. Change to stocking stitch and knit two plain rows before starting a pattern. Arrange placing of patterns so that incomplete parts are at the inside (thumb side). Larger patterns should be centred on the back for the best effect but, in general, anything goes so far as arranging patterns is concerned. This really is informal knitting. Knit in a 'thumb thread' after 6 to 7 cm (2¼ to 2¾ in.) of pattern knitting. This is knitted in over 12 to 14 stitches, while the pattern colours are carried along at the back.

For the thumb: remove the thumb thread and pick up the stitches it has been holding on both sides. Knit round and knit up one or two more stitches at the side to give it width and avoid holes (twist the threads picked up for a neater effect). Knit the thumb in circular fashion, keeping the pattern going as well as possible, and finish off by reducing regularly all round in one colour.

SELBU MITTENS

These have been knitted in red and white Shetland 2-ply wool on size 2 mm (U.K. 13; U.S. 1) needles. The thumb has been knitted on even finer needles to fit in the pattern of the original Selbu version. It is important here to check your tension before you start as this is a relatively large pattern. It can be adjusted quite easily (on a sheet of graph paper *before* you start knitting) by leaving out the lower half star and sacrificing the little ladies. There could still be room for one of these figures on the thumb in place of the star. However, the whole pattern is given here.

Yarn required is around 50 g of each of two colours. The traditional colours are natural white and natural black, or white and red. Tension as knitted is 34 stitches and 40 rows to 10 cm (2 in.) over the pattern in stocking stitch (more in the thumb).

Method

Cast on 52 stitches on size 2 mm (U.K. 13; U.S. 1) needles and, continuing with the same size, knit 1 round in white and purl 1 round in white. Change to red wool, knit 1 round and purl 1 round. This gives a white stripe and a red stripe. Repeat these four rows six times more. This gives a wide gauntlet. Change to white wool and a smaller size of needle and work 4 cm (1½ in.) in two-and-two rib, to give an overall length of 8 to 9 cm (3½ in.). Change back to the original needles and knit a few rows in plain white, increasing to 68 stitches to fit the pattern. Put all the stitches for the back on one needle and divide the rest between the other two needles if using a set of four. Work on according to the chart. The thumb gusset is set in almost at the edge of the palm stitches and is increased every third round until there are 13 stitches. After completion of the mitten, come back to these 13 stitches and make up to total of 29 by knitting up 12 from the edge above the thumb and making two more at each side. The thumb can be knitted on size 2 mm (U.K. 14; U.S. 0) needles, or even finer.

166 *Knitting Selbu mittens.* LEFT: *pattern for back;* LOWER RIGHT: *palm;* TOP RIGHT: *thumb.*

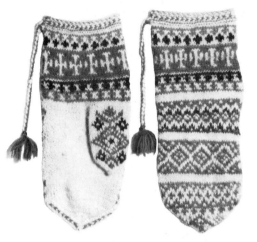

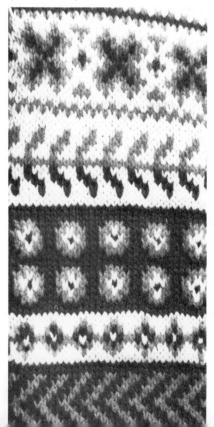

167 *This typical pair of Lapp mittens shows the double purl twists, cuff borders knitted right round, thumb pattern (of a type often used on the back) and combination of patterned back with plain palm. They have the standard cords and tassels and are knitted in red on white with touches of bright blue.*

168 *Lapp patterns. All in red, white and blue; more typical on a white background, but shown here also on a blue ground. The little 'rose' pattern is also knitted, in different colours, in Norrbotten in Sweden (and elsewhere).*

LAPP MITTENS

Lapland lies entirely above the Arctic Circle and winters there are long, dark, and very cold indeed. The semi-nomadic herdsmen now travel less than formerly, sometimes herding reindeer these days by snowmobile, but once they had a community extending from Finnmark in Norway into Russia. The different Lapp populations are now as different as other Norwegians and Russians but have the same love of bright, primary colours. They are not great knitters, although they are said (on what basis I do not know) to have been knitting since the seventeenth century. Their main contribution is their mittens, in red and white with touches of blue. The oldest style is clearly derived from a *nålbinding* mitten with an attempt to knit in the same motif (for good luck?) on the back – not an easy thing to do in stranded knitting – and copying the embroidered cuff patterns as on knitted ones, with more success. A more modern variation, probably copied from those knitted for them by more settled folk in such places as Norrbotten, has bright borders knitted at random all round (sometimes, again, and very oddly, only on the back).

All are equipped with cords and tassels at the wrist. Lapps often have to work with their bare hands even in winter, tying ropes and doing other complicated jobs, and then the mittens are tied together and hung over the wrist or tucked into the belt. Cuffs are often decorated with a few rows of double purl twist in red and white, and a zig-zag pattern of which there are dozens of variations.

MITTENS FROM JUKKASJARVI CHURCH

In 1947 the church at Jukkasjarvi in Norrbotten was being repaired and several graves were disturbed. These dated back to around 1750. One woman had been buried wearing mittens and a copy of them was made by Teres Torgrim who lived locally and who had a great interest in local knitting. Another grave, which might have been that of a man or a woman, contained a pair of half-mittens patterned in natural colours – black, brown and grey wool – in random diamonds and zig-zags.

The pattern of the woman's mittens is simple but effective (*Figs 170 and 171*). The idea of the travelling stitch is still a popular one and is now used to make all-over diagonal patterns, both on mittens and on stockings in Vivungi, another area of Norrbotten.

The cuff has three rows of garter stitch (1 round purl, 1 round plain, repeated three times) then a travelling, zig-zag pattern in plain stitch on a plain ground. In the original, this is not entirely regular, but is probably intended to be a regular zig-zag. The wrist section is in rib, a very interesting early use of ribbing for a closer fit.

Method

Using Aran or similar wool, cast on 48 stitches with 3 mm needles (U.K. 11; U.S. 3). Any multiple of eight will fit the pattern. Purl one round; knit one round; repeat three times. Increase for travelling stitch by knitting into front and back of first stitch, knit 7; repeat to end of round. Work travelling pattern according to the chart, keeping it complete over the join as far as possible. In

169 *Lapp mitten patterns. Large dots: red; small dots: blue; on a white ground, but red and blue interchangeable; red is brighter but blue more beautiful. The charts show two complete and complex mittens with the cuff patterns at the bottom of the page.*

Cuff patterns, or indeed any of the patterns shown, may be used alone at the cuff or in different all-over arrangements. There is always a cuff pattern, knitted in the round, but the rest is often plain with maybe a touch of red at the cast-off edge.

170 *Mitten from Jukkasjarvi (see also Fig. 171).*

171 *Jukkasjarvi mitten.*

Symbols used:

Create a travelling stitch

Knit two travelling stitches together

Travel to right

Travel to left.

the fifth round of the pattern, knit both travelling stitches together to make the same number as you began with as follows: knit 7, knit 2 together. Purl one round; knit one round; purl one round. Repeat travelling pattern. Purl one round; knit one-and-one rib for 2.5 cm (1 in.) – between six and eight rows. Purl one round; repeat travelling pattern; purl one round.

The rest of the mitten is plain with a set-in thumb.

LOVIKKA MITTENS

These thick, white, fluffy mittens are another style that looks very old indeed, but was developed by an enterprising individual within living memory. Before that, mittens in Tornedal, in north Sweden, were made of *nålbinding* with very long and very wide gauntlets, in shape very like the two-stranded mittens of Dalarna (*see page 22*). The 'mother' of Lovikka mittens, Erika Aittamaa, was still alive in 1936 and remembered well her first experiments of 1892. She was then one of a poor family who lived in a wooden cabin and knitted for townspeople. One day a customer wanted really thick, long-wearing mittens. Erika spun special wool and made two pairs of very thick mittens which she thought should last several winters. However, her customer was not enthusiastic and even said she had spoiled good wool. Undaunted she tried again, felted them very carefully and brushed them to raise the pile. This was a success and her mittens were soon in demand especially by farmers who drove during the winter. She got orders from towns in Tornedal and from the Lapps. To please the Lapps, who love bright colours, she began to decorate the cuffs with bright, loosely stranded patterns copied from much older embroidery on the *nålbinding* mittens.

The special yarn is very tightly spun so that it stays very solid even when brushed.

Method

I used Antartex Original Quicknit in white (heavier than *lopi*) and 3 or 3½ (U.K. 9 or 10; U.S. 3 or 4) needles to give a tension of 5 stitches to 3 cm (1¼ in.) approximately. Cast on 33 stitches and knit one round plain and one round purl. Continue in plain for 5 to 6 cm (2 to 2¼ in.) (eight rows is a useful number). Knit one round purl and turn knitting inside out, knitting the first and last stitches at the join together. This gives 32. Continue in stocking stitch. Around 10 cm (4 in.) from the fold put seven stitches, for the thumb, on a length of yarn. Knit 11 cm (4½ in.) more and reduce by knitting 6, knitting 2 together four times. In the next row knit 5, knit 2 together four times; repeat to four stitches; finish off. The thumb is knitted up from the seven stitches left, seven more above and one or two made at each side.

These mittens are best knitted on the large side and felted down into shape. It can be quite hard to felt modern commercial wool (intentionally, that is, as MacGregor's Law applies – if you don't want it to, it will). Scrubbing in very hot water helps, as do sudden changes of temperature, but the felting should be even. (For a traditional method, *see also page 38*.) Stretch into shape to dry and then brush inside and outside to raise the pile. Do not

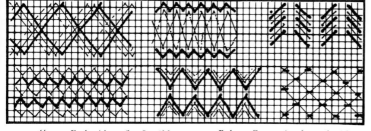

172 *Above. Embroidery for Lovikka* 173 *Below. Stages in the embroidery.*
mittens.

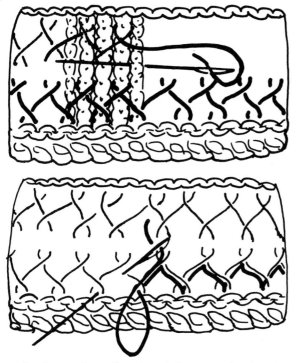

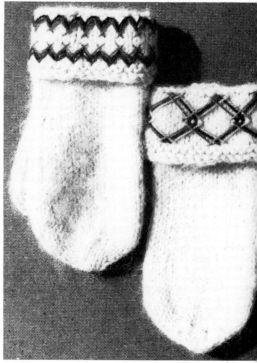

174 *Lovikka mittens. Two different styles*
of embroidery are shown.

175 *Danish glove patterns.*

brush too hard over the cuff as the stitches must be clear for the
embroidery.

The embroidery is done with 2-ply embroidery wool in bright
colours and can be charted. Two or three colours should be used
on each pair. It is applied rather like a smocking effect. The
pattern should avoid very long, unsupported lengths of wool. It
should be designed to make a whole repeat within 32 stitches.

These mittens are very useful for the winter, and can easily be
made large enough to wear over a second pair. They also knit up
in around half an hour.

DANISH GLOVES AND MITTENS FROM JUTLAND

Most Danish knitting of stockings and mittens was mass-produced
and roughly shaped, made for a mass market in areas where the
farmers were richer and, as a result, kept fewer sheep, but could
afford to pay someone else to manufacture knitwear for them.
Stranded knitting is also rare in Denmark, which makes these small
gloves and mittens from Jutland all the more interesting. As the
patterns are very small, they can be adapted easily to fit different
tensions and sizes. All those shown here were knitted in Shetland
2-ply on size $2\frac{1}{2}$ mm (U.K. 13; U.S. 1) needles to a tension of 34

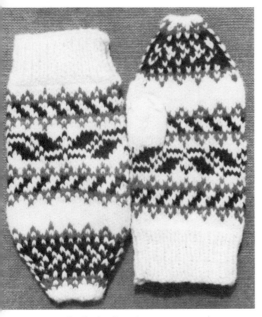

176 *Icelandic mittens.*

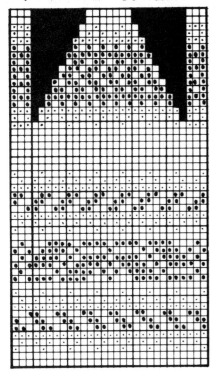

177 *Icelandic mittens with leaf pattern. Back and sides only shown; repeat back to complete (in Aran knitting quality).*

stitches and 37 rows to 10 cm (4 in.), but tension must be checked and the pattern adapted before starting (*see Figs 94–96 on pages 83–84*).

Mittens

These are for a small person but can easily be adapted to any size. Length of sample is 24 cm (9½ in.). The cuff edge is cast on in two colours and there are three rounds of corrugated rib (knit 1 dark, purl 1 light, all round). The mitten is then knitted up without any shaping in pattern for 5 cm (2 in.), and then shaped by changing to a larger size of needle. Ten stitches are set on a holder for the thumb opening when the work measures 10 cm (4 in.) overall. The top is reduced by dividing the work into eight at the level of the tip of the little finger and reducing once at each point in every two rounds until only six or eight stitches are left. They are drawn in together and fastened with a back stitch. The work can also be divided into four (traditionally there would have been four working needles) and one stitch reduced by knitting two together at the beginning of each needle in each round to achieve a similar effect. (This circular method of reducing mitten tops seems to be older than the flat method with reductions only at the sides.)

Gloves

Both pairs are a lady's size and have a ribbed cuff of 5.5 to 6.5 cm (2 to 2½ in.) in one-and-one rib. There are 54 stitches in the cuff. On changing to patterned knitting in stocking stitch, one size larger needles is used, and the number of stitches is increased to around 64 (the number should fit the pattern repeat which is four in one case and three in the other). Eleven or twelve stitches are set aside for the thumb which is knitted up with 24 stitches altogether. The division for the fingers is at 12 cm (4¼ in.) from the beginning of the pattern with two stitches in each finger gusset, and two more made front and back to make a total gusset of five or six stitches. These useful small patterns can be adapted to any commercial glove pattern. They use approximately equal quantities of dark and light wool and look very nice in natural shades.

ICELANDIC MITTENS *(see Figs 176 and 177)*

The north-west corner of Iceland developed its own style of mittens which were knitted in thick wool and decorated with stranded borders of flowers, animals and birds borrowed from embroidery and network. This pair uses an old pattern with new colours, but any colours will do – the originals are as bright as possible but black and white is also effective. They make splendid outer mittens for winter wear – make them large enough to wear over a smaller pair or a pair of gloves. Many more suitable borders will be found on other pages.

Use a white, Aran-weight wool, with small amounts of red and brown, knitted over the stocking-stitch part on 3½ or 4 mm needles (U.K. size 9; U.S. size 5) to give a tension of 21½ stitches and 23 rows to 10 cm (4 in.).

Method

Cast on 52 stitches on half a size smaller needle than that used for the stocking-stitch tension sample, and knit around 5 cm (2 in.) in one-and-one rib. (*Or* cast on 48 stitches and increase in the first plain

row to 52 stitches.) Change to the larger needles and continue in pattern according to the chart. After a further 5 or 6 cm (2 to $2\frac{1}{2}$ in.) put seven stitches on a separate length of yarn for the thumb opening. Reduce on either side of the decorative strip as indicated on the chart.

For the thumb: knit along the seven stitches left, make two at the side, pick up six from above the thumb opening, make one and knit up on 16 stitches, either plain or in a small pattern. Reduce to match the top.

'ESTONIAN' MITTEN *(see Figs 97 and 178)*
My 'Estonian' mitten is copied from a very attractive pair of gloves in the collection of the Danish National Museum. I suspect they may have been imported from Estonia, as very similar gloves have been described there and are also knitted in Finland and even in

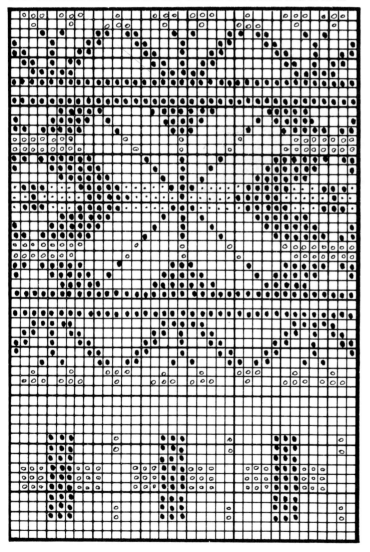

178 *Estonian mittens from Denmark. It has not been possible to give separate symbols for each colour without making the chart more difficult to read. The lower small (cuff) pattern is knitted on a white ground and the chart should be used in conjunction with the colour scheme. Green: a small circle; red: a small dot; both blue and charcoal: a large dot. The centre of the crosses is in charcoal while top and bottom arms are blue and those at the side green as shown. In the centre three rows of the large pattern the background colour changes from white to red and the pattern colour from charcoal to blue, making an effective contrast.*

Sweden. They are certainly worth copying, with many small touches that contribute towards an effective but restrained piece of knitting: the fringed cuffs, double twisted purl patterns, little purl patterns and the rather splendid border. I copied the original colours as far as possible, using Shetland 2-ply (equivalent of 3-ply) partly to reproduce the woolly effect of the original, and partly because of the range of colours available. The green, in particular, is not a bright colour but more like a green lovat, perhaps originally a combination of yellow with pale indigo. You will also need small amounts of natural white, a warm medium blue, a warm medium red or russet and a small amount of dark charcoal grey or black (again not an absolute black; it is slightly grey). The main part of the mitten is knitted in navy.

The copy was knitted on size $2\frac{1}{2}$ mm (U.K. 12; U.S. 2) needles to a tension of 27 stitches and 32 rows to 10 cm (4 in.).

Method

Cast on 72 stitches, allowing for six complete repeats of the cuff pattern. Use cable cast-on with two strands of navy (*see page 32*). Then knit twisted purl stripes in white, green, navy, madder and white as follows: in each colour first knit one round plain and then one round double purl twist. Using two strands of the same colour, and keeping both strands on the *right* side of the work, purl alternate stitches with each strand, meanwhile twisting each strand round the other to bring it into play. (*See also page 24.*) This is a common and useful decoration for cuffs in the Baltic.

Continue in white stocking stitch and knit the cuff pattern in a purl stitch for the colour stitches and a plain stitch for the background. To avoid the back of the purl stitches showing on the right side the first row in each new colour must be knitted in a plain stitch; in this pattern this means one plain row and two purl in each colour. It is an effective technique and looks rather like cross stitch. Follow the colour indications given. Then repeat the twisted stripes in reverse colour order (still knitting one plain row first and then working the purl twist).

Knit the wrist section in plain navy stocking stitch and shape it by reducing midway from 72 stitches to 64, which allows for two complete pattern repeats. After 4 cm ($1\frac{1}{2}$ in.), knit the stranded pattern according to the chart and the colour instructions (not all of which are marked on the chart [Fig. 178]).

Shape the top by reducing in each round on each side of two centre stitches, so that a band of four stitches appears on each side. Finish at the top by grafting four to four or darning through eight and fastening off securely.

Knit a simple thumb by opening up a few stitches at the right point – about eight from front, eight from back and two or three made at each side, and knit up in plain navy, reducing to match the top of the mitten.

Add a fringe if required. Wind lengths of wool round a suitably-sized notebook or piece of cardboard about 10 cm (4 in.) across and cut at one side. Take two or three at once and pull double through the cast-on edge with a crochet hook. Pull the long ends through the loop and pull tight.

Colour scheme

Large pattern:
Two rows green on white;
Two rows charcoal on white;
Three rows medium blue on white;
One row charcoal;
One row white;
One row medium blue;
Three rows charcoal on white;
Two rows green on white;
Three rows charcoal on white;
Three rows medium blue on red (centre rows).
Repeat in reverse order.

Small pattern:
Outer segments of cross, medium blue; intermediate dots, green.
Centre segments of cross, three green on either side of three charcoal.

10 Stockings

It is difficult to over-estimate the importance that stocking-knitting once played in the day-to-day life of many Scandinavian communities. Forty thousand people in Jutland once earned their livings from knitting stockings, and there were similar home industries in Iceland and Sweden on a large scale, and in many other places on a smaller scale. Some areas were the market areas for these industrial knitters, but most areas did at least produce their own fine stockings for their own wear. Ribbed effects were common in stockings to achieve a better fit. For the same reason, lengthwise patterns developed in Norway in stranded knitting as these tend to pull tighter at the vertical lines (and is the reason these patterns are unsuitable for jersey knitting). But in Sweden a different approach lead to stockings patterned horizontally from top to bottom with a great variety of borders, chosen almost at random from a wide selection.

As long as knee breeches were worn, well-knitted stockings remained a crucial part of the costume. When trousers replaced breeches, the importance of stockings dwindled. Today there may again be a new move towards knitted legwear (to use a cautious phrase) and, as a well-knitted stocking is a joy to knit and to wear, I will give a few basic tips.

KNITTING STOCKINGS

Stockings and socks are always knitted on sets of short double-pointed needles. A set in some parts of the world has only four needles, but in Scandinavia usually has five. Two needles can then be used for the front and two for the back throughout the work. If only three are in use (with the fourth working) the knitting must, from time to time, be rearranged to suit the convenience of the knitter. All needles must be the same dimension, but not necessarily from the same set. Knitting round and round in plain stitch produces what is known as 'stocking stitch' – the commonest type of knitted fabric named after its commonest traditional application. It is smooth on the outside and ridged on the inside (the 'purl' or 'pearl' side).

In Scandinavia, as in Europe generally, stockings are knitted from the top down. I will give the method of knitting a stocking in double knitting with 70 stitches cast on at the top – a nominal figure, but it makes the instructions easier to follow. As a great many different yarns can be used to knit stockings, and as legs manifestly vary in length and girth, no one should embark on

a
16

b
10

c
26

d
14

e

f
14

179 *Norwegian stocking patterns. All used in vertical panels with as many repeats as required. Very easy to adapt to jersey knitting, except that the unpatterned* *vertical lines need attention as they may pull tight. All from Norway except* **d**, *which is from Jamtland, the province of Sweden neighbouring Selbu.*

180 *Several 'stock' stocking patterns were used in various combinations, usually two in each stocking. A selection is given here. The type on the right below is unusual for* Norway (*a series of unrelated borders knitted round the leg*) *but was popular further east in Sweden and Finland.*

stocking-knitting without taking measurements of width, rate of reduction, overall leg length and foot length (at least). A check can often be made by trying on the work as it progresses.

The traditional way of estimating length is to take the foot length and double it. If the calf measurement is more than 40 cm (16 in.), an extra inch or two should be added to the length.

Most stockings have an imitation 'seam' knitted in where the seam in a sewn cloth stocking would have been. Some samples are given in Figs 6 and 34. Decreases are usually made on either side of this 'seam', often fitted into the pattern with such effect that they become an important part of it. Either a central vertical panel continues from top to bottom, with reductions tucked under either side, or there may be a central panel which is reduced and eventually disappears, while its neighbouring panels on either side meet at the lower calf. An average reduction would be from 70 stitches to 58, starting 20 cm (8 in.) from the top of the stocking and reducing two in every sixth row, repeated seven times in all. This makes up 14 reductions,

THE HEEL FLAP

At the ankle, half of the stitches are left to be continued later as the instep (front of the ankle) while the other half are knitted on into a square heel flap from which the heel is 'turned'. There must be equal numbers in the heel flap on either side of the 'seam' stitches. Test the squareness of the heel flap by folding over to measure length against width. Slip the first stitch in every row knitwise or purlwise to give a good edge. Leave 29 stitches on a needle and knit backwards and forwards on the other 29 until you have knitted a small square.

The heel flap may be continued in pattern, or it may be knitted with special patterns with slipped stitches, which are an old knitter's trick to make it partly double and longer-lasting (important if the knitter is also the darner).

Method 1
Row 1: knit 1, slip 1; repeat.
Row 2: knit.
Row 3: slip 1, knit 1; repeat.
Row 4: knit.
Repeat these four rows.

Method 2
Row 1: slip 1 purlwise, purl to end.
Row 2: slip 1 knitwise, knit 1, keeping wool at back of work slip 1 purlwise; repeat to last 2 stitches, knit 2.
Repeat these 2 rows.

Method 3
Introduce yarn from a second ball and knit one stitch in this yarn, and one stitch in the original yarn, stranding on the inside throughout (*see page 22*).

TURNING THE HEEL

This is worked only with the heel flap and can be done in several ways.

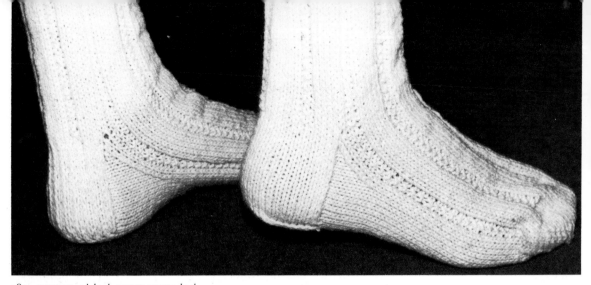

181 LEFT *round heel;* RIGHT *square heel*

Round heel (French heel)

Row 1: knit to seam stitch, knit 2 more, slip 1, knit 1, pass slipped stitch over, knit 1; turn.

Row 2: slip 1 purlwise, purl 7, purl 2 together, purl 1; turn (10 stitches worked).

Row 3: slip 1 knitwise, knit 8, slip 1 (the last stitch previously worked in every case), knit 1, pass slipped stitch over, knit 1; turn (11 stitches worked).

Row 4: Slip 1 purlwise, purl 9, purl 2 together (last stitch previously worked plus one new one), purl 1 (12 stitches worked). Continue until all stitches have been worked once and then work instep.

Square heel (Dutch heel)

This is a good broad heel which occupies more rows than the slimmer round method and is more usual in Scandinavia. The depth depends on the number of stitches at the side. The number of stitches in the middle is not so important; indeed, in Setesdal, they virtually join the two halves with no central underfoot section. Divide the stitches according to the following table noting that the central number should be odd.

Total number in heel flap	Outside/centre/outside
22	8/7/7
24	8/9/7
26	8/11/7
28	10/9/9
30	10/11/9
32	12/9/11
34	12/11/11

In the example worked, divide the 29 stitches of the heel flap 10/9/10. Work the heel as follows:

Row 1: knit 18, slip 1 (the last stitch of the central section), knit 1, pass slipped stitch over; turn

Row 2: purl 8, purl 2 together (the last stitch of the central section and the next stitch).

Repeat these two rows until all stitches have been worked, remembering to slip the first stitch in every row.

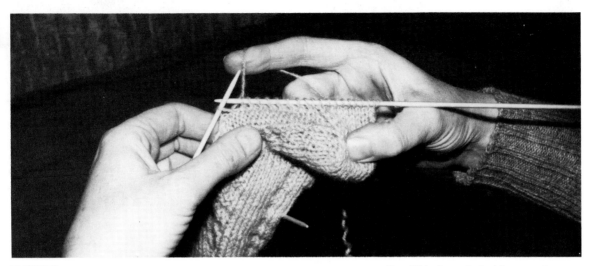

INSTEP

Work in plain stitch along all heel stitches; knit up stitches from
the inner loop of the chain along the edge of the heel flap, working
fairly tightly; knit across the stitches left from the instep, and knit
up the same number of stitches from the other side of the heel
flap. As a general guide, the total number of stitches at this point
should be about the same as was cast on; 70 in this case. So,
subtract from that number the stitches left on the instep needle
(29) and those left after the heel has been turned (nine, if a square
heel) and divide what is left by two (to get 16 to be picked up on
each side).

GUSSET

Having turned the heel we now knit the foot. In all parts of
Scandinavia, if the shoe was the common low-cut slipper type, half
of the pattern – including half the clock pattern – would be
continued along the foot for as long as it might possibly be visible.
The lower part of the foot is always in stocking stitch, often with a
small seeding pattern in stranded stockings. The gusset reduces the
heel stitches at the point of the join to the same number as the
instep stitches (in this case, from 41 to 27). It is not thought good
practice in Scandinavia to reduce these too quickly, so the
reductions should be done on each side in rows 1, 2, 4, 7, 11, 16,
22, 29, etc. (You leave one, two, three, four, etc. plain rows
between each reduction.)

FOOT

When the stocking measures 15 cm (6 in.) or so from the picked-up
stitches (for an adult size), check the length. Begin the reductions
when you get to the level of the end of the little toe. For narrow
feet with long toes a symmetrical reduction on each side is best.
On each side in alternate rounds knit to three stitches before the
mid-line (at the side); knit 2 together, knit 2, slip 1, knit 1, pass
slipped stitch over. Repeat at other side and reduce until there are
around half the number of stitches left. Graft the toe or close it by
double cast-off (*see page 126*).

182 *This shows the heel just turned
(square style) and the stitches being knitted
up along the side of the heel flap to complete
the instep.*

For a broad foot, the typical Scandinavian reduction is suitable: divide the knitting mentally into four or more equal parts, regardless of their relationship to the foot, and reduce once at these points in every second round or so. The top will come together like a cap (this shaping is also used for mittens) and can be finished off by passing the end of the yarn through the last five or six stitches.

PROBLEM POINTS AND SOLUTIONS

⊗ Cast-on edge too tight – use larger needles or another method.

⊗ Too few stitches picked up along heel flap – count again.

⊗ Heel too shallow (or too deep) – count again.

⊗ Gusset reduced too rapidly, making instep tight – unpick and space reductions.

⊗ Straight part of foot too short (or too long) – unpick and alter.

⊗ Point of toe reduced too quickly (or too slowly) – unpick and knit again.

⊗ If knitted in pattern, this has tightened and the stocking is too small (always test a sample in pattern) – improve stranded technique, never pull wool tight.

⊗ Moving from one needle to another in stocking stitch has left gaps from uneven tension or pulled up for the same reason – gaps will disappear with washing and wearing. Tightness must be avoided from the outset.

This gives a practical run through the main points in knitting any stocking. It also gives a pattern which should work for most double-knitting yarns, though I make no promises about the final size, unless you have done your homework. But, if adaptations are made for different yarns and sizes of needles (not to mention sizes of legs), this basic method can accommodate any of the charted patterns to make any type of stocking. Without feet these patterns make great leg-warmers, known in Scandinavia long before they became fashion news again. Knitted only from the ankle or calf down they make super socks.

Knee-length stockings seldom had turn-down tops as part of Scandinavian folk wear. There might be a short length of ribbing which was tucked up inside the lower edge of the knee-breeches and tied round on the outside with braided ribbon. In time, the zig-zags and waves which decorated these braids were transferred to the stockings themselves. An effective and neat modern method of solving the problem of keeping up knee-length stockings is to knit a double top. This follows the same method as for a knitted hem, (*see page 35*). A length of broad elastic can then be threaded through the top.

11 Caps

Scandinavian caps are almost all based on the bag-cap or stocking cap. This is often double, or lined with pile, or both. The simplest form of double cap described here is from Finland, but the method is similar to that used elsewhere. It is in one piece, lining and outer cap, and the lining is simply pushed up inside the cap. Danish caps were very similar, except that thrifty housewives there knitted the inner lining only large enough to fit the head and used white wool. When a pile lining was used as well, it was white where it would not show and usually red on the outside. So, a typical Danish cap (similar caps were worn in Norway and Sweden), was long and red, finished with a red tassel, decorated with red pile round the brim and lined with white pile sewn on to a separate white lining, or perhaps knitted in using a 'John Thomas'.

The traditional Swedish double cap was decorated, everywhere that showed, with a whole selection of small patterns. The lining was usually knitted slightly shorter than the outside part and the brim folded up on the outside so that there were four thicknesses of wool round the ears. Thrifty Swedish housewives could calculate exactly where each fold would be, and even the inside of the brim was mainly in white. (It is interesting to see that the traditional Fair Isle caps were identical, except that the lining did not extend right to the top of the cap.)

As with mittens, caps are known to have been traded around a great deal and the same styles can be found over a much wider area than with many forms of traditional knitting. Various local variations are interesting: Norwegian coastal caps and Setesdal caps; Finnish and Swedish double caps; Swedish fiddlers' caps; and I have adapted a few patterns for less traditional tastes.

As you can see in Fig. 183, Scandinavian caps can be single or double, lined or unlined, brimmed or brimless, patterned or plain, and knitted in stocking stitch, garter stitch or many other stitches.

DESIGNING A CAP

The first step in designing a cap is the same as with any other piece of knitwear: take the wool you want to use and the size of needles recommended by the manufacturer and knit a sample of at least 10 cm (4 in.) square. Measure round the head to be covered at the largest point, which is just above the ears. Divide this by ten and multiply by the number of stitches in 10 cm (4 in.) to give the number to cast on, or to increase towards. Wool seems much better than synthetic yarns for caps as it does not stretch so much.

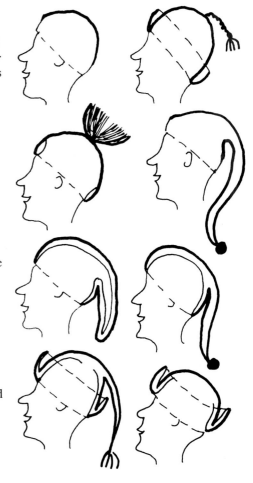

183 *Varieties of caps.* FROM LEFT TO RIGHT: *plainest skull-cap, simple turned-up brim, knitted together brim, simple long-peaked stocking-cap; simple double-cap, double-cap with close-fitting lining, double-cap with turned-up brim, ski-cap with half-lining and turned-up brim. The parts which should be knitted with a smaller size of needle are drawn with a thinner line.*

Caps are always knitted on circular needles! If starting at the brim, with no fold-up planned, use a size larger needle for the cast-on edge and a size smaller for the rib, if you knit one. Start the first round by knitting into the first stitch of the cast on. If this is a double loop, do not count it as a stitch but drop it off and knit into the second stitch. If you are knitting a lining, either a complete lining or a short piece to knit in as a hem, use a size smaller needle for a neater fit. A neat turn is got by knitting one row of purl at the fold, knitting into the back of the stitches.

The part of the cap from brim to top of head is done without shaping and must be deep enough or the cap will slide off. Even for a small child's head this usually needs to be at least 10 cm (4 in.). Remember, a child's head can be as large as an adult's. A man's cap will normally have at least 13 or 14 cm (5 or 6 in.) before any reductions are made.

There are many ways of finishing off a cap. The simplest is to make no reductions, but simply to gather in the stitches of the last row of what is simply a knitted tube, oversew firmly and cover the space in the middle with a large tassal (see page 37).

Fig. 184 shows a number of other methods. Reduction positions are marked with the thicker lines or points. If you want a flat crown (for a fitted cap, such as a ski cap, or to wear under a hood) you will reduce rapidly. If you want a long pointed cap, you will reduce slowly with many rows between reduction rows. Many methods are very attractive, indeed they may be the only decoration on a cap, and involve dividing the stitches into a number of equal sections and reducing according to a pattern in these sections. This takes a fair amount of expertise and planning but, if you try it, make notes and you will end up with your own pattern and no doubts about how to do it next time round.

The commonest method in Scandinavia is probably the spiral crown. This consists of dividing the crown into a convenient number of sections and reducing at the same point and in the same way in every second or third round (depending on yarn thickness and shape desired). The direction of the spiral depends on the reduction used and whether the stitch before or the stitch after is knitted in at every reduction round. If you knit 2 together to give a right sloping decrease and then knit the resulting stitch in with the preceding stitch in every round, then the pattern will spiral to the right. If you slip 1, knit 1 and pass the slipped stitch over, and each time slip the knitted stitch, then the spiral will move to the left.

CAP PATTERNS

NORWEGIAN BAG-CAP FROM VALLE, SETESDAL

Setesdal has contributed more than its share to knitting tradition, perhaps because the drastic change in its local costume in the nineteenth century coincided with awareness of pattern knitting of various kinds. This cap has many features found in other Norwegian and, indeed, Scandinavian caps generally – its long peak, finished with a tassel; its 'floss' edge stitched on later; its series of small patterns repeated along the length. There are at least two very similar old caps known. Although the patterns vary

184 *Methods of reducing crowns of caps. The dark lines and points indicate reductions.*

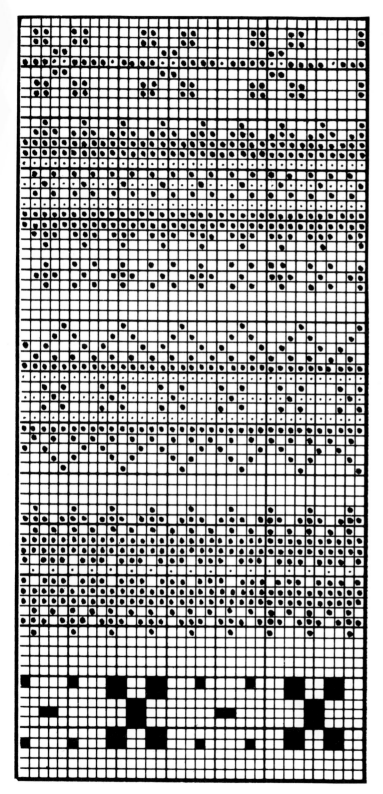

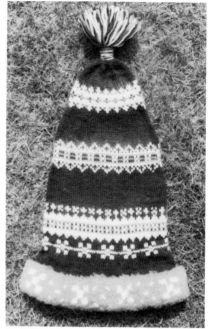

185　Cap from Setesdal, Norway.

186　Pattern to knit Setesdal cap.
Background: natural brown; large dots:
white; small dots: red. Lower chart in black
squares shows pattern for embroidered brim.

very slightly, both are patterned in red and white (with touches of green) on a dark blue ground. My version is patterned in red and white on dark brown, with a red and white border. The originals often use three colours in one row but I have designed this version to use only two colours.

Double knitting wool is used, knitted on size $3\frac{1}{2}$ mm (U.K. 9; U.S. 5) needles, to give a tension of 29 stitches and 29 rows over stocking stitch in pattern.

Method

Cast on 144 stitches (for a normal adult size) and knit about 5 cm (2 in.) in one-and-one rib. For a tighter fit use a size smaller needle. Knit 1 purl row for the turn and continue in plain knitting in the ground colour for a further 9 cm ($3\frac{1}{2}$ in.). Reduce by one stitch in twelve to 132 stitches, and knit the first pattern band without further shaping. Knit a further 6 cm ($2\frac{1}{2}$ in.) in plain knitting with a spaced reduction to 114 stitches, and knit the second pattern band. Knit a further plain section reducing in two or three spaced rows down to 72 stitches. Knit the third pattern band. After 1.5 cm ($\frac{1}{2}$ in. or so) knit one final reduction row. Knit up a further 3 to 4 cm ($1\frac{1}{2}$ in.), and finish off the top by reducing rapidly over two or three rows and passing the end of the yarn through the remaining few stitches and fastening off firmly.

Contrive a tassel from spare yarn of all the colours used, and sew on securely.

Fold the ribbed hem to the inside and stitch in place. Add the pile brim with an embroidery needle. *Note:* this uses a fair amount of wool if sewn to every stitch (as it should be) but makes a very warm and windproof protection for the ears in winter.

SIMPLE DOUBLE CAP

Traditionally knitted in fine red wool to a tension of 38 stitches and 48 rows to 10 cm (4 in.) on 2 mm (U.K. 14; U.S. 0) needles.

Method

Start with eight stitches (cast on, or picked up from a crochet chain) and knit one round. Increase then as follows:

Row 1: knit 1, increase 1; repeat four times.
Row 2: knit 2, increase 1; repeat four times. Continue in this way to row 13 is reached.
Row 13: knit 13, increase 1, repeat four times.

Now knit two plain rows between each increasing row, and continue until you get to knit 17, increase 1, repeat four times. There are now 144 stitches, and this completes the crown. Continue knitting until the work measures 20 cm (8 in.) from the beginning.

Increase for the head as follows:

Row 1: knit 1, increase 1, knit 70, increase 1, knit 2, increase 1, knit 70, increase one, knit 1.
Rows 2 to 5: knit.
Row 6: knit 1, increase 1, knit 72, increase 1, knit 2, increase 1, knit 72, increase 1, knit 1.
Rows 7 to 10: knit.

Continue until there is a total of 172 stitches.

Knit 16 rows with no shaping (this is the brim). Then reverse all the instructions, beginning with the head shaping, and checking

187 *Simple double cap.*

that the shape matches that of the other half. When there are eight
stitches left, pull the end of the wool through them and fasten off.

SWEDISH DOUBLE CAP
Method
Knit a lining in plain white using the above method as a guide.
Some linings are as large as the outer half of the cap; some are
head-hugging and much smaller than the outer part; some, again,
are just extensions of the brim, with little or no shaping, and some
thrifty (or hard-up) knitters would use parts of old caps and knit
on a new outer piece.

When the work measures (very roughly) 30 cm (12 in.) in total
length, and is wide enough to fit the head, begin the first pattern
row as shown on the chart, or as chosen from elsewhere. Suggested
colour and pattern variations are as follows:
Pattern A (six rows) in blue on red.
Two rows white, one row blue, two rows red.
Pattern A (six rows) in red on white.
Two rows red, one row blue, two rows white.
Pattern B (27 rows) in blue on red. This marks the centre of the
brim. Knit the preceding patterns and stripes in reverse order to
complete the brim. Reduce at this point by four stitches.
Continue, knitting the brim lining in white, with pattern C (6
rows) centred on it in blue, altogether about 20 rows.
Then continue as follows, reducing regularly by four stitches every
eight–ten rows, where this will not disturb the pattern:
Pattern A in white on red.
One row blue, two rows white.
Pattern D in blue on red, white on red and blue on red.
Two rows white, two rows blue.
Pattern A in white on red.
Two rows white, two rows red, two rows blue.
Pattern A in white on red.
Two rows white, one row blue, two rows red.
Pattern E in blue and white.
Two rows blue.
Pattern F in white on red.
Two rows blue.
Pattern E in blue and white.
Two rows red, one row blue, two rows white.
Pattern A in white on red.
Two rows white.
Pattern G in blue on red.
Two rows white.
Pattern A in blue on red.
Two rows white, two rows blue, two rows red.
Pattern H in blue on red.
Two rows red, two rows blue, two rows white.
Reduce crown in red and white stripes according to chart, dividing
into four for reductions.
Finish off with a tassel sewn to the top.
As given there are 223 rounds; this can be increased or decreased
by changing the number of patterns and stripes.

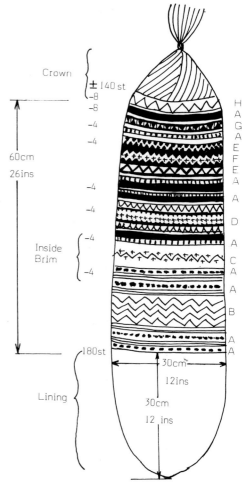

188 *Swedish double cap. Letters at right
refer to patterns described on page 160;
alternative patterns are also given. There is
a small but regular reduction in the top of
the cap, spaced out regularly in plain rows,
as shown on the left.*

189 *Swedish double cap.*

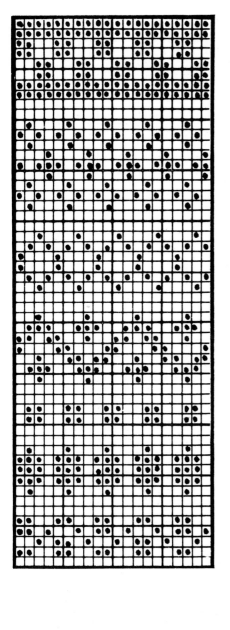

Red ◉ Blue ⊡ Yellow ⊙ White ☐

Crown Reduction

Gooseye Pattern

Turn Work at this point

Turn-up Lining (not seen)

Brim Pattern

Cast on

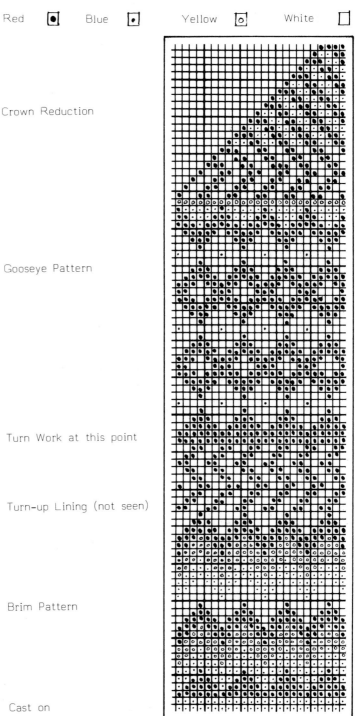

191 *Swedish fiddler's cap. In the bright primary colours so popular in northern Sweden, this cap is knitted from the brim up. The work is turned inside-out after the brim has been knitted (knit first and last stitch together to avoid a hole), and the crown is reduced in six sections. The tension of the original is around 30 stitches to 10 cm (4 in.), with 168 cast on, and the traditional colours are red, blue, yellow and white.*

GLOSSARY OF ENGLISH AND SCANDINAVIAN KNITTING TERMS

These are not always exact grammatical equivalents but intended to help decipher any Scandinavian knitting instructions you might come across.

English	Norwegian/Danish	Swedish
knitting	strikking; binding	stickning
mittens	vanter	vante
cap	lue	mössa
stockings; socks	strømper; votter	strump
jersey	trøje	tröja
sleeves	ermene	ärmer
armhole	aermegab; ermehull	ärmhal
neck edge	utringning	halskant; urringning
yarn (quantity)	garn	garn otgang
ball of yarn	nagel; nøste	nysta
cast on	sla op; legg op	lägga upp
cast off	lukke af; felle av	släppa av
width	bredde	vad
size; measure	male	mäta; storlek
number of rows	antall rader	varvantal
pattern	mønster	mönster
tension	strikkefasthet	maskatathet; sträkning
work	arbejet	arbete
round; row	rad; omgang	varv
needle; pin	pinne; pinde	sticka (pl. stickor)
plain (stitch)	ret	rät
right side	retten	rätsida
stocking stitch	glattstrikking	slätstickning
purl	vrang	avig
stitch	maske	maska (pl. maskor)
purl side	vrangen	avigsida
edge	fall; bord; kant	kant; bord
loop (stitch)	løkke	ögla
knitting together	sammentakning	hoptagning; intagning
knit together	strikke sammen	hopsticka
slip 1	tag 1 m los af	lyftad 1 maska
turn	vend	vända
repeat	gentag	rapporten
increase	utlegning; udtagning	ökning
decrease	fellinger; indtagning	minskningar
ribbed edge; ribbing	ribbort; vrangbord; ret og vrang	resarstickning
twisted (stitch)	drejet; vridd	snodd
cut	innsnitt	sprängveck

WOOL STOCKISTS

FAEROESE WOOL

Faeroese wool is available in all the undyed natural colours: white, light grey, grey, light brown and dark brown and in three thicknesses of which the thickest is the most popular. This is more closely spun than Icelandic *lopi*. A medium-weight yarn (approximately a double-knitting thickness) is useful for finer jerseys and gloves. The finest yarn is a specialist one-ply yarn used only for shawls and fine openwork. It must be handled with care as it is loosely spun. Faeroese wool is available from:

Denmark
Søndags-B.T.s Butik
Grønnegade 4
1013 Copenhagen K
Norway
Nästebaren Postservice
Postboks 320
N-5051 Nesttun
Sweden
Färöprodukter
Tystagatan 11
S-11524 Stockholm

ICELANDIC WOOL

Icelandic wool is available in several types but *lopi* is the best known – the loosely spun single-ply bulky yarn available both in the original natural colours and now in dyed shades. Natural *lopi* is available from:
Alafoss Limited
P.O. Box 404
121 Reykjavik

They can supply the names of their stockists worldwide.

NORWEGIAN WOOL

A.S. Dale Fabrikker supply a wide range of excellent yarns in natural and fashion colours and have one of the widest range of shades available.

Most are in the middle range of thickness. They are available from:
A.S. Dale Fabrikker
Strandgaten 209
5011 Bergen
Norway

Other outlets are the Knitwear and Fashion Centre, Kirkwall, Orkney Islands; their U.S. agents are William Unger & Co., and in Canada S.R. Kertzer & Co.

The thick and substantial wool favoured by 'traditional' knitters in Norway today can be got from the Husfliden organisation in all parts of the country. It is between Aran and double-knitting weight and is much coarser than earlier types of Norwegian wool (such as that used in Selbu).
Den Norske Husflid Forenigen
Møllergaten 4
Oslo 1
Norway

DANISH WOOL

The Danish home-craft organisation, Haandarbejdets Fremme, market a great variety of all-wool yarns in superb colours, some plied and some of *lopi* type. Their main address is:
Haandarbejdets Fremme
Vimmelskaftet 38
1161 Copenhagen K

BRITISH EQUIVALENTS

A variety of natural yarns from such British breeds as the Herdwick, Swaledale, Jacob and Black Welsh Mountain is available from:
Lakeland Knitwear Manufacturing Limited
The Factory
Old Lake Road
Ambleside
Cumbria LA22 0DL

Shetland wool, with its 'woolly' handle, suits some types of Scandinavian knitting well. The range includes 1-ply and 2-ply lace-weight (1-ply in white only), 2-ply jumper weight (for gloves), and 3-ply yarns in several natural colours which reproduce well the home-spun appearance of the heavier Scandinavian knitting. The main stockists are:

Jamieson & Smith (Shetland Wool Brokers) Limited
90 North Road
Lerwick
Shetland Islands.

GENERAL ENQUIRIES

U.S. enquiries to:
Fiber Design Studio
927 John Alden Road
Stone Mountain
Georgia 30083

U.K. enquiries to:
Emplus Distribution
14 Lockharton Avenue
Edinburgh EH14 1AZ

KNITTING NEEDLE SIZES

Exact needle size is not of crucial importance as tension (see page 29) must always be established. It can, however, be useful to have a variety of needle sizes, and some idea of useful alternatives is given below.

Metric	U.K.	U.S.A.
8	0	
$7\frac{1}{2}$	1	11
7	2	$10\frac{1}{2}$
$6\frac{1}{2}$	3	10
6	4	9
$5\frac{1}{2}$	5	8
5	6	
$4\frac{1}{2}$	7	7
4	8	6
$3\frac{1}{2}$	9	5
$3\frac{1}{4}$	10	4
3	11	3
$2\frac{1}{2}$	12	2
$2\frac{1}{4}$	13	1
2	14	0

FURTHER READING

Aamlid, Olav, 'Strompe fra Flesberg, Numedal', *Norsk Husflid*, No. 3,
 1975.
Aamlid, Olav, 'Kvinnesokke fra Toedal, Aust-Agder', *Norsk Husflid*, No.
 1, 1977.
Aamlid, Olav, 'Eit Tilfang fra Setesdal', *By og Bygd* 27, 1978.
Aamlid, Olav, *Mannsokk fra Aust Telemark* (sheet), Norsk Folkemuseum,
 1981.
Aune, Hermann and Haukdal, Jens, 'Bygefolk og Bygeliv i Støren', *Gard
 og Grind*, III, 1970.
Bengtsson, Gerda, *Danish Embroidery*, B.T. Batsford Ltd, London, 1959.
Bitustøl, Torbjørg, 'Votter', *Norsk Husflid*, No. 5, 1979, pp. 9–13.
Bjelland, Anna Marøy, *Votter og vanter*, Oslo, 1955.
Bøhn, Annichen Sibbern, *Norwegian Knitting Designs*, Grøndahl & Søn,
 Oslo, 1975. (Original version in Norwegian, 1952.)
Bondesen, Esther, *Continental Knitting*, Maurice Fridberg, Dublin and
 London, 1948.
Broholm, H.C. and Hald, Margretha, *Costumes of the Bronze Age in
 Denmark*, Copenhagen, 1940.
Chatterton, Pauline, *Scandinavian Knitting Designs*, Charles Scribners
 Sons, New York, 1977.
Clausen, Minna Holm, *Strikkemetoder og Strikkede Dragtdele isaer hos
 dansk bondestand*, Schweitzers Bogtrykkeri, Jelling, 1968.
Collin, Maria, *Skansk Konstväfnad i Allmogestil*, Collin & Rietz, Lund,
 1890.
Crottet, Robert and Mendez, Enrique, *Lapland*, Hugh Evelyn, London,
 1968.
Dansk Farvebog (Anon), Copenhagen, 1768.
Dale Yarn Company, *Knit your own Norwegian Sweaters*, Dover
 Publications, Inc, New York, 1974.
Debes, Hans M., *Føroysk Bindingarmynstur*, Føroyskt Heimavirki,
 Tørshavn, 1932.
Debes, Lucas Jacobsen, *Faeroe et Faeroa Reserata*, 1670 (English version
 1676)
Engelstad, Helen, 'En bonnett og åtte bordyrede og flossese nattrøyer',
 Vestlanske Kunstindustrimuseum Arbok, 1954–7, p. 37 ff.
Faerøerne I, II, Dansk Faerøsk Samfund, Copenhagen, 1958.
Fangel, Esther, *Danish Pulled Thread Embroidery*, Dover Publications,
 New York, 1977.
Frederiksen, Tove, *Tvebinding*, Clausen Bøger Aschehoug, Copenhagen,
 1982.
Geijer, Agnes, *A History of Textile Art*, Pasold Research Fund,
 Stockholm, 1979
Gudjonsson, Elsa E., *Notes on Knitting in Iceland*, National Museum of
 Iceland, 1979.
Haglund, Ulla and Mesterton, Ingrid, *Bohus Stickning 1939–1969*, Bohus
 Stickning, Göteborg, 1980.
Hansen, H.P. *Spind og Bind*, Ejnar Munksgaard Forlag, Copenhagen,
 1947.
Haarstad, Kjell, 'Selbu in Fortid og Natid', Selbu Kommune Bygdebok,
 Trondheim, 1972.
Hazelius-Berg, Gunnel, *Folk Costumes of Sweden*, ICA Bokförlag, Västerås,
 Sweden, 1976.
Joensen, Robert, 'Fareavl pa Faeroerne', *Faeroensia Vol XII*,
 Copenhagen, 1979.

Johansson, Britta and Nilsson, Kersti, *Binge, en Hallandsk Sticktradition*, LTs Forlag, Stockholm, 1980.

Krafft, Sofie, *Pictorial Weavings from the Viking Age*, Dreyers Forlag, Oslo, 1956.

Kragelund, Minna, *Folkedragter*, Lademann, Denmark, 19??

Larsson, Marika, *Stickat fran Norrbotten*, LTs Förlag, Stockholm, 1978.

Lind, Vibeke, *Strik met Nordisk Tradition*, Høst & Søn, Copenhagen, 1981.

Løset, Margret, 'Ragga fra Nordmøre', *Norsk Husflid*, No. 4, 1970.

McGregor, Sheila, *The Complete Book of Traditional Fair Isle Knitting*, B.T. Batsford Ltd, London, 1981.

McGregor Sheila, *Traditional Knitting*, B.T. Batsford Ltd, London, 1983.

Mygdal, Elna, *Amagerdragter*, Den Schønbergske Forlag, Copenhagen, 1932.

Nordland, Odd, *Primitive Scandinavian Textiles in Knotless Netting*, Oslo University Press, Oslo, 1961.

Nylen, Anna Maja, *Swedish Handcraft*, Häkan Ohlssons, Lund, 1976.

Nylen, Anna Maja, *Swedish Peasant Costumes*, Nordiska Museet, Stockholm, 1949.

Ploug, Marianne, *Strikkede Nattrøjer*, Danmarks Folkelige Broderier, Aarhus, 1979.

Ploug, Marianne, *Gamle Lollandske Strikkemønstre*, Museum Maribo, Denmark, 1981.

Røset, Ingulv, 'Selbustrikkinga, ein lokal kulturskatt', *Aarbok for Trøndelag*, Trøndelag, 1977.

Saust, Elizabeth, *Strik med Faerøgarn*, Berlingske Forlag, Copenhagen, 1976.

Stewart, Janice Smith, *The Folk Arts of Norway*, Dover, New York, (second edition).

Sundt, Eilert Lund, *Husfliden in Norge*, Blix Förlag, Oslo, 1945.

Trotzig, Eva, *Stickning, Tradition och Kultur*, LTs Förlag, Stockholm, 1980.

Tvebandstrikking, (Norwegian version of *Tvaändsstickning*, Dalarna Museum, 1981), Den Norske Husflidsforening, Oslo, 1982.

Various, *Sticka med Hemslöjden*, Svensk Hemslöjd, Stockholm, 1980.

Warburg, Lise, *Strikkeskeen – et glemt redskab* (with a summary in English), Herning Museum, Herning, 1980.

Warburg, Lise, 'Strik med begge ender', reprinted from *CRAS, Tidsskrift for Kunst og Kultur*, No. 29, 1981.

Wiman-Ringquist, Gia (Ed), *100 Landskaps Vantar*, ICA-Forlaget, Västerås, Sweden, 1982.

Wintzell, Inga, *Sticka Mönster*, Nordiska Museet, 1976.

INDEX